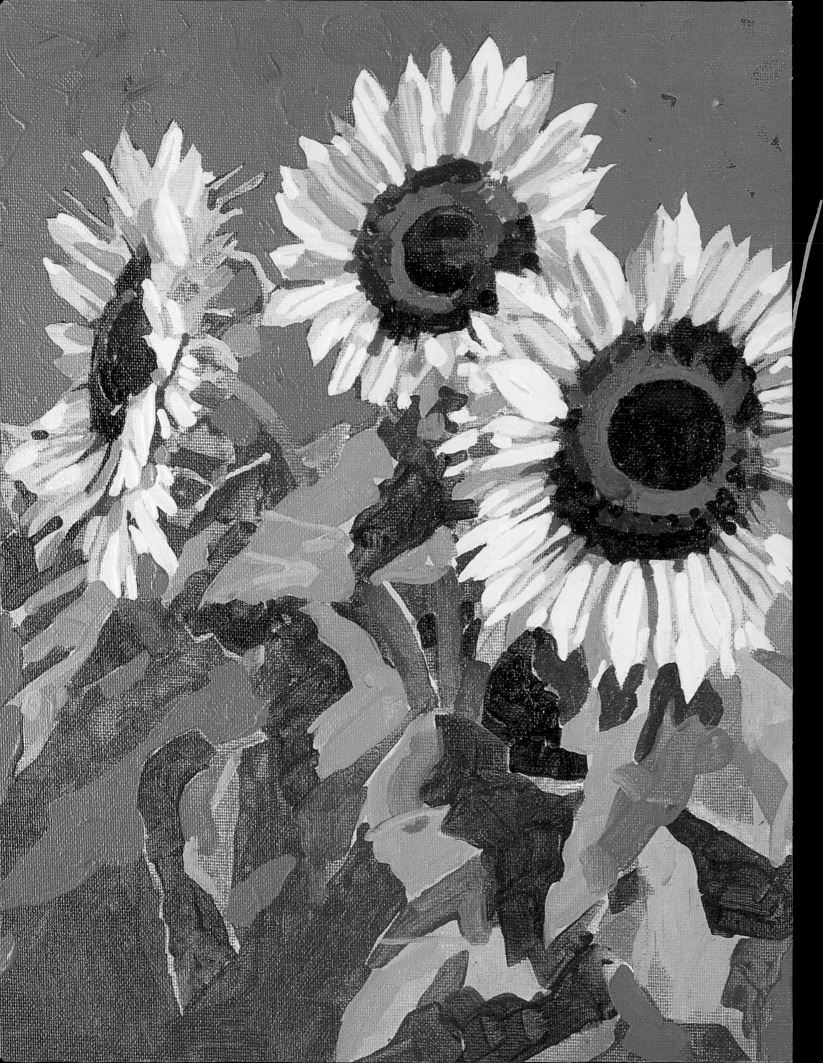

painting
with acrylics

**A step-by-step course complete with
techniques, materials and projects**

Ian Sidaway

APPLE

A QUARTO BOOK

Copyright © 2005 by Quarto Publishing plc

Published by Apple Press
Sheridan House
114 Western Road
Hove
East Sussex BN3 1DD
United Kingdom
www.apple-press.com

ISBN 1-84543-080-8

QUAR.TAL

Conceived, designed and produced by
Quarto Publishing plc
The Old Brewery
6 Blundell Street
London N7 9BH

Project editor Jo Fisher
Art editor Anna Knight
Designer Julie Francis
Photographer Martin Norris
Text editor Hazel Harrison
Picture researcher Claudia Tate
Proofreader Alison Howard
Indexer Pamela Ellis
Assistant art director Penny Cobb

Art director Moira Clinch
Publisher Paul Carslake

Colour separation by PICA Digital, Singapore
Printed by Star Standard (PTE) Ltd, Singapore

10 9 8 7 6 5 4 3 2 1

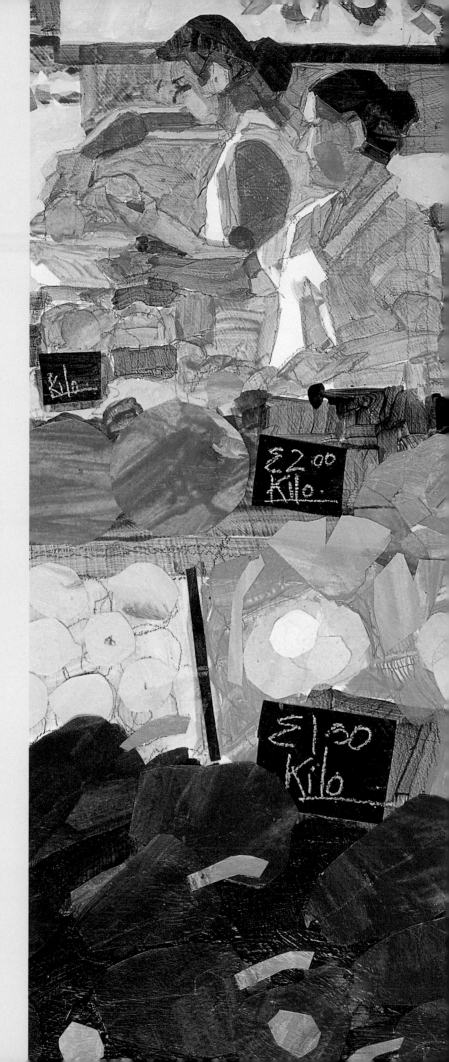

"colour in a picture is like picture is like enthusiasm in life"

—Vincent Van Gogh

Contents

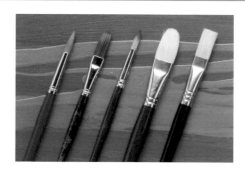

Making pictures

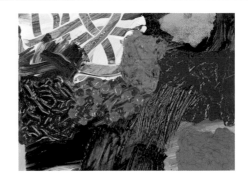

Projects

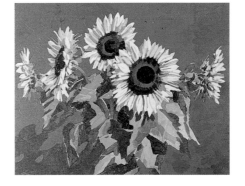

Introduction

Acrylic is the newest of all painting mediums, and one that offers the most in terms of experimentation. In the field of texture, there is no paint that can rival it.

The main advantage of acrylic over other painting media is its sheer versatility. It can be applied in many different ways – as a thin watercolour-like wash or a thick oil-paint impasto built up with a variety of painting implements. Because it dries so fast, layers of paint can be applied over one another without waiting days for each one to dry, as would be the case for oil paints.

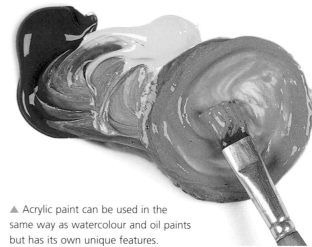

▲ Acrylic paint can be used in the same way as watercolour and oil paints but has its own unique features.

◄ A wide range of application techniques is possible.

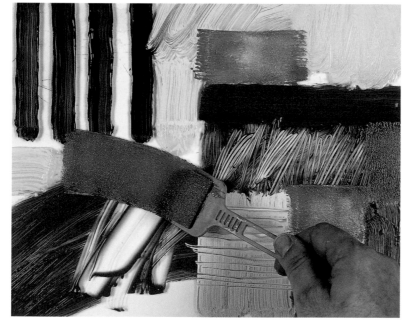

◄ Brushstrokes retain their freshness and texture once the paint has dried.

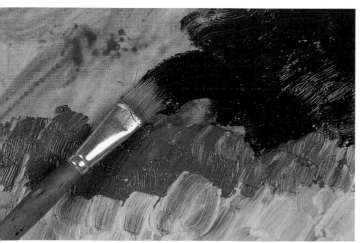

Acrylic imitates watercolour and oil paints, so you can apply acrylic using the many techniques associated with those mediums. But acrylic should not be seen as a substitute for watercolour or oils. It has very special characteristics of its own, and these have given rise to a whole range of exciting techniques. When you combine acrylics with various painting mediums designed to alter the nature and handling properties of the paint, the possible techniques you can use can be extended even further. Acrylics are ideal for mixed-media and experimental techniques, such as collage.

Painting with Acrylics provides a complete course in using this exciting medium, guiding you through your initial choice of materials and demonstrating the range of techniques in easy-to-follow steps with captions and annotations. The chapter "Making pictures" gives invaluable advice on choosing colour and arranging compositions, which are just as important as developing technical skills. The final chapter, "Projects", is devoted to a series of full-scale demonstrations showing a range of different painting subjects, from land- and seascapes to figures and portraits. Clear step-by-step photographs

enable you to "look over the artist's shoulder" to see how the artist builds up each painting from the preliminary drawing to the finished work. Each painting features one of the techniques shown in the "Techniques" chapter so that you can see them all in context. Browsing through the compositions will help you to develop your own style and preferred way of working.

this exciting medium as far as you can in your own way. And keep a lookout for any exciting new painting mediums and additives – manufacturers keep their eyes on market trends, and it's to their advantage and yours as an artist to continue to develop the possibilities of the acrylic medium.

▲ Acrylic paint is the ideal medium for mixed-media and experimental work.

Further experimentation

Although the book is aimed primarily at novice painters or those who have not tried acrylics before, more experienced artists will also find inspiring ideas in these pages, such as building up textures with modelling paste or sawdust. Or perhaps some of the techniques shown here will prompt new ideas. The beauty of acrylic is that there are no "dos and don'ts", as with oils and watercolours. This medium actually invites experimentation. So whether you are painting with acrylic for the first time or have some previous experience, learn to push the potential of

◀ Artists who use traditional methods are continually surprised at the versatility of acrylic paint.

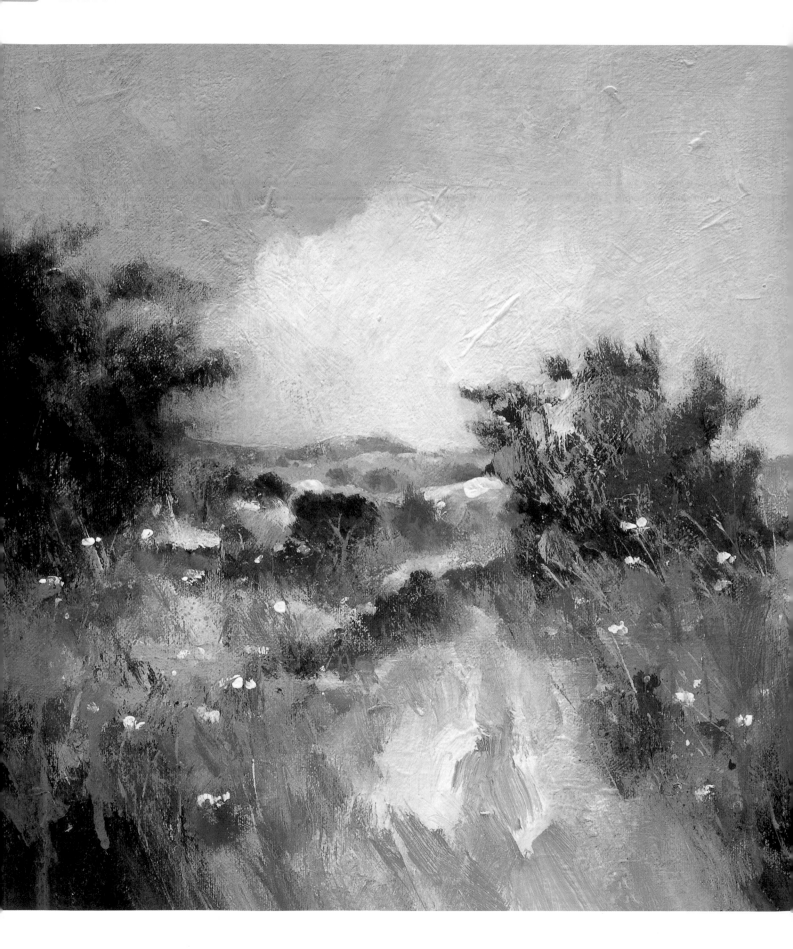

The joy of acrylics

One of the pleasures of artistic endeavour is that, given the same materials and subject matter, different artists will produce works that vary considerably, both in the techniques used and the imagery created. This gallery of artwork features a range of subjects and painting styles; all have been painted using acrylic paint, and the results serve to demonstrate the immense versatility of the medium.

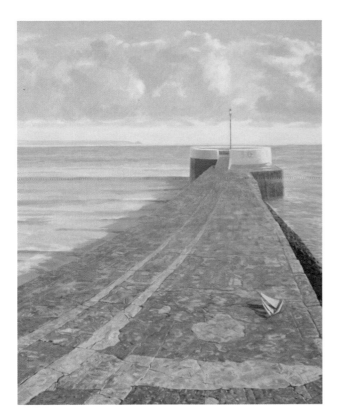

▲ **(Peter Warden) Perspective** The dramatic use of perspective (page 82) brings this relatively simple seascape to life. The triangular composition also draws on the Rule of Thirds (page 81): the sky, the sea and the pier each occupy an area that is approximately one third of the total. The circular end of the pier, with its warning light, falls at a point approximately one third from the right-hand side of the painting.

◄ **(Stephen Rippington) Impasto techniques and perspective** The fast-drying qualities of acrylic paint are perfectly suited to the impressionist style of this painting. The paint has been built up using impasto techniques (page 42) and multidirectional brushstrokes. Aerial perspective (pages 82–83) is also a feature: cool colours and light tones have been used for the distant hills, while touches of warm red in the foreground suggest nearness.

▼ **(Marco Ronga) Light and tone** Here, the light source (page 86) originates outside the picture area, but interestingly, it is the reflection of this light from the tabletop that appears to provide the main light in the picture. The dark, solid mass of the woman's figure and her shadow serve to accentuate the brightness of the light. Fast-drying acrylic paint is ideal for producing the layering seen in the multicoloured background. The loose application contrasts nicely with the blended skin tones (page 56).

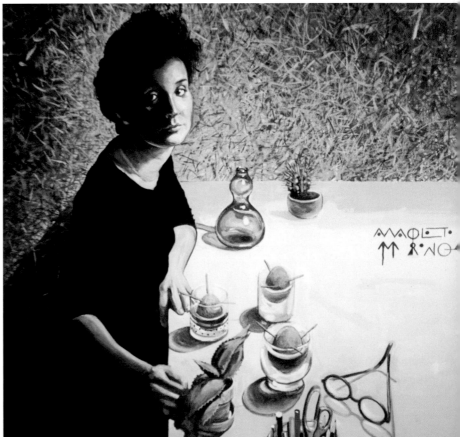

▶ **(Colin Freeman) Composition**
Subtle mixed colour combinations have
been worked in layers to provide a
background for the intense hues used
to depict this boat and its reflection.
The craft seems to float on the surface
of the support as if in space. This
semiabstract composition is a difficult
one: the viewer is drawn to the top
left-hand corner, risking an imbalance
within the picture. However, the blank
right-hand side of the image works as
an anchor to pull the viewer's attention
back to the centre (page 80).

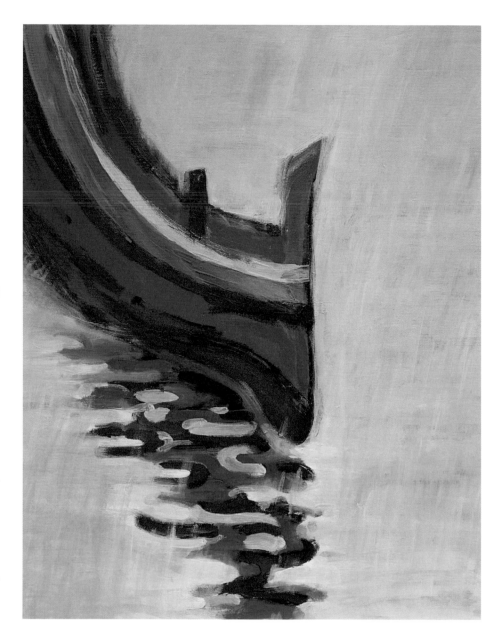

▼ **(Marco Ronga) Colour** Bright,
intense colour combinations and direct
brushstrokes evoke a warm, exotic
night in this panoramic view of a town.
The range of primary hues used is at
once inviting and exciting, yet the
deep, restful blue of the sky tones
down the vibrant colours below,
bringing a surprising stillness and quiet.
The choice of colours has captured the
mood perfectly (page 78).

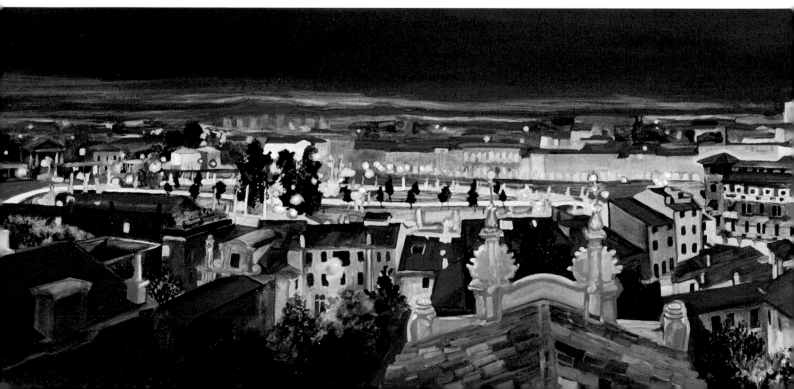

▶ **(Andrei Savich) Masking and sgraffito techniques** This still life recalls the cubist imagery created by Picasso or Braque and makes use of several different painting techniques. The series of parallel lines that represent the tabletop have been made using masking tape (page 50), while the background and surface of the objects has been created by applying paint and then scraping and blotting it away (page 64). The contrasting applications of thick paint and thinner paint works well.

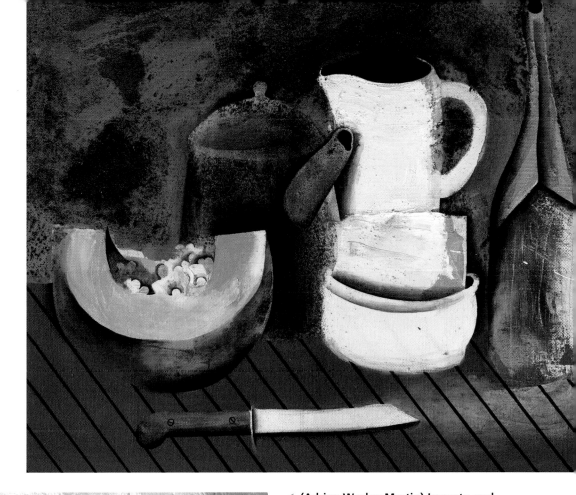

◀ **(Adrian Wesley Martin) Impasto and texture paste techniques** Impasto techniques (page 42) have been used here to create this image of a town. The relatively fast drying time of acrylic paint makes it perfect for thick impasto work. Texture or modelling pastes (page 52) could also be used to create this kind of texture; mix the pastes with paint, or apply them first and paint over them once dry. Note that the heavy brushstrokes do not necessarily follow the lines of the image but are used to give texture to the piece.

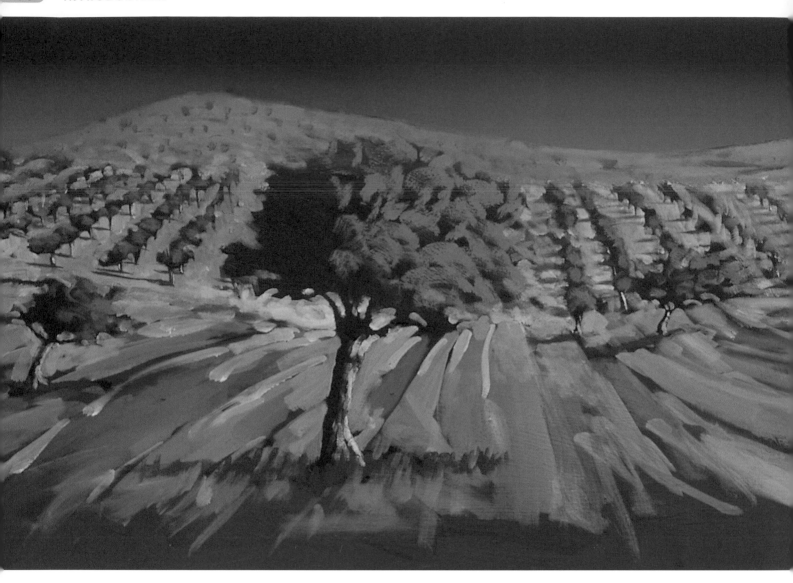

▶ **(Ian Sidaway) Colour** Complementary colours of red and green are used to create a striking contrast and lead the eye straight to the centre of this flower portrait. For the foliage, a thin, light green underwash was rapidly applied. The darker negative shapes behind the leaves were then painted in with a darker wash with the effect that the leaves appear to grow out of the background shadows. White was then added to the green wash for the opaque splashes of light. The flower was gradually built up with radiating brush strokes using various mixes of cadmium red, alizarin crimson and white, with ultramarine blue added for the shadows. The focal point of the composition is the stamens, painted in cadmium yellow as a final touch.

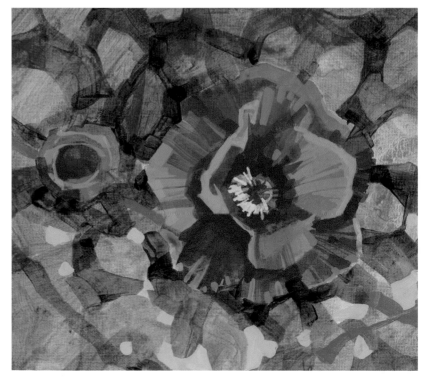

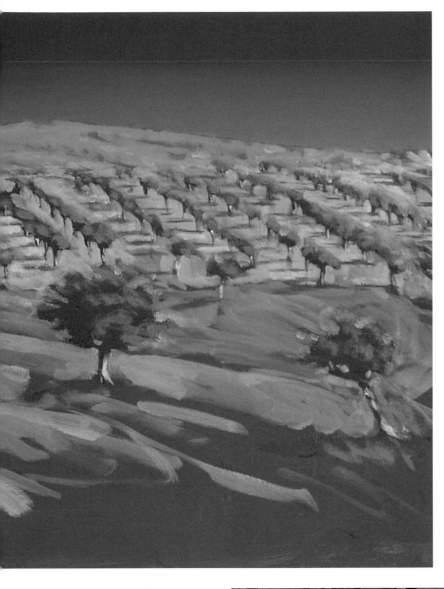

◀ **(Paul Powis) Colour and perspective** A bright palette of colours enlivens this sweeping panorama of a hillside with regimented lines of olive and fruit trees (page 78). A loosely applied red makes up the underpainting; the contrasting deep green of the trees and hillside serves to intensify the brilliance of both colours. In the same way, the blue of the sky stands out against the deep orange earth surrounding the trees. The transition from warm to cool colours, from the front to the back of the painting, enhances the illusion of space suggested by the perspective used to illustrate the rows of trees (page 82).

▶ **(Tomomi Maruyama) Opaque techniques and laying washes** This shows an interesting combination of techniques. The initial layers of the image have been painted with thin acrylic paint in a variety of colours and in a random manner to produce an abstract underpainting. The simple, graphic image of a street scene has been painted carefully over this with an opaque layer of black paint.

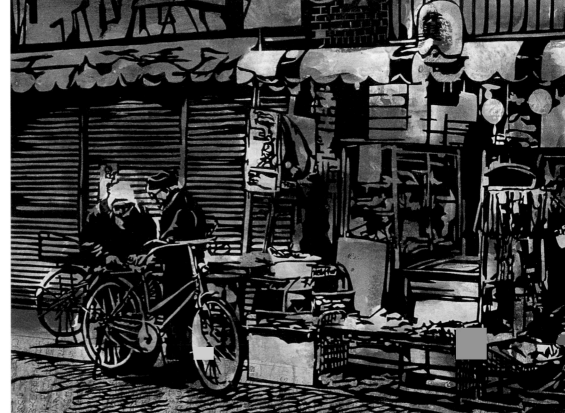

Materials

Just using good-quality materials will not make you a good artist; if you use fine paints and painting implements, you will broaden your scope for experiments, and the actual painting process will be more satisfying for you. Buy the best materials you can afford since poor-quality paints and brushes may lead to frustration. Most materials currently available in art-supply stores are made by reputable and well-established manufacturers who pride themselves on the quality of their products. If you decide to purchase acrylic materials by mail order or through Internet websites, buy well-known brands or ones you are familiar with. Don't be misled by special discount offers from unknown manufacturers.

Acrylic paint

Choosing paints

Formulas for producing paints and mediums vary only slightly from one manufacturer to another. Some manufacturers advise against mixing their paints with other brands. This is possibly just a marketing ploy; most artists find no real problems when mixing different brands of paint. Mixing different brands can in fact sometimes be necessary if a certain colour is made only by one manufacturer. If in doubt, follow the manufacturer's advice.

Acrylic paint comes in tubes. Larger quantities are available in plastic containers or bottles. Paint consistencies vary by brand but, in general, the tube colours are slightly thicker and stiffer than colours in containers and bottles, which tend to be more fluid.

Paint is made in different qualities for artists and students, although this distinction is not always clearly marked on labels. However, there is an easy way of telling one from the other: different colours made for students all have the same price, whereas the prices of artists' colours vary according to pigment content.

Some colours are considerably more expensive than others. This is because artists' paints are made from only the very best pigments and offer a wide range of hues, while students' paints have a smaller colour range that is limited to less costly pigments. Lesser-quality paint is still good enough to use for sketching, preliminary work, underpainting and blocking in. But bear in mind that since this pigment is often thickened with an inert pigment like barium sulphate, it is less pure and the paint has reduced covering power.

Reading paint labels

If you understand the information on the labels of paint tubes and containers, you can make better decisions regarding which colours to purchase.

The most important item the label will list is the name of the colour. Many colour names, such as cadmium red or cobalt blue, are universal, but you will also come across colour names that are restricted to certain brands, since some manufacturers specifically formulate particular colours.

ACRYLIC PAINTS
1. Standard, or "full-bodied", acrylic paints – a relatively thick, buttery texture
2. Liquid, "flow-formula" acrylic paints – a runnier preparation
3. Student acrylic paints – usually of the "flow-formula" type
4. Tubs of acrylic paint

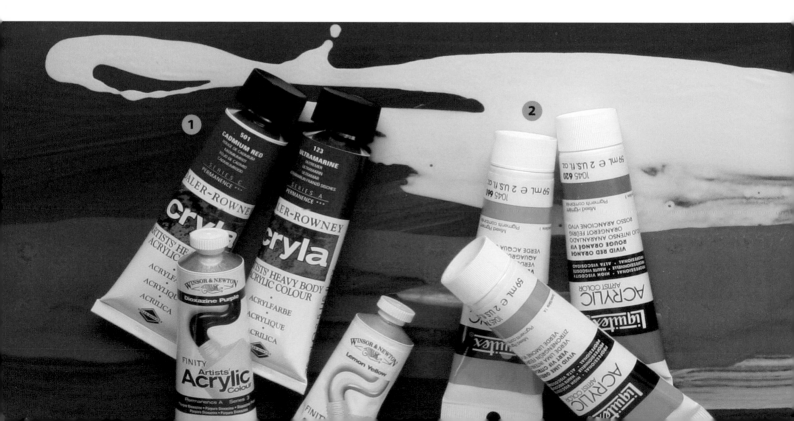

All pigments have a code that is listed on the colour index. Cadmium red, for example, is coded as PR108; the PR stands for pigment red. This code is included on most paint labels and tells you what pigments were used to make the colour. Many colours, regardless of the brand name, are made from a single pigment. Some are produced by mixing several different pigments, and these colours may vary slightly according to different manufacturers.

If the paint is part of a series, the series number or letter will also be included. The paint vehicle may also be mentioned, along with the degree of lightfastness and whether or not the colour is defined as being intrinsically opaque or transparent. American Society for Testing and Materials (ASTM) ratings refer to whether the product conforms to certain standard criteria set by this society. Labels may also refer to the Chroma, or the degree of purity of the colour, and the Munsell value, or the comparative saturation of both hue and brightness.

Painting with acrylics

Acrylic paint can be used on any permeable surface (see *Supports*, page 32), but on non-permeable surfaces such as glass or plastic, the paint dries to form a film or skin that peels away easily or becomes damaged. Use paint straight from the tube or thin it with water. Acrylic paint dries relatively quickly, though the drying time is affected by the water content and thickness of the paint. You can use mediums and additives to alter the characteristics of acrylic paints (see *Mediums and additives*, page 22).

As soon as you begin to use acrylics you will notice the slight colour variation that occurs as the paint dries. It becomes darker as the milky emulsion used to bind the colour dries out and becomes transparent, allowing the true colour to emerge. This can be a little disturbing at first, but you will learn how to make adjustments to wet colour.

tips

A few tips will help you to get the most from your paint.
- Change your water frequently – clean water will help you to achieve purer colour mixes.
- Only put out as much paint as you can use in a short time. Acrylic dries very fast and will quickly form a skin that will prevent you from making smooth mixtures.
- Always securely close the lids on tubes and containers. If exposed to air, paint will rapidly become unusable.

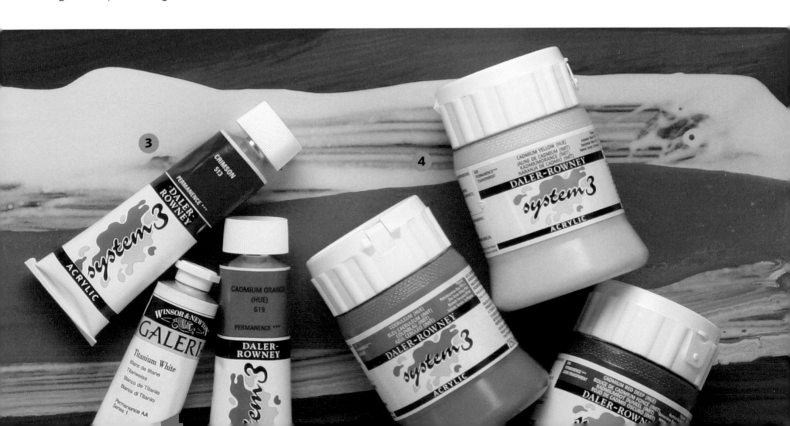

Palettes

Palette, in an abstract sense, refers to an artist's chosen range of colours. A palette is also a physical entity – the surface upon which the artist mixes paints. The traditional wooden oil-painter's palette is not suitable for acrylic. The paint will sink into that surface and be impossible to remove when dry. Palettes used to mix acrylics must be made of a hard, non-porous material that prevents the paint from taking hold as it dries; this non-permeable surface will allow it to dry to form a skin that is easy to remove, once you wet it again.

Suitable palette materials include ceramic, glass, stainless steel, plastic, enamelled tin, Formica and laminated wood. Plastics and laminates may become stained with use; it's better to use glass, ceramic and stainless steel. They can be cleaned back to their original condition.

Many artists improvise their own palettes using laminates, stainless steel pans, old ceramic plates or glass. If you are using glass, take extra care, as you can easily cut your fingers. Use only heavy plate glass and either have the edges polished smooth or tape them with a suitable heavy adhesive tape. An advantage of using glass is that it enables you to place a sheet of paper that has been painted to correspond with the ground colour you are working on beneath it. This will help you to mix your colours more accurately.

Palette types

The usual palette consists of a flat surface that allows the mixing of relatively thick or creamy paint, but watercolour palettes that have recesses for mixing very fluid paints are also useful. Palettes are designed in various shapes, ranging from the traditional oval or kidney shape with a thumb hole, to round, square or rectangular shapes. Choose the type that suits you best, but make sure that it is large enough – you will be surprised at how quickly you will fill it with colour mixes.

Two relatively new types of palette have become popular over the years. Disposable palettes consist of sheets of non-porous paper that are sold in blocks, very much like sketchbooks. Once you finish your work or fill a sheet, just tear it off the block and throw it away. Stay-wet palettes, specially designed

PALETTE SURFACES
1. Laminated wooden palettes
2. Old plates/paper plates
3. Aluminium palette
4. Porcelain palettes
5. Plastic palette
6. Stay-wet palette

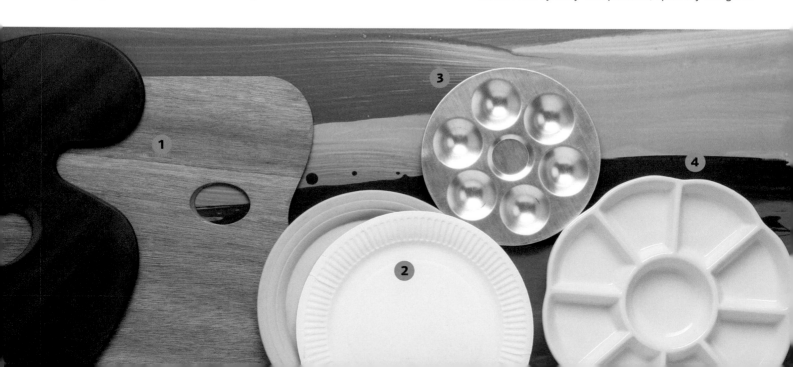

for acrylic work, cut down waste since they keep paint moist for long periods. This type consists of a shallow plastic tray with a lid and two packs of special paper. A sheet of thick, absorbent paper is placed in the tray and thoroughly soaked with water. A semipermeable membrane, on which the colour is mixed, is placed on top. The water from the paper below permeates through to the paint, keeping it moist. At the end of the working session, the lid is put in place. The paint will remain workable for several days, if not weeks.

Laying out your palette

The colours you decide to use and the way in which you arrange them on the palette are up to you, but your choice is dictated partly by the subject matter and partly by experience. The number of colours that you include in your palette is also a personal choice, but there are some practical matters you might want to consider. While in theory all colours can be mixed from just three primary colours – red, yellow and blue – this does not really work in practice. Not many artists work with fewer than eight colours, while some may use sixteen or more.

Even if you are not using a wide range of colours, it's best to arrange them in some kind of logical order on your mixing palette, from warm to cool, or from light to dark, for example. Always place colours in the same position. This will speed up your work, as you will instinctively know where to go for each colour.

Making your own stay-wet palette

You will need a shallow plastic or metal tray, a piece of capillary matting (as used by gardeners for keeping seed trays moist), same-sized pieces of drawing paper and either thin tracing paper or wax paper. Use clingfilm to seal in the moisture.

1. Soak the capillary matting and place the drawing paper on top. An alternative is to use blotting paper instead of the matting, in which case you don't need the drawing paper.

2. Carefully place the tracing paper or wax paper on top, and you have your palette.

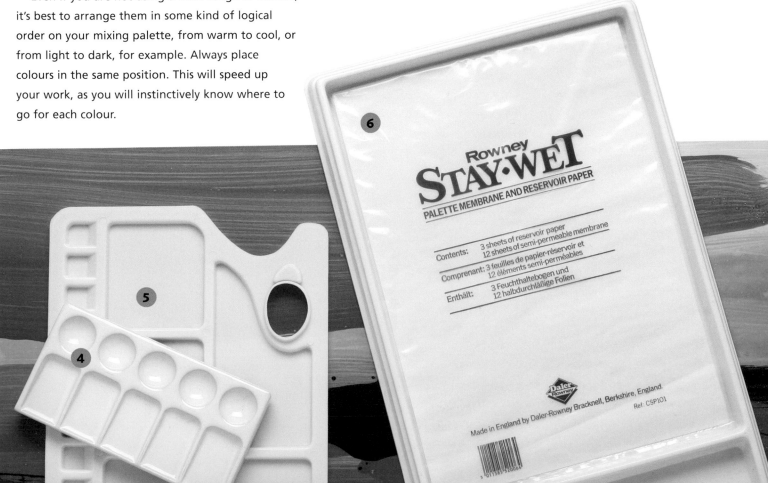

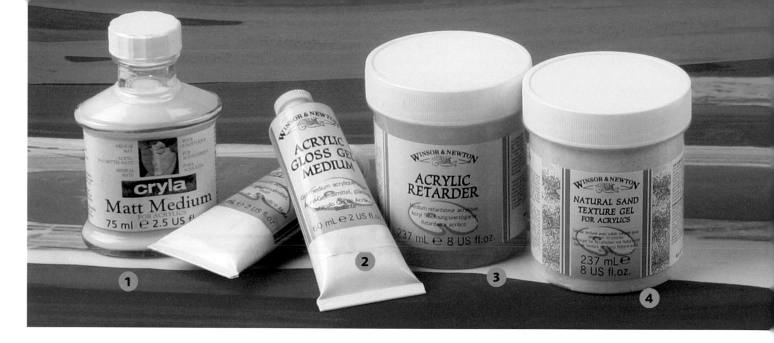

Acrylic mediums and additives

Although you can work with acrylic paint using nothing but water, you may achieve the true potential of this medium more fully if you take advantage of the wide range of its specially formulated mediums and additives. Mediums alter the way paint behaves and also create a wealth of exciting effects and textures.

Matt and gloss mediums

These are the two most basic and commonly used additives, both sold in bottles. Matt medium is a milky, slightly viscous liquid that, as its name implies, gives paint a matt surface when dry. Gloss medium looks exactly the same and is mixed with paint in the same way, but it imparts a sheen to the dry paint surface. Mixed together, they produce a subtle satiny surface. Gloss medium also increases the transparency of paints and its reflective qualities make colours appear more intense. It can also be used as a varnish (see Gesso primers and varnish sealers, right).

Gel mediums and extenders

Gel mediums are thicker versions of the basic matt and gloss mediums. They are available in tube form. They add body to the paint and are used for impasto work when worked with either a knife or a brush (see *Impasto*, page 42 and *Knife painting*, page 44).

The paint and medium mixture holds the brushmarks and can be pulled into peaks, making it possible to create a range of raised marks and textures. Although gel mediums thicken paint, they also make it more transparent. Extending mediums, on the other hand, increase the volume of paint without altering its colour, making them ideal when covering large areas with paint.

Retarders and flow improvers

All additives increase paint-drying times to some degree, but fluid and gel retarders are made specifically for that purpose and are especially useful when working wet-into-wet or blending colours (see *Wet-into-wet*, page 46 and *Blending*, page 56). Be careful not to add too much medium; always follow the manufacturer's instructions.

Flow improvers reduce the surface tension of the water in the acrylic emulsion, making the paint flow

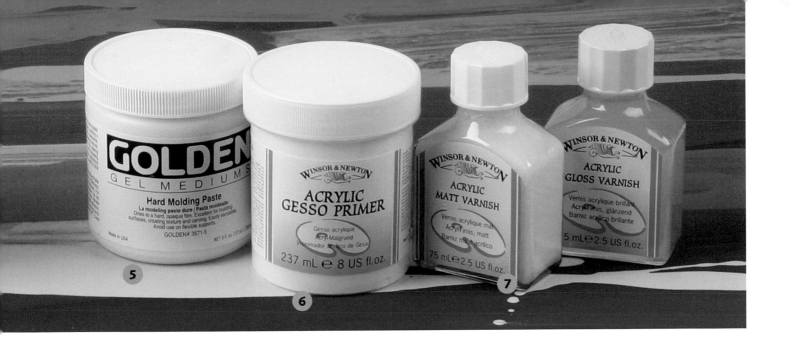

more smoothly onto the support. They are especially useful when working on unprimed canvas or on highly sized smooth papers or cardboard surfaces. These may cause the paint to puddle rather than spread and soak in. Added to thicker paint, flow improvers help it to brush out smoothly without any obvious brushmarks.

Texture pastes

Texture pastes (see *Texture pastes*, page 52) are basically gel mediums into which various aggregates such as small, gritty pieces of pumice or lava, natural and resin sand, tiny glass beads, soft fibres, flakes and small granules of ceramic have been added. Modelling pastes are slightly different. Made from marble dust, once dry they create a hard surface that you can cut or carve into with hand or power tools. Due to their weight, it's best to use traditional texture and modelling pastes on rigid supports, but lighter versions are also available. You can also reduce their weight and increase their flexibility by adding gel medium.

Gesso primers and varnish sealers

Although you can use acrylic paint on raw paper, canvas or board, usually it's best to prepare surfaces beforehand by sealing or priming them. If you want to preserve the natural colour of your surface, seal it with acrylic medium. If you would rather have a white or self-coloured surface, acrylic gesso primer is your best choice. It is specially made for sealing, and in spite of its name, is quite different from

traditional gesso, which is made with chalk and glue size. Acrylic gesso primers remain flexible and can thus be used on canvas or paper as well as board. If you want a smooth surface, sand it down between coats. You can also tint it with acrylic paint to provide a base colour – many artists dislike working on a white surface. You may need to apply more than one coat of colour to cover the brilliant white of the gesso. Acrylic paint is thick, but it is not completely opaque. A hard non-flexible gesso is available.

Once you complete a painting, you may wish to apply a coat of varnish to avoid any possible damage from abrasion and atmospheric pollution. Some acrylic varnishes will also protect your work from the fading effects of ultraviolet light. Acrylic varnish is available in matt, satin and gloss finishes, any of which you can mix to create the required degree of sheen. Certain varnishes are removable, but others are not, so, as with any mediums and additives, always read the manufacturer's instructions before you start.

Brushes

Brush types traditionally used for watercolour and oil painting can also be used with acrylic, although some are more suitable than others, depending on your personal painting techniques. Several manufacturers also produce a selection of brushes in materials that are especially well suited to acrylic work.

Brush-making materials

Brushes are made from either natural hair, synthetic fibres, or a mixture of both. Animal-hair brushes are made from hog, sable, ox, squirrel, goat and badger pelts, while synthetic brushes are made from polyester and nylon filaments.

Soft hair and bristle brushes are traditionally thought to be superior to synthetic-fibre brushes, because of the way they hold and deliver the paint. Natural hair is covered with small scales that hold paint well, and the hairs taper naturally. Hog bristle used in the manufacture of good-quality oil-painting brushes is split at the end (the split is known as a flag). These bristle brushes hold creamy paint especially well. So do the supple, springy sable-hair brushes. But rapid advances in paintbrush technology have produced many synthetic brush fibres that now mimic the action of natural-hair brushes and they are equally tough and resilient.

Brush shapes

Hundreds of different brushes exist on the market in both natural and synthetic types, but they all fall into the same basic shape categories: round, flat, filbert and fan shapes, all of which come in different sizes and with slight variations in design.

Round: round brushes are made so that the fibres come to a point – or form a dome in some large sizes. These brushes hold large quantities of paint and are ideal for making raised brushmarks and for delivering paint in broad, fluid washes. Small round brushes are most often used for adding detail and lines in the final stages of a painting.

Flat: flat brushes deliver paint in a precise and controlled way and are used for applying flat areas of colour and for building up areas of impasto using short, square or rectangular strokes. Use them also to blend areas of paint (see *Blending*, page 56). Large flats are useful to block in large areas of colour, but

BRUSH MATERIALS
1. Synthetic fibre
2. Synthetic mongoose bristle
3. Hog bristle
4. Horse hair

BRUSH SHAPES
5. Round
6. Flat
7. Filbert
8. Fan
9. Rigger

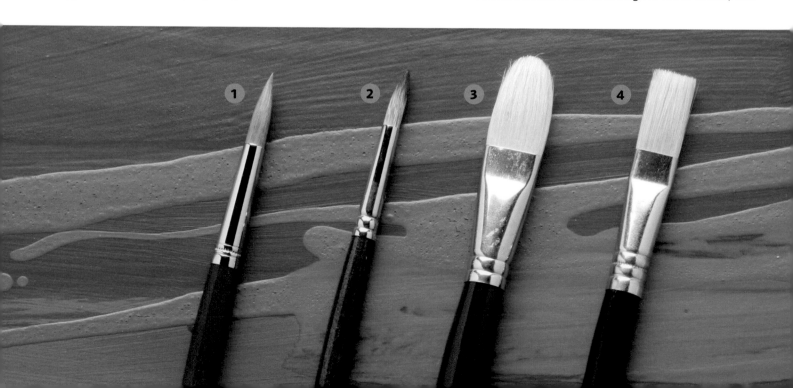

you can also use them on edge to make very thin marks. A short-fibre model of the flat brush, known as a "bright", has less spring than the standard flat, but is useful for very precise work.

Filbert: filbert brushes are flat, full-bodied brushes that taper to a dome shape, resembling to some degree well-worn flat brushes. They are very versatile brushes and, like flats, they can be used on their edge to create a thin mark or flat to paint marks that are the full width of the brush.

Fan: fan brushes are really designed for just one purpose – they facilitate blending colours wet-into-wet. You can also use them to create texture, and they are especially useful for suggesting foliage in landscape work and for dry-brush techniques (see Step 9, *Fishing Boats*, p 93).

Rigger: a very fine, round, long-haired brush, originally invented for painting the rigging of sailing ships.

Taking care of your brushes

Brushes used for acrylic work are very prone to wear and tear. Due to the fast drying time of the paint, they have to spend long periods in water. Always clean your brushes carefully before storing them to keep them in the best possible condition. See the panel to the right for tips on brush care. Once clean, store your brushes hair-side up in a jar or container.

Brush care

Because acrylic dries so quickly, brushes must be kept wet throughout the working process, but don't leave them upside down in a jar of water for long periods, as this will splay the bristles. Stay-wet palettes (see page 18) have a special compartment for brushes, but if you don't have one of these, place the brushes flat in a shallow dish.

Brushes can very quickly become clogged with paint from the tip to the ferrule.

Before placing in water, remove the excess paint with a palette knife.

To clean, rinse the brush in warm water and then rub it into the palm of a soapy hand.

If the hairs have become splayed, reshape by dampening the brush and stroking it between finger and thumb.

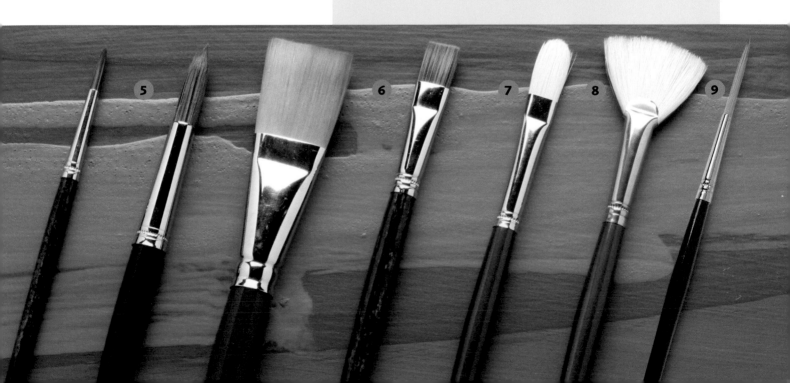

Painting supports

Acrylic paint can be applied to any surface that is permeable (allowing a degree of penetration) and non-greasy – grease or oil repels water-based paint, which is why acrylic cannot be used over oil paint. Choose painting supports with care, because the type of surface you use will not only affect the way you apply paint and the techniques you use, it will also have a considerable influence on your final composition.

Paper and cardboard

You can select any type of paper and cardboard for your work, including inexpensive alternatives to art papers, such as plain wallpaper, wrapping paper and cardboard cut from packing cases. These may discolour or deteriorate over time, but are perfectly adequate for preliminary work and experimentation.

Watercolour paper is the natural choice when using watercolour and wash techniques (see *Transparent*, page 36). Three main surface types are available: "hot-pressed" paper, which has a very smooth surface; "cold-pressed" paper, which has enough surface texture to hold the paint; and "rough" paper, which has a pronounced surface texture. All of these watercolour papers are available

in different thicknesses, described in terms of weight in grammes per square metre (gsm), such as 250 gsm, 425 gsm and so on.

Work on any paper "as is", or you can seal and prime your choice (see *Gesso Primers and Varnish Sealers*, page 23 and *Supports*, page 32). If the paper is left in its raw state, the paint will tend to soak into the fibres, making the work resemble traditional watercolour. If you seal it with an acrylic medium or gesso primer, the paint will "sit" on the surface and the colours will appear brighter. It will also flow more easily on a sealed surface and will take slightly longer to dry. Very thin paint may puddle, in which case it could benefit from the addition of a flow improver (see *Mediums and additives*, page 22).

PAPER AND
CARDBOARD
1. Cardboard, wallpaper, envelopes
2. Hot-pressed watercolour paper
3. Cold-pressed watercolour paper
4. Rough watercolour paper

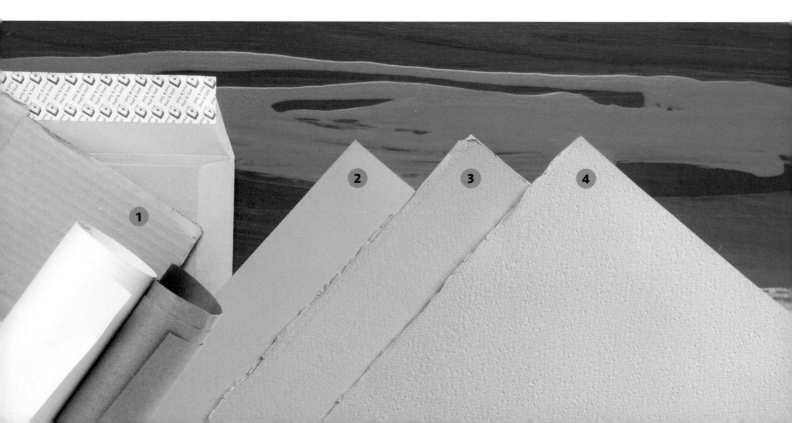

Acrylic painting paper, sometimes called acrylic sketching paper, is suitable for either thin or thick applications. This paper has a textured surface that imitates canvas weave and is available in tear-off pads. Other papers that you may like to try are those intended for pastel work. These are always slightly textured and are available in a range of pleasing colours. But they will almost certainly need to be stretched before use, because they are relatively thin and will buckle when you apply wet paint on them. The same applies to any lightweight paper.

Boards

Wooden or composition boards, such as plywood or medium-density fibreboard (MDF), make excellent supports for acrylic work. Plywood has a strong straight-grain texture that you can use to good advantage. MDF has a smooth surface and is available in different weights, making it useful for both outdoor and studio work. Both types of board are easily cut to size. Prepare them with gesso primer or slightly diluted acrylic medium if you want to enhance the natural colour of the board. Give boards a textured surface by using a texture paste or modelling paste (see *Texture pastes*, page 22) or cover them with canvas or other fabrics using the marouflaging technique (see *Supports*, page 32).

Canvas

Cotton and linen are the two main types of canvas made for artists. Cotton canvas is also known as cotton duck; linen is more expensive than cotton. Both are available in a range of weights and different surface textures, with the texture, or tooth, usually more pronounced in the heavier weights. Cotton duck colour is light cream, while linen comes in a natural brown or ochre shades that are often used as ground colours. It is usually sealed instead of being primed with gesso. Ready-made stretched canvases in either cotton or linen are available for purchase, but it is more economical to stretch your own (see *Supports*, page 32), especially if you want to work on a large-scale project.

A variety of other fabrics, including cotton sheets, muslin and some cotton and polyester blends are suitable for painting purposes, but it's best to prepare these using the marouflaging method since they are too flimsy to stretch (see *Supports*, page 32).

CANVAS AND
OTHER SUPPORTS
5. Acrylic pad
6. Pastel paper
7. Unprimed canvas
8. Sealed linen canvas
9. Canvas board primed for acrylic work
10. Medium-density fibreboard (MDF)
11. Stretched and primed canvas

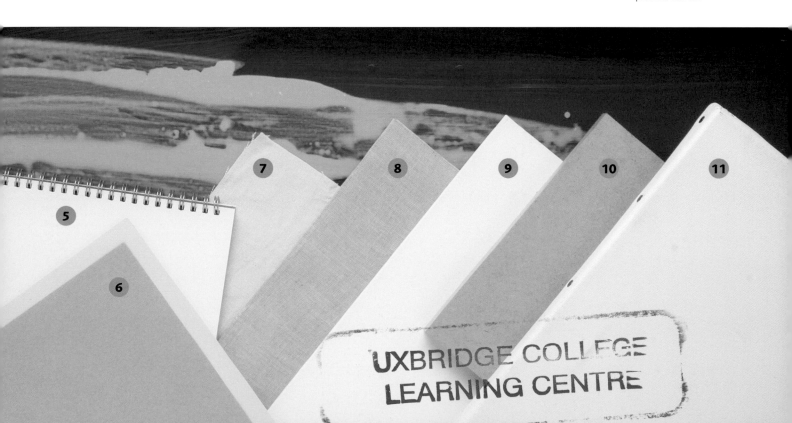

Extra equipment

You can make a good start in acrylic painting without using any other equipment than paints, brushes, a palette and a working surface. As you become more experienced, you may wish to add extra items to your kit. Painting knives, for example, are well worth trying, either as an alternative to brushes or in addition to them. They are especially well-suited to acrylic work. You may find painting knives are better than brushes for achieving impasto effects with texture and modelling pastes (see *Knife painting*, page 44, *Texture pastes*, pages 52, 54).

Painting knives vs. palette knives

Painting knives and palette knives are both made with wooden handles and both have flexible stainless-steel blades, but they are designed for different purposes. Palette knives have a long, flexible, spatula-shaped blade intended for mixing paint on the palette and for scraping up unused colour. You can apply paint to the working surface with palette knives, but they are only suitable for covering large areas of flat colour. Painting knives, designed specifically to apply paint, are a great deal more sensitive to your touch, and you can achieve a wide variety of marks with them. Unlike palette knives that have handles in direct line with the blade, painting knives have bent handles that let

you keep your hand above the work when you place your blade flat against the work surface.

These knives come in a wide range of shapes and sizes and each yields a different kind of mark. In order to work with them successfully you will need several types, just as you do with paintbrushes. But before you invest in this fairly expensive piece of equipment, you may want to try out one or two of the cheaper plastic models. You'll only find a limited selection and they will not last as long as steel knives, but at least you may find out whether you like working with knives or not. No matter what type you choose, always keep your blades clean, as paint builds up quickly and will prevent you from making crisp, distinct marks. If paint does dry on the blade, you can remove it easily by slicing it away with a

PAINT APPLICATORS
1. Plastic palette knife
2. Palette knife
3. Painting knife
4. Paint shaper
5. Paint shaper
6. Household paintbrush
7. Foam rollers
8. Natural and synthetic sponges

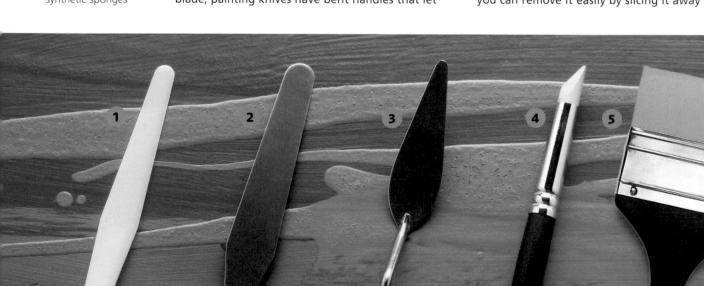

sharp knife. If you prefer, dip the blade in paint stripper. Don't try this with plastic knives, as it could destroy them.

Paint shapers and household implements

Paint shapers are a relatively new addition to the artist's toolbox. They resemble traditional brushes, but have a flexible rubber tip instead of hair or fibre bristles. The tips can be either soft or firm and are made in different shapes: flat, pointed, round, chisel and angled. You will be able to make a wide range of marks with them. Using shapers feels like handling brushes, but the marks shapers leave resemble those made with a knife. They are exceptionally durable, and it's easy to clean any paint off the rubber tip.

Always keep your eyes open for other possible tools to vary your marks and make your work more personal and expressive. You can apply paint with all sorts of implements, such as natural and man-made sponges, foam brushes, small foam rollers, wallpaper strippers and plastering trowels. You can also cut pieces of cardboard into shapes you can use the same way as painting knives.

Easels

Although it is possible to work without an easel by propping your work upright or by working flat, an easel will make the painting process a good deal easier. The kind you buy depends very much on the type and size of work you envision and whether or not you plan to work indoors or outdoors.

Easels are designed roughly in three types: table easels, portable easels and studio easels. Table easels can be adjusted to hold the support either upright or at a slight angle. They are really only suitable for small-scale work or watercolour-type paintings.

Portable easels have three legs and are made in both wood and metal. They can be adjusted to a variety of heights and angles and are designed to fold up flat for easy carrying. They can, of course, be used indoors as well as out, so are probably your best choice – unless you work on a very large scale, in which case you will need to invest in a good studio easel.

Studio easels come in two distinct types, based on either an A-frame or an H-frame. A-frame easels are usually small. H-frame easels are much larger and can hold more or less any size of work. Both allow supports to be positioned at different heights. Heights of supports on an H-frame are adjusted either by a ratchet system or by turning a handle. H-frame easels have castors and locks so you can position them easily.

EASELS
1. Portable easel
2. Studio H-frame easel
3. Table easel

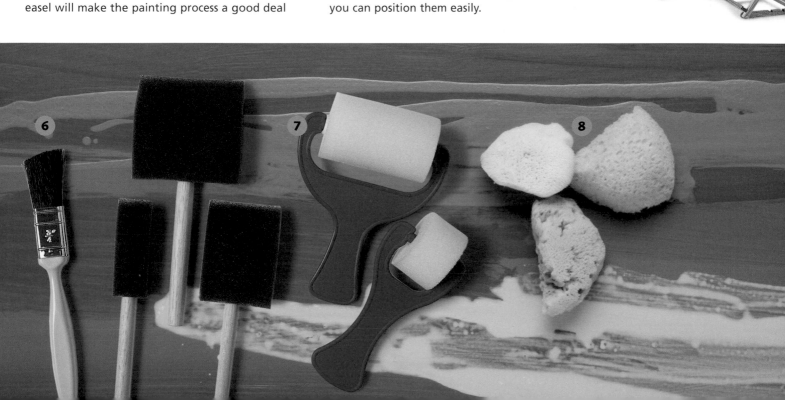

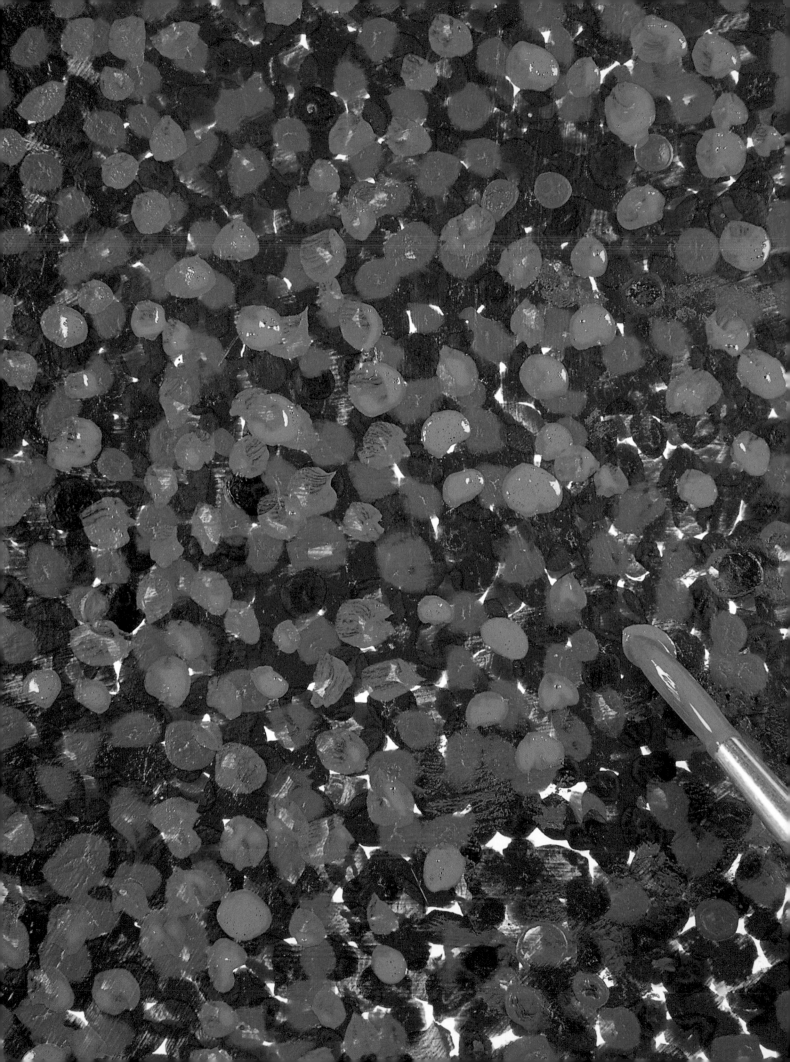

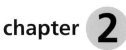
chapter **2**

Techniques

The art of acrylic painting borrows from both oil and watercolour traditions, which means you can choose from a vast number of techniques when working with acrylic mediums. Artists continue to pioneer new methods as they explore the possibilities of this versatile art form. These full-colour step-by-step instructions illustrate a range of acrylic techniques. Enjoy experimenting with them as you duplicate some of the compositions in the "Projects" section.

Preparing supports

The unique quality of acrylic paint – its insolubility when dry – makes it possible to paint on almost any surface. The most popular and widely used supports are paper, cardboard, canvas, fibreboard and wood panels. Canvas and fibreboard are usually given an undercoat known as a primer. Paper requires no preparation, but you can prime it if you wish. Although you can purchase boards and canvases that are already primed, it is economical, practical – and easy – to prepare your own. This also gives you a wider choice of surfaces you can tailor to suit your technique, as well as a limitless choice of sizes and shapes. Ready-made wooden boards and canvases are available only in a set range of sizes.

A rigid canvas surface can be produced by attaching canvas or a similar fabric to medium-density fibreboard (MDF) using acrylic medium, which is a very good adhesive. This technique is known as marouflaging.

Canvas

1 To stretch the canvas, start by assembling the four wooden stretcher bars together to create the rectangular frame. Place the frame over a piece of canvas and cut the canvas to approximately 5 cm (2 in.) larger than the assembled frame.

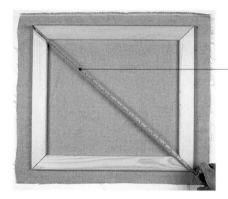

Check that both the diagonal measurements are the same to make sure the frame is true.

2 Fold the canvas over the edge of the stretcher bars, creating neat pleats at each corner, and place staples approximately 15 cm (6 in.) apart evenly around the back to secure the canvas to the frame, making sure the canvas is held flat and taut. For larger canvases, you can staple the fabric to the stretcher edge.

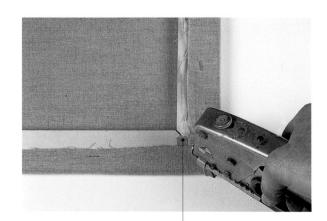

Avoid placing staples across the mitred joint, as this will prevent the wedges from being hammered in when you force the bars apart to tighten the canvas.

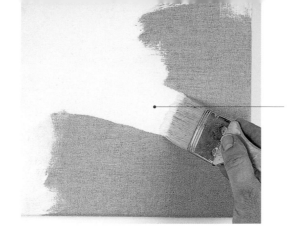

3 Turn the canvas over and prime it using an acrylic gesso primer. You will probably need to give it more than one coat, as canvas is very absorbent. Thin each coat with a little water to help it to brush out easily. Allow each coat to dry well before applying the next.

If you prefer instead to work on raw canvas, you can prevent paint from sinking into it by applying a coat of acrylic matt medium thinned with a little water.

Marouflaging

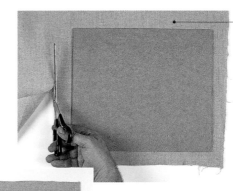

1 If you prefer to work on marouflaged canvas, place a sheet of fibreboard on top of a sheet of canvas. Cut the canvas that is going to cover the board slightly larger all around.

You need to leave enough canvas around the board to be able to secure it to the back.

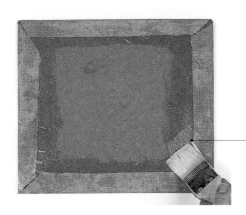

2 Cover the surface of the board liberally with matt medium, using a stiff bristle brush. Place the canvas over the board and brush on more matt medium to secure the fabric to the surface of the board.

When brushing on the medium, make sure that no air bubbles become trapped beneath the canvas, as this will prevent adhesion.

3 While the panel is still wet, turn it over and place it facedown onto an easily cleaned nonabsorbent work surface. Cut across the corners of the canvas and fold it neatly. Secure the overlap to the back of the panel. Once dry, the prepared canvas board can be primed with acrylic gesso primer.

Work quickly so that the wet surface of the panel does not stick to the work surface.

Gesso-primed boards

If you prefer a smooth surface, you can work directly on the board, but first give it three or four coats of acrylic gesso. Allow each coat to dry well before applying the next.

After each coat of gesso dries, sand the surface of the panel before applying the next coat of gesso. This will yield a hard, smooth surface – free of any noticeable brush marks.

Mixing colour

materials

Palette
Acrylic paints
Flat bristle brush
Palette knife
Small mixing bowl
Painting medium
Water

Acrylic paint is available in either tubes or plastic bottles; acrylic paint packaged in tubes has a slightly thicker consistency. Whichever type you use, you will need a palette for mixing colours. You can purchase one or make your own. For most purposes, all you need is a flat, nonabsorbent surface. A piece of thick glass or plastic will hold your paints and mediums very well. You may find it better to mix larger quantities of very fluid paint in some kind of bowl or container. Paper or plastic cups, yogurt containers, tin cans and glass jars will all make ideal receptacles. Cover unused paint with shrinkwrap to prevent it from drying out. (See *Materials*, p. 16, for further information on palettes.)

Ordering your colours

Choose the order in which you arrange colours on your palette according to your preference. It's not practical to lay them out in a random manner, however, so try to arrange them in a logical sequence. In this illustration, the colours were arranged on a plastic palette by various hues. The white was kept separate to avoid contamination from the other colours.

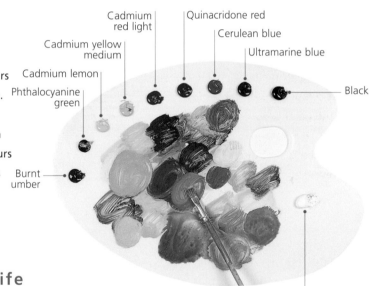

Cadmium yellow medium
Cadmium lemon
Phthalocyanine green
Cadmium red light
Quinacridone red
Cerulean blue
Ultramarine blue
Black
Burnt umber
Titanium white

Mixing with a palette knife

1 There are several ways to mix colour. For heavy impasto work, it's best to mix large amounts of thick paint with a palette knife (also known as a mixing knife) on the palette.

Always keep palette knives clean. A dirty knife may contaminate colours and mix them less efficiently.

2 Mix the paint continuously by turning and folding it in on itself until the colours have merged completely. Try to keep the paint in a confined area by using the knife to scrape it together. Unless you want a streaky effect, as you mix, spread the paint occasionally to check for unblended streaks.

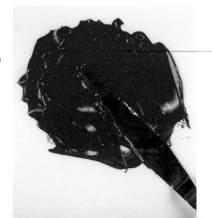

Be sure to mix enough paint for the job. It can be difficult later to make a new batch that exactly matches the first.

Mixing small amounts of paint

1 Mix smaller amounts of thinner paint with the same brush you use to paint. Always add small amounts of the stronger, darker colour to the lighter, weaker colour.

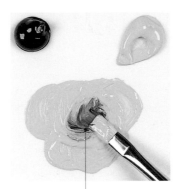

Here, a small amount of dark green is mixed into a light yellow.

2 Keep adding colour until the desired mix is achieved. Once the colour is correct, add medium or water to give it the desired consistency.

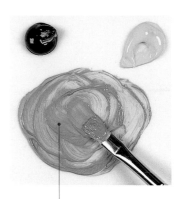

To avoid streaky brushstrokes, be sure the colours are combined well.

Wet and dry colours

Acrylic colours darken as they dry because they are made with a white, milky medium. This makes wet colours appear lighter, but as the paint dries, the medium becomes transparent and the true strength of the pigments is revealed.

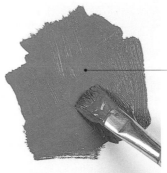

With practice, you'll be able to judge this change and learn how to mix your colours a little lighter than you want them to appear.

Creating a smooth mix

1 When mixing large amounts of thin or relatively fluid colour, it is important to make sure that all the components are thoroughly combined. Avoid putting thick tube colour into a container of water (or water mixed with medium). You won't be able to obtain a smooth, thorough mix.

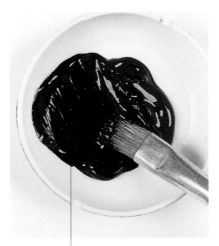

Mix the paint well before adding any water or medium.

2 Once the colours are well mixed and the correct colour has been achieved, add water and medium slowly, stirring continuously.

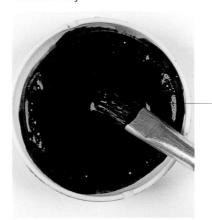

Adding water and medium will increase the volume of paint, but don't forget that this will reduce the intensity of the colour.

Laying washes

materials

Acrylic paint
Watercolour paper
Watercolour wash brush
Palette with mixing wells
Water

Acrylic paint diluted with water and/or acrylic mediums acts as a transparent medium that resembles watercolour. Laying washes one over another produces lovely effects. But remember, acrylic becomes insoluble once it dries, so you can't move it around on the surface or use watercolour techniques such as lifting out to remove it. When using acrylic paint in watercolour mode, don't mix white into it; instead, rely on the white of the support to lighten the colours. Mixing white into heavily diluted acrylic paint will create a gouache effect, which is the opaque version of watercolour.

Creating even washes

1 Mix a thin wash of colour using a little paint and plenty of water. When mixing colour for large, flat washes such as skies, be sure you have enough paint to cover the area. If you have to stop to mix more paint, the paint already applied will dry and it will be impossible to extend the wash without leaving a very visible mark. Fill the brush with paint and make a horizontal stroke across the surface.

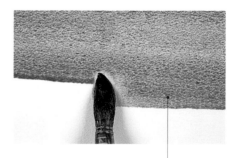

Tilt the support at a slight angle to let the paint collect at the bottom of each stroke.

2 Paint tends to run down the support and puddle along the bottom edge of each brushstroke, so each pass of the brush must overlap the previous stroke slightly. As you work downward, each horizontal stroke picks up the excess paint, which in turn collects at the bottom of the next stroke. Depending on the area to be covered, you may need to refill the brush with paint after every stroke.

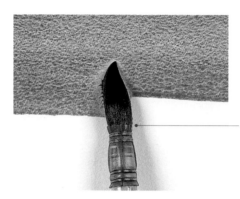

Once you make the pass, don't be tempted to go back and repaint an area. This will result in a visible brushstroke.

3 After you complete the wash, you can remove the puddle of paint along its lower edge by drying the brush slightly and running it along the puddle to pick up the excess.

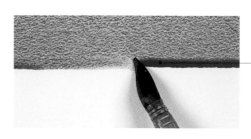

If you wish, leave the puddle of paint to provide a darker edge that can be effective in certain circumstances.

Changing the intensity of washes

1 Here, mixing the yellow with water alone made thin washes through which the white of the paper is reflected. To darken any colour, add more pigment; to lighten a colour, add clean water.

When planning the work, it's vital to remember that dry paint cannot be removed with water.

2 After a wash of colour dries, you can paint over it with further transparent washes so each successive layer will modify and consolidate previous ones. This technique is known as wet-on-dry and results in a crisp, sharply focused image.

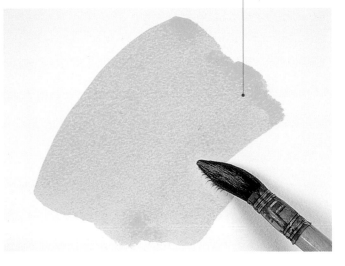

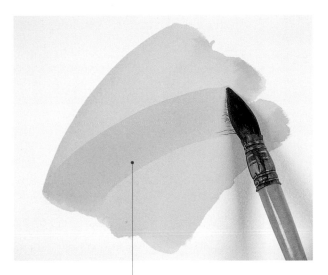

Here, a second wash of the same colour was applied over the dry first wash. This intensified the colour and darkened the tone without altering the hue.

Mixing colour washes

By applying washes of a different colour, complex and vivid mixes can be achieved, with the colours mixing optically rather than physically (see *Mixing colour*, p. 34).

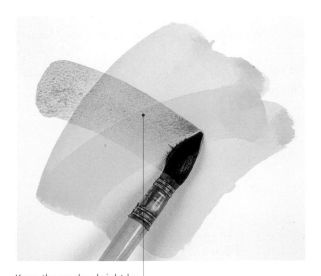

Keep the washes bright by limiting them to no more than three. Too many overlaid layers dulls colours.

Wet-into-wet washes

You can paint colours and washes wet-into-wet (see *Wet-into-wet*, p. 46) so that they merge together on the painting surface rather than form hard edges. This gives a soft, ethereal quality to the composition – or parts of it. Wet-on-dry and wet-into-wet are often combined in the same composition.

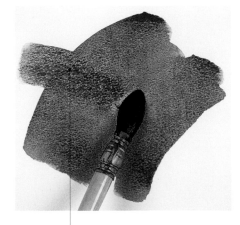

Take care when working wet-into-wet, as it is very easy to end up with muddy, dull colours.

Glazing

materials

Acrylic paint
Flat bristle brush
Matt or gloss medium
Water

Glazing is one of the many techniques that acrylic borrows from oil painting. It involves building up depth of colour by laying successive "veils" of transparent or semitransparent colour so that each one modifies those beneath. It is related to the watercolour techniques shown on the previous pages, except that the glazes can be laid over opaque colours and are mixed with medium rather than pure water. Each layer needs to be dry before the next is applied, and several glazes can be laid on before the colours begin to lose their brilliance. In the early days of oil painting, glazes were laid over a monochrome underpainting, which established the tonal pattern. This can also be an exciting way to work with acrylic paint. Although glazing is most often associated with richness of colour, it can also be used to tone down or mute colours that are too bright without substantially changing them.

Glazing over base colours

1 The base colour can be as thick or thin as you wish, but in general it is best to glaze dark colours over light ones. As with watercolour techniques, the more light that is allowed to reflect back through the paint layers, the more vivid the colours will be. Take care not to make the layers too dense and dark in the early stages.

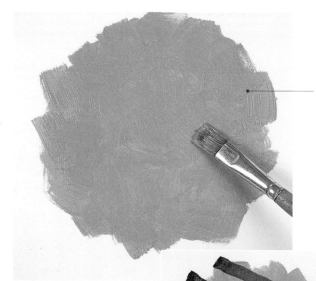

Give careful thought to the first colour you apply, as this will have a profound effect on all successive layers.

2 Here, a second layer consists of a thin glaze of alizarin crimson over a cadmium yellow base. As you can see, the effects achieved by glazing are quite unlike those associated with opaque pointillism techniques, where the colours mix optically on the painting surface (see *Pointillism*, p. 62).

The yellow shows through the crimson glaze to give a deep, rich orange.

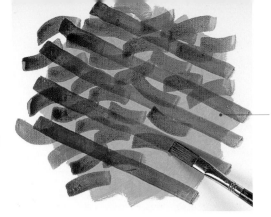

3 The next layer, a deep purple, was applied when the second layer was fully dry. The fast drying time of acrylics makes it ideal for this technique, but bear in mind that it may take slightly longer to dry if a lot of medium is used.

Take care when you choose colours and tones. The purple here is close in tone to the crimson over yellow.

4 The lightness of a colour does not determine how well it will work as a glaze – some colours are by nature heavy with pigment and thus more opaque. Experiment with colours on a spare piece of paper or board to discover which ones are more transparent than others.

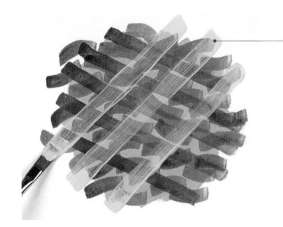

Cadmium yellow is relatively opaque and will cover an underlying colour unless well thinned with water and medium.

Glazing over impasto work

Glazing can be very effective over thick impasto work. You can enrich or modify colours without building up a heavier paint layer or destroying pleasing paint textures.

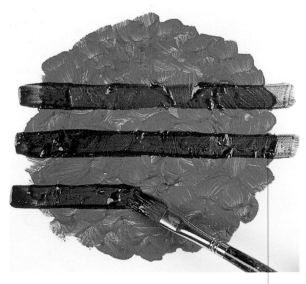

Paint glazed over thick impasto tends to accentuate textures and bring out brushstrokes.

Thinning paint

You can thin paint with water alone, but using matt and especially gloss mediums will give better results. They increase the transparency of the paint, and the brushstrokes stay where you put them instead of dribbling down the painting surface. If you want to extend the drying time of thin glazes, mix in some retarding medium.

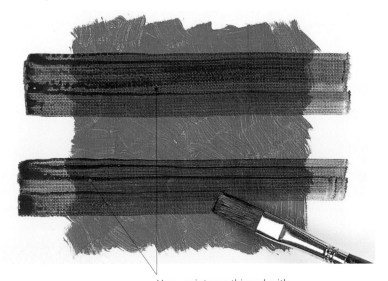

Here, paint was thinned with water to create the top brushstroke and with gloss medium to make the lower one.

Opaque techniques

materials

Acrylic paint
Flat bristle brush
Matt medium
Water

Opaque painting techniques are more forgiving than transparent ones. You can correct mistakes simply by overpainting them, and alter a composition or colour scheme as many times as you please. Opaque paint – which is not necessarily thick – has good covering power. When you overpaint in layers, it will cover any previous colours – even strong, bright ones. The creamy consistency of the paint when expressed straight from the tube or bottle (without the addition of water or medium) is ideal for opaque work. Some colours are less opaque than others, and you may need to add some white. If you want to amend a strong colour or dark area, you might need to paint on a layer of white first.

Applying paint

1 Not all acrylic colours produce completely opaque coverage when you brush them out. You'll notice this especially when you work with dark colours on a white support surface.

Adding water and/or acrylic medium will lessen the opacity of the paint.

Varying the direction of the brushstrokes will produce a flatter coverage.

2 For more opaque coverage, as when you want a flat area of colour, work colours in successive layers, allowing each one to dry before applying the next.

3 With most colours, especially those that are naturally more opaque, you can achieve total coverage in two layers. Those that are less opaque may require three or more layers.

Avoid a thick buildup of paint by brushing the colour out well.

Adding white

White acrylic added to your mixes will increase opacity, but this will, of course, lighten the tone and make it impossible to achieve dark, intense colour mixes. Adding white is perfectly acceptable in all light-toned paintings where there are few, if any, really dark passages.

Adding even a very small amount of white will alter the colour tone of the paint.

Using extenders

1 Add acrylic extenders (see *Mediums*, p. 22) to make the paint more opaque as well as to increase the volume.

Mix extenders with the paint in the same way as any other acrylic medium.

2 As well as increasing the opacity of the paint, extending mediums dry to a matt finish that absorbs rather than reflects light. This accentuates the opaque effect. Like other acrylic mediums, extenders are milky white until dry, and the paint dries darker than it appears on the palette.

Extenders slightly increase the thickness of the paint as well as add volume.

Impasto

Palette knife

Bristle brush

Acrylic paint

Palette

Extending or heavy gel medium

Retarding medium

Water (for diluting the paint to underpaint)

Wedge-shaped piece of thick cardboard

The impasto technique manipulates very thick paint. Paint is applied so thickly that the marks of the painting implement can still be seen after the paint has dried. Impasto paint can be applied with either a brush or a painting knife and is usually characterized by strong colour and expressive, fluid strokes that have exciting textural qualities. You can create whole paintings in impasto or restrict it to certain areas to give emphasis to a focal point or a foreground feature, for example. Acrylic paint is particularly well suited to impasto work, since even thick applications will dry in a few hours, whereas impasto oil paint can take months.

Applying thick paint

1 Undiluted acrylic paint in tubes has sufficient body to be used for impasto work. The bottled version is thinner, and you may need to mix it with a bulking medium to add body to it and increase its stiffness. Adding extending medium and heavy gel mediums (see *Mediums*, p. 22) adds volume to the paint without altering the colour.

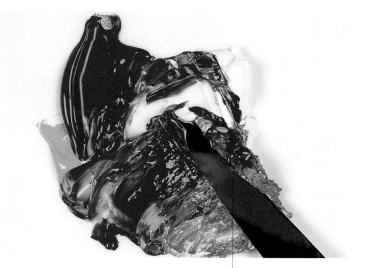

The rough action of mixing very thick paint on the palette can damage brushes. It's better to use a palette knife.

2 Even thick impasto work allows the support surface to show through in places. Underpaint thinly as a guide to placing colours.

Lightly colouring the support with diluted colour helps to bring out the texture. This plays an important part in the finished work.

3 When applying thick paint with bristle brushes, aim to make purposeful, flowing brushstrokes. Don't brush out the paint, as this will destroy the impasto effect. Let the underpainting and the surface texture show through in places to provide textural contrast.

Use brushstrokes of thick paint in the required direction to model form as well as provide surface texture.

4 As long as the paint remains pliable, add more colour by painting wet-into-wet (see *Wet-into-wet*, p. 46), but once the brushstrokes begin to harden and form a skin, wait until the paint is completely dry before overpainting. The drying time can be slowed down by adding retarding medium to your mixes (see *Mediums*, p. 22). Painting in a cool atmosphere will also keep paint pliable for longer.

When using wet-into-wet impasto techniques without a retarding medium, limit yourself to painting relatively small areas at any one time.

Using paint directly from the tube

Colour can be squeezed onto the painting surface straight from the tube, but you will be limited to premixed colours. An alternate method is to add your own colour mixes to a piping bag, or a plastic bag with one corner removed, and squeeze them onto the support surface.

After using the tube-painting method, clean the neck and thread of the tube thoroughly before you replace the cap.

Using different tools

You can use any number of tools to apply thick paint (see *Knife painting*, p. 44). Wedges of thick cardboard are very useful since they can be cut to any size. It will gradually lose its stiffness during use because water and acrylic medium soften the fibres, but you can easily cut off the soft portion or use a fresh piece.

Use cardboard to apply paint, blend colours together and generally manipulate the paint once it is on the support.

Knife painting

materials

Painting knives

Gel medium

Retarding medium

Acrylic paint

Water (for keeping knives clean)

Sandpaper

Painting knives enable you to create the most dramatic impasto effects. Produced in both steel and plastic in a range of shapes and sizes, painting knives facilitate a wide variety of marks. Unlike palette knives, they have bent handles to keep your hand and fingers away from the work. Once you become accustomed to using them, you will find you can create surprisingly delicate effects as well as robust sweeps. Knives are as versatile as brushes; they can be used at different angles to vary the marks, and you can increase or decrease the pressure to push paint onto the support or lightly glide paint over it. A specific characteristic of knife painting is the way it can create a flat stroke bordered by a ridge of paint on the outside edge of the stroke. For thick impasto work, paint can be bulked by adding a gel medium or thickened with a texture paste (see *Mediums*, p. 22).

Using a painting knife

1 To apply the paint, mix the required colour on the palette and scoop it up with the base of the knife. Apply it to the support as you would plaster a wall or ice a cake.

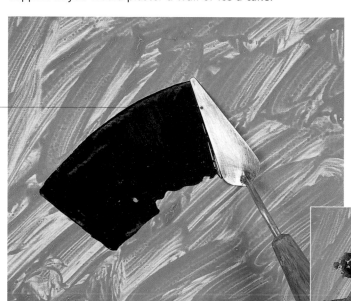

Keep your painting knives clean so that paint can be applied smoothly. Use sandpaper to remove dried paint.

If you want to blend several applications of colour, add a retarding medium to the mixes to prolong the drying so you will have enough time to blend them well.

2 Premix colours on the palette or apply separate colours directly over each other and then mix them on the painting surface.

3 Use painting knives to remove paint while it is still pliable (see *Sgraffito*, p. 64). If you intend to use scratching methods, add retarding medium to slow down the drying and give you time to work this technique.

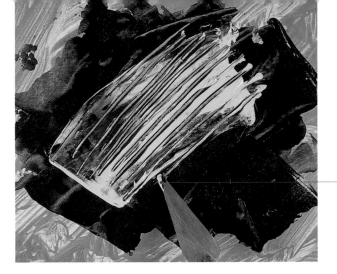

You can remove paint in as many ways as you apply it. Use the point, the side and the edge of the knife.

Using an oval knife

Painting knives come in many different shapes, all of which make distinctive strokes. Try several to realize the full potential of this technique. As with brushes, you will also need different knife sizes, depending on the dimensions of the area to be covered.

Here, this small oval knife is ideal for building up areas of broken colour such as foliage.

Using a long-bladed knife

To establish broad areas of colour quickly, use a long-bladed painting knife. It's best to begin with a relatively thin application of colour and then build it up as needed after the first layer dries.

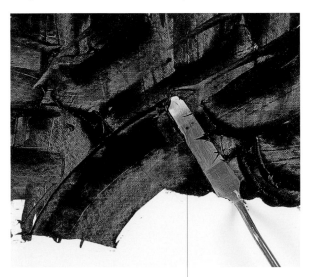

One of the beauties of knife painting is the way the knife strokes form crisp, clean edges.

Using a pointed knife

This long, pointed knife is ideal for both covering large areas and recording fine detail. Flick dabs of paint on with the point, and use the edge to draw lines.

Use relatively fluid paint to draw precise, thin lines. It flows more easily from the blade than paint mixed with bulking mediums.

Wet-into-wet

Wet-into-wet is a traditional oil-painting technique. Colours are applied into one another and manipulated on the painting surface. Painting wet-into-wet with acrylic takes a little more skill since the paint must be prevented from drying out. Accomplish this either by adding retarding medium or by periodically spraying the support with water. Working wet-into-wet has a distinct advantage. It produces soft blends and transitions of colour without hard edges, a useful technique for modelling form or for painting skies and light effects in landscapes. It also lets you make changes without having to overpaint, since you can scrape wet paint off with a palette knife and redo whole areas.

Using retarding medium

Add retarding medium to the paint at the mixing stage, but if you are using relatively thin paint, apply a layer of the medium to the painting surface before you start to work.

Avoid using too much medium; it's best not to exceed 20% of medium to paint.

Applying paint

1 Adding retarding medium gives you more time to handle paint. Add only the least amount of water, as water can affect how it handles. Try to use brushstrokes to their best advantage when you work wet-into-wet; aim for sweeping, rhythmic strokes.

2 Here, the new layer of wet colour partially mixes with the first, creating an attractive streaky appearance that's ideal for landscape elements such as foliage, grass and turbulent, windswept clouds.

Adding gel medium makes the paint feel very smooth.

The wet-into-wet acrylic technique closely resembles the feel of oil paint.

Painting over a thin acrylic wash

1 An alternate way of working with wet-into-wet is to paint your surface with thin washes of acrylic paint with no retarding medium added. Allow the paint to dry. Then spray this underpainting, or brush it over, with liberal amounts of clean water.

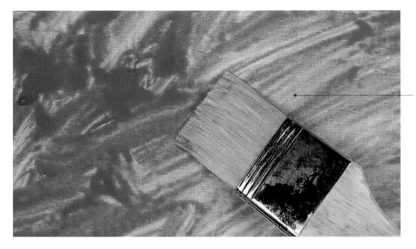

Don't make the undercoat too even; use the same kind of brushstrokes as for the wet-into-wet technique.

2 While the surface is still wet, another layer of paint can be added. You can repeat this technique several times. This wet-into-wet effect is very different from that achieved by adding retarding medium, as each layer of paint retains its integrity and only mixes optically, rather than physically, with the fresh layers.

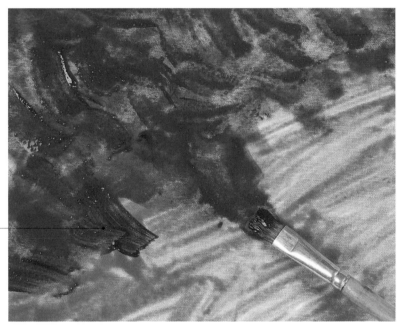

If the painting surface dries out while you are working, simply rewet any area still to be painted and continue as before.

Slowing drying time

If you are using paint without retarding medium, spray the surface at regular intervals before the brushstrokes begin to form a skin.

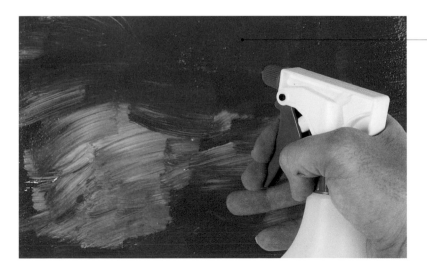

To prevent the colours from dribbling down the surface, lay the painting flat when spraying.

Sponging

materials

Natural sponge
Acrylic paint
Water
Sponge roller
Foam brush
Sponge pan scrubber

Sponges are usually a watercolour tool, but they are equally useful for acrylic work. Sponges apply large areas of colour more quickly than brushes, and they are ideal for building up areas of texture and broken colour. They are relatively clumsy implements, however, and not suitable for fine detail. Use either natural or man-made sponges, depending on the effect you want. Natural sponges make pleasing and less mechanical-looking patterns. They're expensive, but will last a long time if you wash them thoroughly before the paint dries. It's also worth trying out foam decorating "brushes", paint rollers and scouring pads. They produce patterns that complement those made with traditional painting tools.

Using a natural sponge

1 Sponges soak up considerable amounts of liquid. To cover a large area, mix the paint in the usual way, making sure there is enough for the entire project. The paint needs to be relatively free flowing. You may find it better to mix it in a deep container rather than on a palette. Use acrylic mediums or just mix the paint with water alone.

The sponge pattern creates a pleasing linear effect. The thicker the paint mix, the more obvious the pattern.

2 Using a natural sponge in a dabbing motion creates an attractive random texture. The paint needs to be fairly thick in order to hold the pattern; very fluid paint tends to form blobs with a less distinct pattern.

Let the base colour dry well before applying texture.

3 You can dab several layers of colour on top of each other. Let the paint dry between each one and rinse out the sponge between applications to create a crisp and distinct texture.

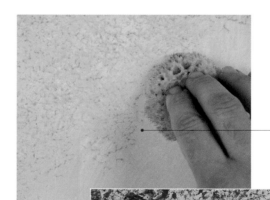

Turn the sponge as you work to create a random pattern that does not repeat in an obvious way.

4 Sponging lets you build up highly intricate colour combinations. The result is areas of sparkling, broken colour that would be difficult to achieve by any other method. Vary the effect by wetting the surface between layers so that some of the sponge marks will look soft and out of focus while others will remain crisp and sharp.

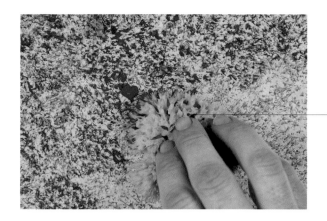

Sponge the paint gently; if you press too hard, the effect will be lost.

Using foam brushes

Foam decorating brushes hold a great deal of paint, enabling large areas to be covered quickly. Several sizes are available, and they can be cut to shape for working in confined areas.

The fine foam texture produces a much smoother stroke than a bristle brush.

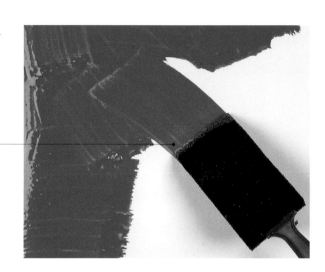

Using foam rollers

Foam rollers add another dimension. You can achieve flat areas of colour by using thick paint and steadily building up the surface in layers. Allow each to dry before applying the next.

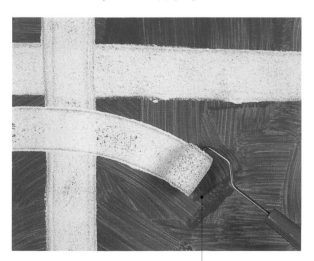

Small rollers create curved and wavy lines.

Cutting sponges to size

Use a sharp craft knife or scissors to cut sponges and foam easily when you want to create interesting shapes. Discard any used and dirty pieces of sponge.

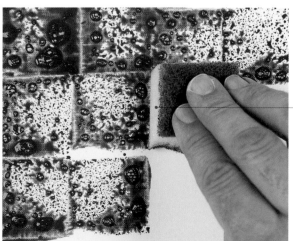

The softer foam side of this cut sponge creates a completely different texture than the pot-scrubber side.

Masking

materials

Paper and canvas to make masks

Adhesive tape

Flat bristle brush

Acrylic paint

Water

Scissors

Masking tape

Masking techniques serve two main purposes: to isolate an area and prevent paint from getting onto it and to create an interesting edge quality either to a design element or to a larger area of paint. Paper or cardboard, masking tape and fabric are all good for masking. When working with watercolour techniques on paper (see *Laying washes*, p. 36), paint viscous masking fluid onto the paper, allow it to dry and then paint over it. Once the paint dries, remove the masking by rubbing with a finger or eraser. Masking techniques are often used in conjunction with spattering (see *Spattering*, p. 58) or loose scumbling (see *Scumbling*, p. 60), since masking restricts their effects to a specific area, but masking is also useful to create shapes that stand in their own right.

Preparing and using a mask

1 Use any piece of paper or cardboard as a mask. This is a good way to recycle discarded projects. Newspaper is readily available masking material, but use it only if the paint is relatively thick, as thin, free-flowing paint will seep through and under the mask. The best all-around choices are drawing paper and watercolour paper since you can cut and tear them easily. Prepare the mask by cutting and/or tearing out the desired shape.

For an even, crisp edge, tear the paper along its grain; for a rougher, broken edge, tear against the grain.

2 Place the mask where you want it on the support. If you are masking out a previously painted area, make sure the paint is dry or you may spoil existing work.

3 Mix your paint colour, making the mixture fairly thick. Secure the mask with adhesive tape or hold it with your free hand. Apply the paint in the direction away from the mask to prevent pushing paint beneath it.

For more interesting effects, try contrasting torn with cut edges. The quality of the mask plays an important part in the finished composition.

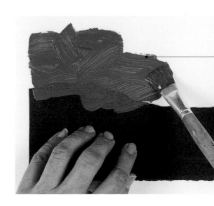

Very liquid paint may creep beneath the edge of the mask, even when you use adhesive tape. With thicker paint, this is seldom a problem.

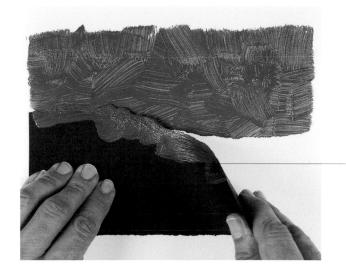

4 Remove the mask as soon as you finish applying the paint. Some artists wait for the paint to dry first, but it is better to remove it immediately. The skin formed as the paint dries will seal the joint between the mask and the paint. Removing the mask from dried paint can tear the edge and leave a jagged finish.

Carefully peel the mask away from the painted area, lifting it slightly and pulling it downward.

Cutting masks

If you want to mask an area with an intricate edge, you can draw the shape on the paper first to guide you when cutting or tearing. For cutting, use scissors or a sharp craft knife.

Paper masks can be cut into intricate shapes and reused several times.

Fabric masks

Cut and tear fabrics in the same way as you do paper, though they are difficult to tear against the grain. Remnants of canvas and hessian are especially useful for making masks since they fray easily, creating an interesting broken line that can be very effective for certain subjects.

Pull out the fibres running across the fabric to leave a frayed edge.

Using masking tape

Masking tape is ideal for small areas or square or rectangular straight-edged shapes. Several different widths are available. Tear the tape in the same way as you do paper. Masking tape is easy to use and remove from canvas and fibreboard but may tear paper if you're not careful.

Use masking tape to create detailed, intricate masks, ideal for replicating fabric patterns in a still life.

Texture pastes

materials

Palettes

Texture pastes

Acrylic medium

Water

Acrylic paint

Large palette knife

Flat bristle brush

Retarding medium

Acrylic is an excellent medium for creating surface texture. Inherent properties in acrylic paint are enhanced by using thickening texture pastes in conjunction with the paint (see *Impasto*, p. 42, and *Knife painting*, p. 44, for texturing techniques that facilitate thick applications). Manufacturers produce acrylic paints with varying degrees of texture, according to the amounts of thickening agents added to the paint. Select one that will create the specific texture you want to achieve. Try additives of sand, fibre and larvae to imitate actual, real-life textures or just to create surface interest. Mix texture pastes with paint beforehand on the palette, and then apply the mixture with a brush or palette knife; alternately, you can apply texture pastes directly onto the painting surface and then overpaint them. Texture pastes are heavy and call for a substantial fibreboard or heavy canvas support. You can custom-make your own texture pastes by adding fine- or coarse-grained sand or sawdust to your acrylic medium.

Using textured paste

1 Use a palette knife to mix the texture paste with the intended colour. (Here, steps 1–4 illustrate using a light-textured sand paste, but you can apply the techniques to any texture paste.) Mixing with a brush is not advisable, as the paste can easily ruin it by clogging the bristles. When you use concentrated pastes straight from the tube, they will be thick; thin them the same way you do paints, by adding water and acrylic mediums. You can also add retarding medium to keep the paint pliable for longer.

Combine the paste and paint thoroughly.

2 Trowel the mixture onto the support and spread it over the surface. Vary the direction of the knife marks to increase the textured effect.

3 Allow the paint and paste mixture to dry well before overpainting the area. Use relatively thin paint for the second and successive applications so that you don't cover up the underlying texture.

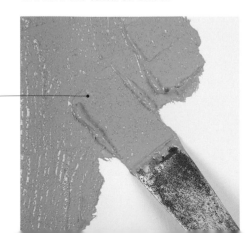

As long as the paste stays pliable, you can scrape it off the support and reposition it.

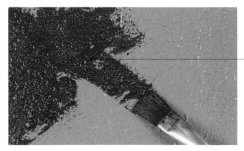

Thin paint slides off the raised areas of texture, creating a lively, speckled effect.

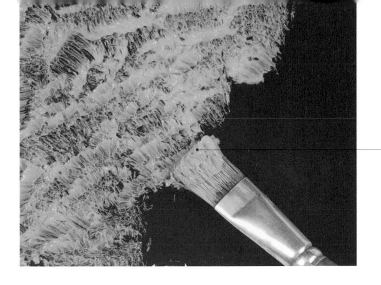

4 Texture pastes work especially well when applied over previously painted areas. Here, the paste is mixed with colour and applied with a flat bristle brush in a stippling action, allowing much of the underlying colour to show through.

The brushwork creates a highly complicated surface that combines texture with broken colour.

Fibre pastes

Texture pastes that contain fibre are stiffer than those that contain sand or larvae. It's best to apply them with a painting knife or palette knife. Use this type of texture in landscape paintings to suggest dramatic skies or storm-tossed seas.

The peaks created by the texture paste throw small shadows that change according to the source of light and the viewing angle.

Natural sand pastes

Texture paste made from natural sand is more finely grained and more fluid than fibre pastes. Although sand adds body to the paint, the actual texture of the paste will become more evident when you apply it thinly onto a smooth surface such as fine canvas or gesso-primed board.

The high viscosity of some pastes lets you pull them into peaks or brush them out flat.

Black larvae pastes

Pastes containing black larvae have less body than many of the other pastes, but the colour of the texture ingredient creates lovely speckled effects.

Colours need to be relatively light in order for the black specks of larvae to be visible.

Homemade pastes

materials

Palette

Sand

Grit

Paper for masking

Palette knife

Painting knife

Flat bristle brush

Acrylic gloss or matt medium

Acrylic paint

Thanks to the adhesive qualities of acrylic paints and mediums, you can add all kinds of materials to create your own personalized textures. Acrylic paints and mediums can hold sand, plaster, marble dust, sawdust, dried vegetable matter and even relatively large chunks of gravel or wood chips. Make sure the material you plan to use is clean and will not rot or deteriorate. Making your own may be the best alternative if you wish to cover large areas with texture or simply want to experiment without going to the expense of purchasing commercial texture pastes (see *Texture pastes, p. 52*).

Making and using pastes

1 Try to use clean materials when making your own texture pastes. Washed children's play sand is ideal. Combine the sand with the paint on the palette, adding a little matt or gloss medium as the mixture begins to stiffen.

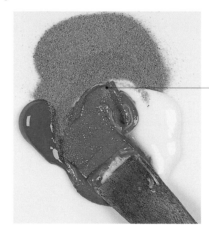

Mix the ingredients well, making sure all the grains of sand are coated with paint and acrylic medium.

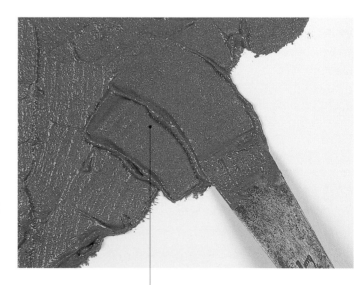

2 Use the palette knife to apply the mixture to the support. You will find it easier to work on a horizontal surface so that you can apply pressure when required. This will also prevent the mixture from dropping off the surface and onto the floor. Let the support lie flat until it is dry.

Paste is very easy to manipulate and can be scraped off and reapplied until it begins to harden.

3 While the texture paste is still malleable, you can manipulate it with any handy implement, such as the end of a brush handle (see *Sgraffito*, p. 64). Here, the end of a painting knife scratches designs into the paste.

Work quickly. If you don't like the effect, you can smooth the paint out before it begins to dry and try again.

4 Thick paste takes at least an hour to dry out completely. Make sure it is dry before you overpaint. Keep testing by pressing your nail into a thick part of the texture. You can speed the process by blowing warm air over it with a hair dryer or by positioning the support close to a radiator.

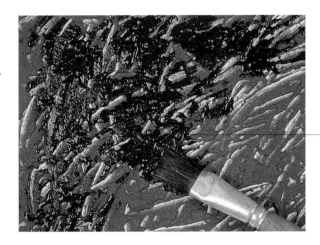

Once dry, you can scumble paint loosely over the top to create exciting colour effects (see *Scumbling*, p. 60).

Isolating an area

Because the textured paint is so thick, it is difficult to restrict it within precise boundaries or small areas, but you can use masking methods to isolate an area (see *Masking*, p. 50).

Here, this sharp edge was achieved by using a simple mask – the straight edge of a sheet of thick paper.

Heavier textures

Paint and medium will hold even very large materials in place. Here, a strong relief effect was created by mixing washed agricultural grit with paint and a heavy gel medium. Once dry, the texture could be painted over loosely to disguise the material being used.

Thick, heavy textures such as this will need to dry overnight before you overpaint them.

Blending

Bristle brush
Acrylic paint
Retarding medium
Water
Rag or paper towel
Fan-shaped bristle brush
Small round brush

To achieve gentle transitions, when one colour or tone gradually changes to another, you need to blend colours. This is especially important when you model form in figure or portrait painting, where the gradations are often very subtle. It is more difficult to blend acrylic paints than oil paints, because their fast drying time tends to result in hard edges, but there are ways to solve this problem. One method is to mix retarding gel into the paint. This slows the drying time considerably, making it possible to blend even large areas. Retarding medium has been used in the steps below, but alternately you can mist the surface from time to time with a fine spray of water to keep the paint malleable (see *Wet-into-wet*, p. 46). You can loosely blend small areas even without a retarding medium, as long as you work quickly and use fairly thick paint.

Blending with a small brush

1 Here, the colours to be roughly blended were painted onto the surface so that they almost touched. After applying yellow and green areas next to each other, rapid, dabbing brushstrokes of green were inserted into the edge of the yellow area, and dabs of yellow into the edge of the green.

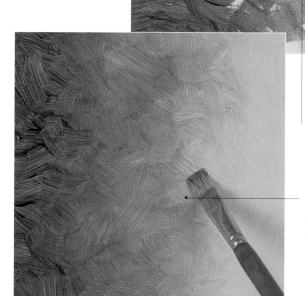

This rough-blending technique works best if you vary the direction of the brushstrokes.

2 Continue the blending process so that the brush pushes and pulls the colours together. It will continuously pick up colour as well as move it around. Clean your brushes periodically by wiping them on a rag or paper towel; don't dip them in water.

Because the green tone was applied lightly, more of the yellow base colour was allowed to show through.

3 Here, the transition between the colours is more and more gradual. Keep working your brushstrokes in several directions and wiping your brush until you achieve the results you want.

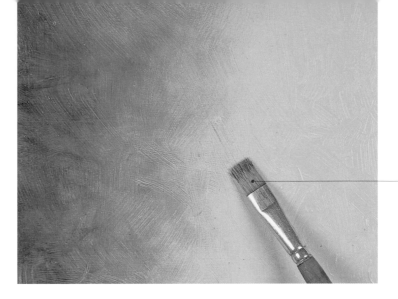

Gradually lessen the pressure of the brush as the blend becomes smoother.

Blending with a fan-shaped brush

Fan-shaped brushes are made specifically for the purpose of blending colours. They may take some getting used to, but they do speed up the process.

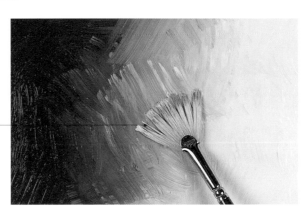

As with the flat bristle brush, it's important to vary the direction and pressure of the brushstrokes.

Finger blending

You can also use a rag or your fingers to blend colours while the paint is still wet. Wet your finger first by dipping it in water. This will help it slide easily through the paint.

Don't let the paint begin to dry out or your finger will lift it off and scuff the surface.

Cross-hatching

Cross-hatching is a slower and more painstaking method of blending. Make a series of little cross-hatched brushstrokes using a small round brush and working on a small area at a time. Early Renaissance artists used this technique when they painted with tempera, also a fast-drying medium. The brushstrokes are worked in layers, letting each one dry before applying the next.

When viewed from a distance, the network of linear strokes appear to combine seamlessly.

Spattering

materials

Watercolour wash brush
Bristle brush
Acrylic paints
Water

Spattering or dripping paint onto the picture surface is a quick and direct way of adding interest and enlivening areas of flat colour. Spattering can also suggest specific textures or landscape features, such as millions of pebbles on a beach, broken earth in a ploughed field or falling snow. However, to use spattering successfully when you want to depict figurative shapes, spatter the paint subtly so it won't stand out too much or jar with brushstrokes – if the effect is overused, it can look mechanical and contrived. You can control spattered paint to some extent, but droplets of colour tend to appear where you don't want them. To prevent this, combine spattering with masking (see *Masking*, p. 50).

Complex spatter effects

1 To build up a complex area of spattered colour, loosely paint a base colour over the area using the watercolour wash brush. Then lay the support flat. Mix your colour and thin it with water to the desired consistency; for the paint to leave the brush easily, it needs to be quite fluid. Hold the bristle brush over the area and tap the handle sharply against your free hand to release small droplets of colour.

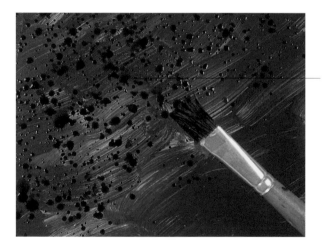

Don't overdo the spatter; the blobs of paint will begin to join.

Once you make the marks, let them dry without disturbing them.

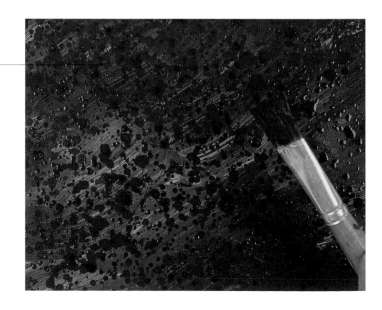

2 Allow the first spattered layer to dry, then repeat the process using either the same or a different colour, depending on the effect required. Again, stop once the blobs of paint begin to flow into one another.

3 To achieve exciting areas of broken colour, repeat the process as many times as you wish. If you are not satisfied with the effect, you can remove the top layer by wiping with a wet cloth.

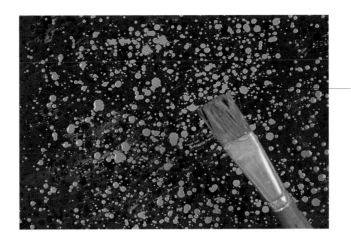

Vary the size of the droplets by altering the consistency of the paint.

Spattering wet-into-wet

Spattered paint can be made to spread out and diffuse by first wetting the surface with either water or thin paint and then spattering slightly thicker paint onto it. The weight of the new paint pushes the water or thin paint away but blends slightly with it to give each blob a soft, irregular edge.

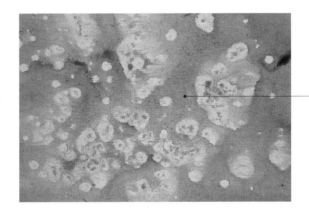

This could be a useful technique for suggesting foliage or a mass of flowers.

Fine spatter

Fluid paint flicked from a bristle brush gives a very fine spatter. Here, the brush was held over the work and the bristles pulled back by the fingers and then released.

It is important not to overdo each layer of spattering or the individual marks begin to lose their definition.

Sweeping spatter

Here, spattering was created by flicking paint in sweeping lines onto the support from an angle rather than from above. Use this technique with caution, as the direction of the spattering could lead the eye away from the focus of the composition. However, if you control spattering with masking, you can take advantage of the possibilities of this technique to depict seascapes or stormy weather.

If you plan to use bold marks such as these, practise some of them on a sheet of scrap paper before you commit paint to paper.

Scumbling

materials

Flat bristle brush

Acrylic paint

Water

The term scumbling refers to a loose, rough, deliberately uneven application of opaque or semiopaque paint over other colours without completely covering them. This creates an effect known as broken colour. Another technique borrowed from the oil-painters' repertoire, scumbling is even better suited to fast-drying acrylic. When you apply several layers of scumbled paint, parts of each one remain visible, resulting in an intricate, colourful surface that would be impossible to achieve by any other technique.

Scumbling over a smooth surface

1 It's important to choose the base colour carefully because scumbling over it will not cover it completely and, therefore, it will set the tone for all successive layers of paint. Here, the base layer was roughly applied. In some cases scumbling is a good way to enliven an area of colour that is too smooth and featureless.

A loose application of paint, with brushstrokes going in different directions, provides the perfect base for broken-colour effects.

2 The second layer of slightly thicker red paint was applied in a haphazard way. It was scrubbed onto the support with strokes in various directions so that some of the green base coat shows through. The support in this case is **gesso-primed board**.

When working on a smooth surface, try rolling your brush and using a scrubbing-brush motion rather than painting with brushstrokes.

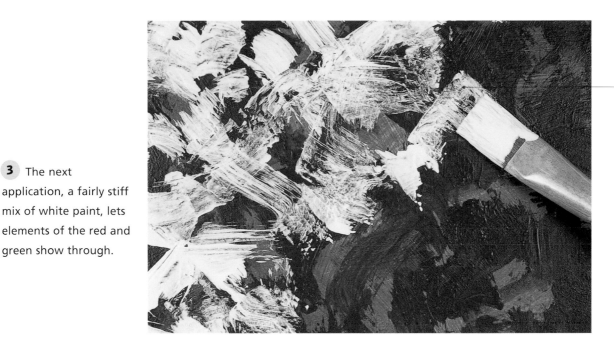

3 The next application, a fairly stiff mix of white paint, lets elements of the red and green show through.

Try to vary the direction of your brushstrokes so you don't leave a discernible pattern in the composition.

Combining scumbling and glazing

When scumbled and combined with the glazing technique (see *Glazing*, p. 50), thin, semitransparent paint produces colourful, lustrous surfaces with great depth. Thin scumbles can be built up in thin layers or applied over thick paint. Here, the base layer of red was glazed over with loose, fluid brushstrokes. Once dry, red paint was used sparingly once more to deepen the overall colour effect.

Working on a textured surface

Scumbling is easier to do on rough or textured surfaces, as the uneven surface picks up the paint in a slightly random manner. Here, white paint settles on the rough hessian weave.

You can let your brushstrokes be distinct, but always run them at different angles to those still visible in previous layers.

Use a dry mix of stiff paint to avoid filling in the weave of the fabric.

Pointillism

It's an optical illusion that the human eye sees one colour when viewed from a distance when, in fact, it is actually a combination of small blobs of pure colour that are relatively close in tone and placed next to each other. They mix "in the eye", or "optically". In 19th-century France, Georges Seurat thoroughly developed this technique and it became known as pointillism (although he preferred the term divisionism). Pointillism is a slow and laborious technique if strictly followed, but it has a unique charm. Mixing colours optically in this way produces a lovely shimmering effect that cannot be achieved by any of the more usual painting methods. It is also worth trying from an instructional point of view; using it will teach you a great deal about colour relationships and interactions.

Creating the effect

1 Here, as a preliminary stage toward painting a light purple panel, dots of cadmium red were painted across the area. They were fairly even-spaced but varied slightly in size.

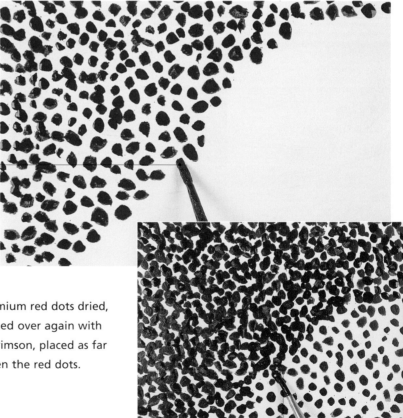

Old brushes with worn-away points are perfect for making small dots.

2 After the cadmium red dots dried, the area was worked over again with blobs of alizarin crimson, placed as far as possible between the red dots.

You may need to experiment with the consistency of your paint. It needs to be fluid enough to blob easily when you touch the brush tip to the surface.

3 The alizarin crimson was allowed to dry, and a new second stage, a layer of ultramarine dots, was added in the same way, filling in the spaces between the red dots.

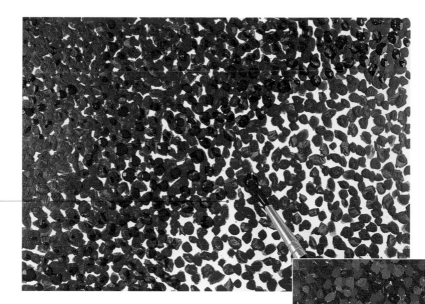

The white of the support was gradually obscured by the blobs of colour.

4 Next, the area was painted over with violet dots.

5 Lightening and/or darkening the colour of the dots creates variations in tone and colour, but take care not to juxtapose very light and very dark tones, as these will not be perceived as one colour.

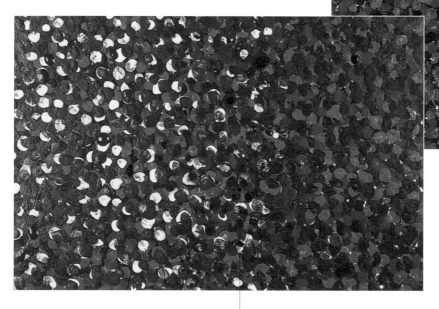

The effect begins to become coherent, and the eye begins to see the colour as an area of purple.

Seen up close, the dots appear to be placed haphazardly, but when viewed from a distance, the transition from light to dark is clearly visible.

Using related colours

You can create subtle areas of colour by using blobs of colour in similar hues or colours that are closely related by their proximity on the colour wheel.

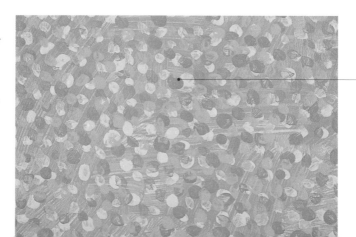

To speed up the process, overpaint a loosely blocked-in underpainting.

Sgraffito

"Sgraffito" is derived from an Italian word, *graffiare*, meaning "to scratch". The term encompasses any technique that involves using a sharp implement to scratch into a layer of colour in order to reveal the one below. This can be an earlier layer of paint or the painting surface itself. Sgraffito is an excellent way to create fine lines or intricate patterns without having to paint them on, to achieve areas of texture and to add highlights. Approach sgraffito techniques carefully, especially if you use sharp blades, as it is all too easy to cut into the paper or canvas.

Applying the paint

1 Choose colours in advance, bearing in mind that the first colour will show through the second, scratched layer. If you intend to scratch away a large area, pay attention to the quality of the underlying brushstrokes, since these will also be visible.

Paint the first colour as usual. Let it dry thoroughly to a hard surface.

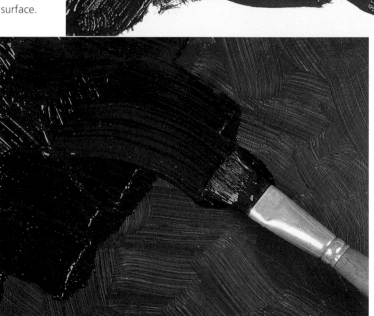

2 Apply another layer of paint, mixed with retarding medium, on top of the base layer. Then, scrape paint away using one or more of the techniques opposite.

Apply paint as a thick impasto or a glaze (see *Impasto*, p. 42, and *Glazing*, p. 38). It can be manipulated until it begins to dry.

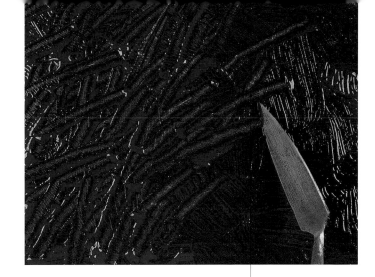

Scratching with a knife

You can manipulate paint with any suitable implement. Here, a linear pattern was created in the blue medium with the point of a trowel-shaped painting knife. Make lines that are more blunt with the end of a paintbrush. If the result is unsatisfactory, there should still be time to remove or brush over the marks and redo them.

The paint, although wet, is thick enough to hold the shape of any suitable implement you use to make marks.

Using a rubber-tipped paint scraper

Try out a variety of tools to become aware of the possibilities of this method. A rubber-tipped paint shaper creates clear, precise edges, as the rubber collects the wet paint rather than pushing it aside.

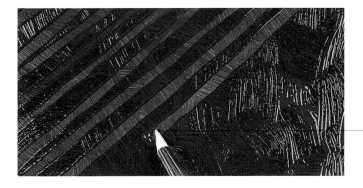

In order to keep marks clean and sharp, wipe any collected paint from the rubber tip after making each mark.

Using an adhesive spreader

Artists are inventive by nature and often turn household or home-decorating implements into useful and unusual tools. Here, an adhesive spreader was used to scratch an interesting pattern. Search for an old comb or broken hacksaw blade, whatever you think would achieve special effects.

You can build up intricate patterns by letting the paint dry, laying on another layer, and then repeating the process.

Removing paint by rubbing

Another variation of sgraffito is to rub paint off rather than to scratch into it. This is useful if you want to lighten an area, create diffused highlights, or enliven an area of colour by letting some underlying colour show through. If the topcoat is still wet, simply rub it off with a rag; dry paint requires rougher treatment.

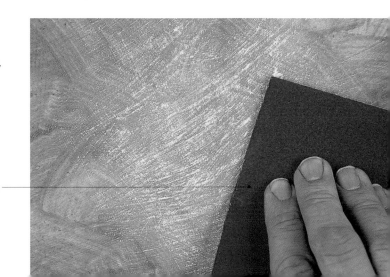

Remove thin, dry paint by gently rubbing with a medium-grade sandpaper.

Imprinting and printing

materials

Prepared canvas or gesso-primed fibreboard

Flat bristle brush

Roller

Acrylic paint

Water

Retarding medium

Aluminium foil

Bubble wrap

Hessian

Bamboo stick

Leaves

Modelling paste

Imprinting and printing are related techniques that offer exciting opportunities to add an extra dimension to your work. They're simple to carry out yet look complicated; viewers often wonder how the artistic effects were done. In the imprinting method, a patterned or textured object is pressed onto wet paint on the painting surface and then removed. It leaves an impression behind. In printing, the object itself, such as a leaf, is covered with paint and then pressed onto the surface. Printing requires only flat paint, while the effects of imprinting are most dramatic when objects are pressed into impasto or thick paint (see *Impasto*, p. 42). You can also use thick white acrylic modelling paste to make an imprint and then paint over it.

Using aluminium foil

1 Aluminium foil was scrunched and then carefully opened out to provide a flat but textured surface. A fairly thick mixture of paint was applied, letting it adhere only to the raised parts of the foil.

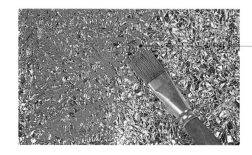

To prevent paint from drying out before you make a print, add retarding medium.

2 The foil was painted and placed painted side down on the area to be printed. You can use a roller or the side of your hand to apply pressure to the back of any foil you use. It is essential to work on a rigid support. If you wish to make a print on canvas, place a board beneath it. The board should be deep enough to fill out the hollow area between the stretcher bars.

3 To check the progress of the print, the artist carefully peels back a corner of the foil. Once the print can be seen clearly, peel away the foil carefully.

4 Use the printing technique to lay colours over each other when you want to imitate real textures, such as sand on the seashore, a rock face or an old stucco wall.

Do not move the foil from side to side as you peel it back. The impression may become smudged.

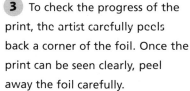

Allow the finished print to dry thoroughly before you overpaint it.

Hessian

In this example, a coarse piece of hessian was used to make an imprint on a smooth gesso-primed fibreboard that was painted with bright yellow, mixed with a little retarding medium.

The imprint was made by rubbing the back of the fabric with the side of the artist's hand.

Bubble wrap

Bubble wrap makes an interesting honeycomb pattern. Paint the bubble side and carefully apply it to the painting surface, gently rubbing the back of the wrap and then peeling it away.

The printed pattern doesn't have to be perfect. Actually, any imperfections in the print may add to the charm of the method.

Bamboo stick

Many objects found lying around the studio or home make interesting printing tools. Below, the end of a bamboo stick was dipped into thick paint and used to print an entire block of purple discs.

It is important to obtain the correct paint consistency; if it is too wet and runny, the printed image will lack definition.

Using elements from nature

Select objects for their shape. Then print exact copies of them. These leaves, printed in green, could enhance a still life or landscape. Incorporate prints from dried flowers or grasses into your painting to add texture and realism.

If an object refuses to accept the paint, try rubbing a little washing-up liquid onto its surface before applying the paint.

Finger painting

A thin layer of modelling paste applied to the support will hold the imprint of a thumb or any other object that has a surface texture or raised pattern.

After the modelling paste dries, you can apply thin paint over the imprint.

Monoprinting

materials

Sheet of plate glass or plastic laminate

Acrylic paint

Water

Retarding medium

Flat bristle brush

Foam roller

Painting knife

Sheet of thin drawing paper

Professional printmaking requires heavy and expensive equipment. Monoprinting is a "kitchen table" method that is fun to do and produces similar, exciting results. True printmaking creates a series of identical images, but monoprinting, as its name implies, produces just a single image that can stand in its own right or be used as a starting point for further work. The monoprinting process is simple: a design is painted on a smooth surface, such as a sheet of glass; paper is placed over it, rubbed with a hand or a roller and then removed. The paint will adhere to the paper, but only partially, producing an attractive texture that characterizes this method and gives it a special quality.

1 Mix the required colours with retarding medium to slow down the drying time, preparing them all beforehand so you can work relatively quickly.

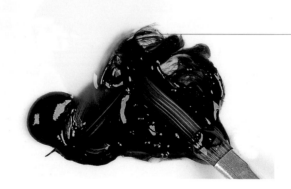

The paint mixes must be reasonably thick, as runny paint results in a messy, indistinct print.

2 Use a brush to paint your design onto a clean sheet of glass or laminate, bearing in mind that the printed image will be reversed.

3 At this stage, you can work into the paint and remove some of it with any handy implement. Here, a painting knife was used to scrape off paint and insert some lines.

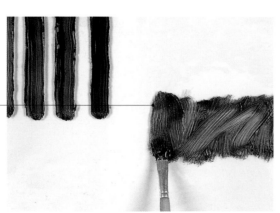

Do not apply paint too thickly or the marks you make on the surface will be squeezed out of shape when you rub the paper.

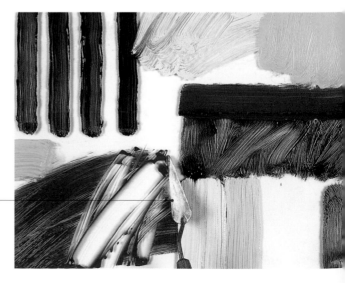

The paint knives used for the sgraffito technique (see *Sgraffito*, p. 64) are ideal for manipulating the paint in this technique as well.

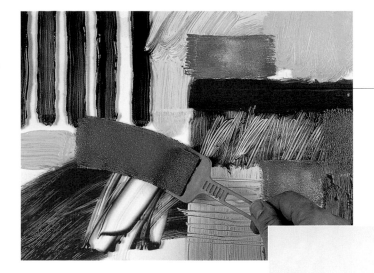

4 Different marks and more paint can be added for as long as the paint remains pliable.

Avoid building paint up too heavily.

Gently but firmly rub your hand over the whole surface of the paper.

5 Place a sheet of smooth, lightweight paper over the painted design. Be sure to position it squarely and correctly since you won't be able to reposition it.

6 Once you're certain the image has transferred onto the paper, carefully peel the paper away from the glass.

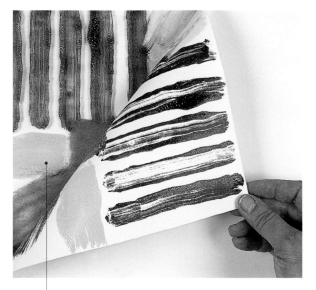

7 Put the print aside until it is thoroughly dry. Once it is completely dry, leave it as is or use other acrylic or mixed media techniques on it (see *Mixed media*, p. 74). Occasionally, if the paint on the glass printing surface has not yet dried, you can make a second print. This will be a ghosted image of the first, but second prints can be very attractive. Another approach is to add more paint and take a different, but related, print.

Before removing the paper completely, check to see if the print is satisfactory by carefully lifting one corner.

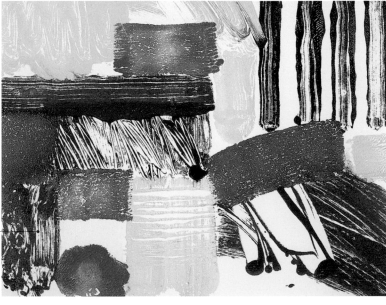

A mottled texture is a typical feature of monoprints. Try to preserve this whenever you are painting over a print.

Wax resists

materials

Acrylic paints

Flat bristle brush

Water

Wax candle

Sharp craft knife

Watercolour wash brush

Wax crayon

Oil pastel

Paint thinner or turpentine

Resist techniques have something in common with masking techniques (see *Masking*, p. 50) in that they both hold paint away from paper. Resist techniques, however, are permanent and form an integral part of the design. Resists rely on the natural antipathy between oil (or wax) and water. Materials used most commonly are wax candles, crayons, oil pastels and mineral solvents such as paint thinner or resin solvents such as turpentine. Wax resist is a common watercolour technique. For acrylic, the paint must be runny and well thinned. Thick, opaque paint will simply cover the resist and fail to slide off. The best surfaces for this method are paper or gesso-primed fibreboards.

Using a candle

1 Use a white household candle to draw your design on a gesso-primed board. Be careful when placing marks, since they will all remain visible through the thin layers of paint. Because clear wax is hard to see, try holding your board at an angle to keep wax marks visible.

Sharpen your candle to a point, using a sharp craft knife.

2 After establishing the design, apply a smooth wash of relatively thin paint mixed with water. This paint needs to be the consistency of watercolour (see *Laying washes*, p. 36).

You don't have to make the wash too even; variations in tone make the effect more interesting.

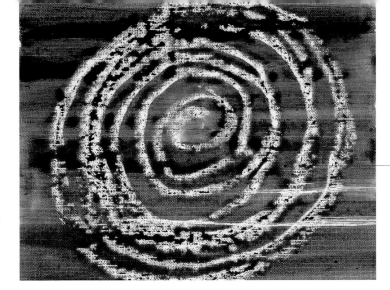

3 Allow the wash to dry without disturbing it or adding more paint, as any subsequent paint may cover the design in places, making it less distinct.

Depending upon how heavily you apply the wax, some of the design may fill in with paint, but this is a distinctive feature of the method.

Using turpentine and paint thinner

Turpentine and paint thinner act as resists since both are slightly oily. Paint them onto a surface, allow them to dry and then overpaint them. This method can be hit-and-miss. An easier, more reliable technique is to manipulate thin, wet colour with either of the solvents.

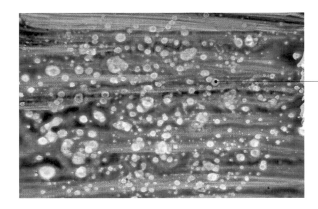

Spattered turpentine pushes back the watery acrylic paint, and together they dry to create interesting effects.

Using wax crayons

Wax crayons work in much the same way as candles, but when using them, you have the advantage of being able to see what you are doing. Even the limited range of wax-crayon colours available helps to expand the possibilities of the method.

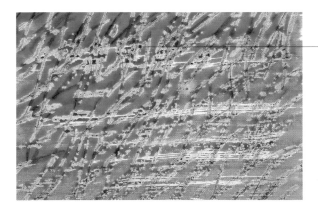

Wax-crayon colours tend to be relatively weak.

Oil pastels repel watery paint and work better than wax crayons.

Using oil pastels

Oil pastels come in a much larger range of colours, many of them vivid and strong, enabling bold effects. Unlike ordinary (chalk) pastels, they won't smudge when rubbed.

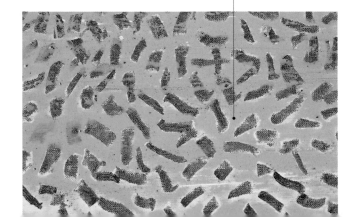

Collage

The adhesive qualities of acrylic paints and mediums make them ideal for collage treatments, in which paper, photographs or other printed materials are stuck onto a surface. You can incorporate even large objects when you use heavy gel mediums and texture or modelling pastes (see *Mediums*, p. 22). After you secure collaged materials to the support, leave them as they are or paint over them as long as they are porous. In order to create a firm surface, a strong support is needed. Heavyweight paper or cardboard is usually adequate as a support for paper collage, but for more bulky materials, such as wood or shells, it is best to work on a well-prepared fibreboard or wooden panel.

Making an acrylic collage

1 Assemble components before you start so that everything you need will be handy. Always be on the lookout for interesting collage materials.

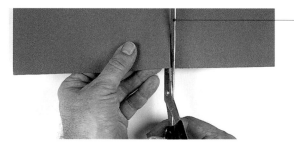

Prepare papers by cutting them with a knife or scissors or tear them to create a more interesting edge (see *Masking*, p. 50).

2 Don't secure the collage materials until you decide where you want to place them. Start by moving them around on the dry support, rearranging them until you arrive at a satisfactory design. You will then need to remove the pieces, so make a small drawing on a separate sheet of paper to remind you of the position of the various elements.

3 Use an acrylic medium in the same way you would paper adhesive and paint the back of the collage materials with it.

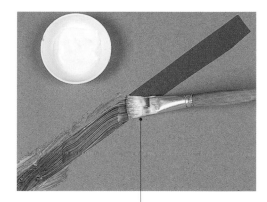

Gloss or matt painting mediums have enough adhesive power to stick paper, but thicker materials will require heavy gel mediums.

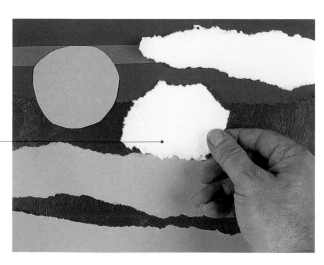

Elements of the composition can be arranged and rearranged until the composition is satisfactory.

4 Place the materials, adhesive-side down, onto the support and press into position. Once everything is in place, cover the whole composition with a heavy board and weigh the board down with books or bricks until the collage dries.

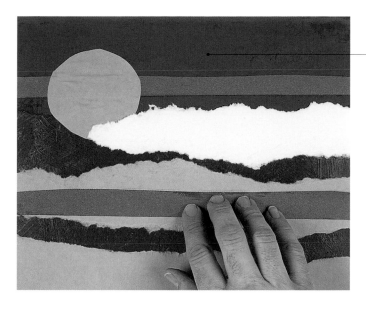

After the collage is complete and dry, you can work on it using acrylic paint or other materials (see *Mixed media*, p. 74).

Colouring your own papers

You needn't be restricted to commercial coloured papers when pasting up your collage. Broaden the artistic possibilities by preparing your own. Try contrasting spattered or sponged effects (see *Spattering*, p. 58, and *Sponging*, p. 48) with transparent glazes and opaque paint.

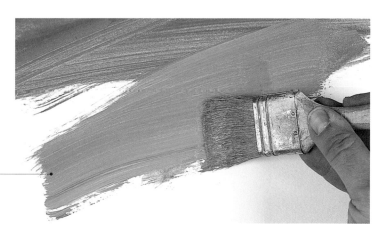

Preparing your own collage papers offers almost limitless possibilities.

Using tissue paper

Thin tissue papers and lightweight cotton fabrics soak up acrylic mediums and adhere very easily. Place them onto the support and ease them into shape with a stiff brush.

Once dry, tissue or thin fabric becomes hard and can be painted over.

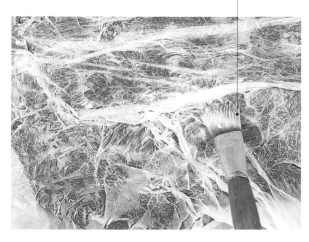

Creating textured surface effects

You can scatter lightweight granular materials such as sand, rice or lentils onto the surface, either into thick paint or onto a surface painted with an acrylic medium.

After it dries, the acrylic medium will become transparent and invisible; viewers will see only the sand and any paint designs.

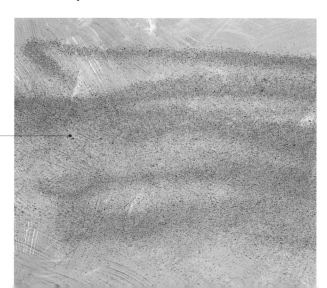

Mixed media

materials

Acrylic paint
Hard or soft pastels
Graphite stick
Graphite powder
Charcoal
Water
Acrylic medium
Painting support
Paintbrush
Fixative

All drawing and painting materials – soft and hard pastels, coloured pencils, graphite pencils, charcoal, watercolour and gouache – are suitable for use in combination with acrylics. Oil paint combines well as long as you use it over the dry acrylic rather than beneath it. All of these materials (except oil paint) can be used on or under acrylic work, or they can be incorporated into acrylic paint or mediums. The important thing to remember is that anything that is physically integrated into acrylic paints or mediums will take on the same physical properties as acrylics. After they dry, they become stable, and you won't be able to manipulate them by the usual techniques.

1 Apply hard or soft pastels to the painting surface, using any of the normal pastel methods.

Pastel works particularly well on any textured acrylic paint surface.

2 After you have laid enough pastel colour and are satisfied with the composition, you can manipulate it with water and acrylic painting medium. This will turn the pastel – which is simply pigment shaped into sticks – into paint. After it dries, the pastel and medium mixture becomes impermeable.

3 Here, acrylic paint was painted over certain areas. This picked up any pastel not previously mixed with medium.

You can paint over the pastel and medium mixture with more pastel or paint, but you won't be able to move it.

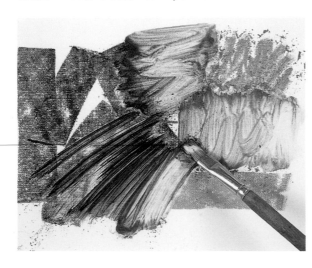

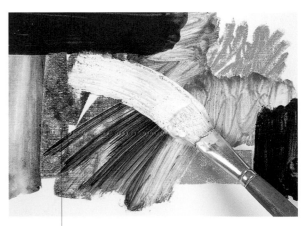

If you want areas of pastel to keep their own identity, spray with fixative instead of mixing them with medium.

4 An additional layer of pastel was worked into the wet surface, mixing with the paint and medium (as illustrated in the previous step).

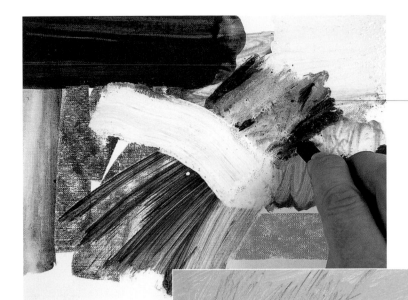

Use a rag or paper towel to remove any acrylic paint or medium from the pastel before it dries. If you don't remove the acrylic paint, it will dry to form a skin over the pastel, making the pastel unusable.

5 A graphite stick was used to draw through a thin layer of wet acrylic paint, producing an effect similar to sgraffito (see *Sgraffito*, p. 64). The sharp point cuts through the paint to make an intermittent mark.

Graphite sticks are available in different grades of hardness. Softer ones make darker marks.

6 Charcoal is a soft, crumbly material with a consistency similar to pastel. It also handles like pastel when mixed with acrylic paint or mediums.

7 A graphite powder was spread onto the support with fingers or a rag, then manipulated with white acrylic paint.

Paint mixes with graphite to produce various shades of grey.

You can use charcoal mixed with acrylic medium to build up tonal underpaintings before you apply colour.

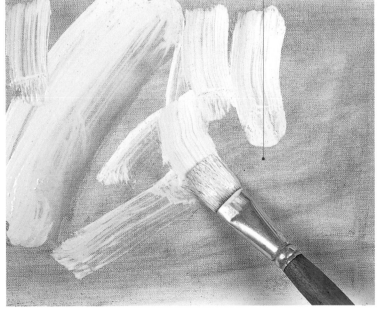

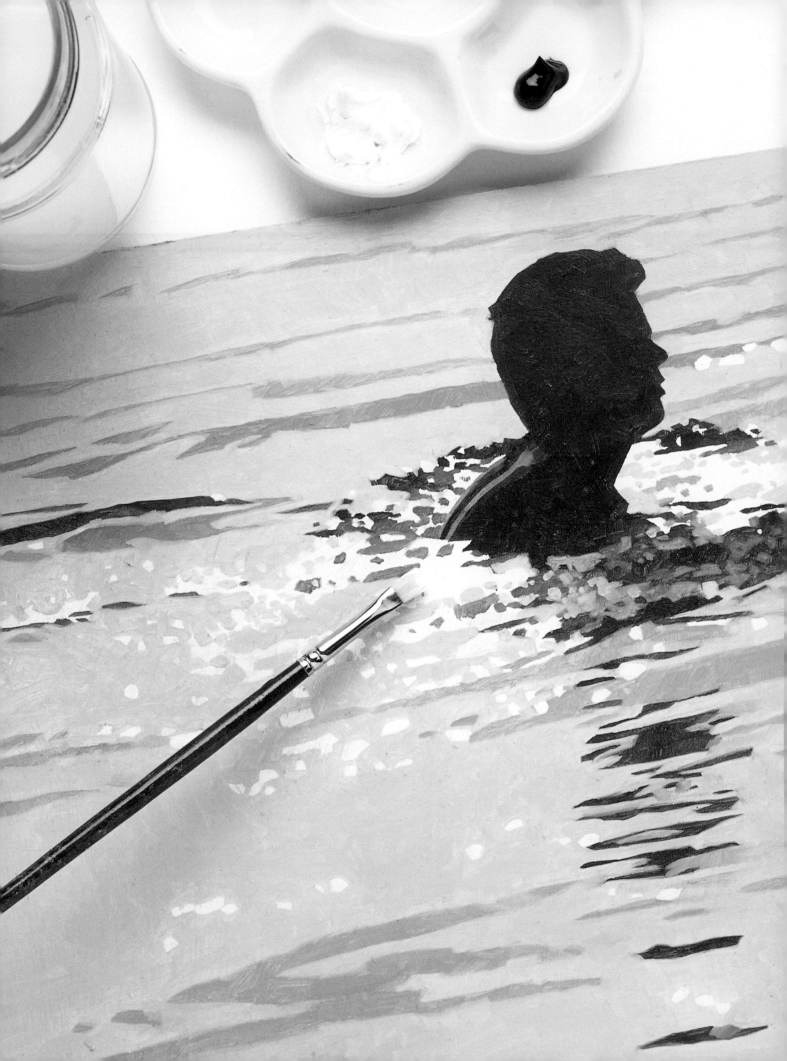

Making pictures

Having a sound knowledge of painting techniques is very important, but techniques are merely the visual language that allows you to express yourself. You will not truly succeed with a painting until you are able to look at your subject in an analytical way, interpret what you see, and then turn it into your own personal vision. Painting is as much about thought and decision-making as it is about the physical application of paint. Any good painting is the sum of many parts, so always pay as much attention to pictorial topics – colour, tonal values, composition, texture, perspective and proportion – as you do to how you manipulate the paint.

Colour

Responses to colour are, to a certain extent, subjective – you may like or dislike a colour because you have personal associations with it. However, handling colour has important objective aspects, and in order to use colours successfully, you will need to understand some of their basic properties. Knowing about colour characteristics will help you to mix colours to obtain shades you desire and make them work for you in your paintings.

THE COLOUR WHEEL
The primary colours are red, yellow and blue; when mixed, they give the three secondary colours of orange, green and violet. Mixing each of these in turn with the primary colour adjacent to it on the wheel results in the six tertiary colours; red-orange, yellow-orange, yellow-green, blue-green, blue-violet and red-violet.

ENDLESS POSSIBILITIES
By continuing to subdivide the wheel in this way, hundreds of different colours can be mixed. Extend the range further by altering the hue of the first three primary colours.

Mixing primary colours

Red, yellow and blue are primary colours. They are called "primary" because they cannot be mixed or derived from pigments of any other colours. Mixtures of any two of these are called secondary colours: red and yellow make orange, yellow and blue make green, and blue and red make violet (or purple). If any of these secondary colours is mixed with the primary colour next to it on the colour wheel, this produces a tertiary colour: red-orange, yellow-orange, yellow-green, blue-green, blue-violet and red-violet. If you continue to mix each colour with its neighbor, the range of colours will run into the hundreds.

Although you can do a lot with just red, yellow and blue, these three primaries cannot fulfil all your needs. Manufacturers' colour charts usually list at least three versions of each primary colour, as colours vary in "temperature", or degree of warmth or coolness. Your palette should include a selection of two or more reds, blues and yellows, giving you the potential for literally thousands of different colour mixes.

Warm and cool colours

All colours are described as being either warm or cool. The colour wheel groups the warm colours – red, orange and yellow – on one side, with the cool ones – blue and the violets – on the other. Colour temperature is very important in painting because cool colours tend to recede while warm ones come forward. Thus, in a landscape, you can create a sense of space by progressively cooling the colours toward the background. Cooler colours are also used when painting shadows.

But it is not adequate to think of all reds and yellows as warm colours and all blues as cool ones, because each has a warm and a cool version. The eye perceives cadmium red, for example, as warmer than alizarin crimson, which the eye sees as tending toward blue.

Complementary colours

Colours that fall opposite one another on the colour wheel – red and green, yellow and violet, and orange and blue – are known as complementary colours. If placed side by side, they enhance one another, each making the other appear brighter and more vibrant. This is known as "simultaneous contrast". The Impressionists often used complementary colours in shadows; a well-known technique landscape painters use is to include a small red object or red-clad figure as contrast against dominant greens in foliage.

Paradoxically, complementary colours cancel each other out when mixed together. When mixed in equal proportions, they produce a neutral colour. It is worth knowing about this phenomenon, because you will not only be able to mix an interesting range of grays, browns and almost-blacks but also be able to subdue, or tone down, a colour that is too bright. If a green is too vivid, for example, simply add a little red.

Choosing a palette

A good working palette usually consists of the primary colours in both their warm and cool variations, together with some secondaries, and earth browns. This selection, along with white, will allow you to blend most of the colours you need. The following list has some helpful suggestions, including a few alternatives that you may wish to try (given in italics). The index number, which is a guide to the pigments in each colour (see page 18), is included.

TITANIUM WHITE; PW6
A clean, bright, opaque white with good tinting power.

CADMIUM RED: PR108
Good tinting strength and opacity. Various shades are offered, with medium being perhaps the best first choice.

ALIZARIN CRIMSON: PR83
The classic cool red, this colour is more transparent than cadmium red but has excellent tinting strength.

QUINACRIDONE RED: PR122
An extremely strong, relatively transparent red with high tinting strength, often used in place of the two previous reds. Due to its strength, it should be used with care.

YELLOW OCHRE: PY43
A useful earthy colour that is opaque. It has reasonable tinting strength.

CADMIUM YELLOW: PY37
Available in various shades, medium being the best choice. The colour has good tinting strength and mixes well with red to create a range of bright oranges.

LEMON YELLOW: PY3
A cool, slightly greenish yellow, which mixes well with blues to create brilliant greens. May be sold under a variety of names, including primrose or hansa yellow.

ULTRAMARINE BLUE: PB29
A warm, strong, transparent blue, which mixes well with cool reds to create bright purples and violets, and with cool yellows to create greens.

CERULEAN BLUE: PB35
Relatively dense cool blue with low tinting strength. Good for mixing greens, and an easy blue to use, as it will not overpower other colours.

PTHALOCYANINE BLUE: PB15
A cool, transparent blue often substituted for other blues. Mixes very well with yellows and reds, but due to its high tinting strength, it must be used with care.

VIRIDIAN: PG18
A bright, transparent, cool green that mixes easily with other colours for a range of greens. Mix it with alizarin crimson for a good "black", which can be diluted with white for lively greys.

PTHALOCYANINE GREEN: PG7
A powerful transparent green with a high tinting strength often used instead of viridian.

DIOXAZINE PURPLE: PV23
A strong, ready-mixed purple that has good tinting strength and is easily modified by mixing with other colours.

RAW UMBER: PBr 7
A strong greenish brown that is excellent in mixes when modifying other colours.

BURNT UMBER: PBr 7
A strong, warm brown with a distinctly red tinge. Mixes well with other colours.

PAYNE'S GREY: PB29/PBK7
There are several versions of this very useful colour by different manufacturers. It has modest tinting strength, but it mixes very well with other colours.

Composition

The composition of a picture refers to the way the entire picture is designed and constructed. It is important for the artist to provide interest in each area of the picture, to pull the viewer into the picture and to lead the viewer around it without getting lost. The way you arrange shapes, colours, tones and textures, as well as the way you create the illusion of three-dimensional space, will help you to achieve this visual balancing act.

BALANCING THE IMAGE
These three compositions demonstrate how balance can be achieved within a composition, using colour, mass (size), pattern and position.

▶ The three lemons grouped on the left of the composition are balanced by colour and mass.

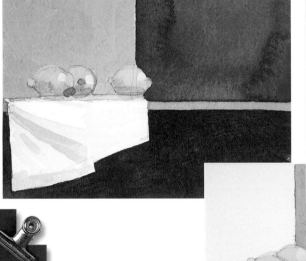

▶ The plate of lemons on the left-hand side of this composition is balanced by mass and pattern.

▲ The small size, position and colour of the single lemon is used to pull the eye away from the imposing mass and interest of the melon and pumpkin.

VIEWING FRAME
A frame will help you decide on the type of format to use for your work. Here, two L-shaped pieces of cardboard are held together with clips. Adjust frames to sample how different formats – squares, rectangles or others – will look.

Choosing the format

Composing your picture starts before you put paint to paper; first you have to decide on a format. The two formats most commonly used are horizontal rectangles, known as landscape format, and vertical rectangles, known as portrait format. Ready-made boards and canvases are usually sold as rectangles in set proportions, but you can custom-design your own square shapes or rectangles.

The format you choose will have an immediate influence on the way you look at the subject of your composition and the way you present it to the viewer. A square format encourages the eye to move around the space in a circular movement or to bounce across the space from edge to edge. In a vertical format, the eye moves up and down. A horizontal format leads the eye from side to side.

The centre of interest

This visual pull is influenced further by elements placed within the picture area. The same principles apply whether you are painting a simple still life

containing a single apple on a plate or a complicated landscape with many different elements. The eye must be led to a centre of interest or focal point. This must be done subtly, so the viewer does not focus attention on this area alone. In general, it is not a good idea to place a focal point right in the centre of the composition; the intention should be to create a visual balance.

Balances and visual links

Balance and symmetry are terms used frequently in the context of composition. They are far from meaning the same thing. When elements are arranged symmetrically in a work, the image tends to look awkward, posed and static. But when balances are set up, it imparts a sense of rhythm and movement. Colour, shape and texture are the most obvious ways to achieve balance. A large, flat area of bright colour might be balanced by a smaller, more textured area, or by an area of similar colour but a different shape. Two small oranges could provide a balance for a larger melon, or a tiny human figure might work to balance a large building.

As you develop expertise, you will learn to link various areas of the composition by shape or colour so that it will be perceived as a unified whole rather than a collection of disparate parts. In a landscape, for example, a large tree in the foreground could be echoed by a similarly shaped but smaller one in the middle ground. Or colours can be echoed from one area to another – landscape painters sometimes bring touches of the sky colour into shadows.

The "Rule of Thirds"

Deciding on the ideal placement of elements in a composition can be difficult, but artists over the years have formulated various ways of arriving at compositions that satisfy many of the desired criteria. The most famous formula is the "Golden Section" devised by the mathematician Euclid. His formula divides any given area into two unequal rectangles, so that the ratio of the smaller rectangle has the same relationship to the larger one as the latter has to the whole. You can use a similar but simpler method, called the "Rule of Thirds". Divide the area of the composition horizontally and vertically into thirds. Then choose some (it doesn't matter which) of

VIEWING GRID
Make a grid to help you envision compositions by dividing the area into thirds. Cut a rectangle out of a stiff piece of cardboard. Stretch four thin rubber bands over it and position them over the opening so that they divide it into thirds.

these divisions and the points where they intersect, and position important elements on or close to them. This principle can be used to good effect for more or less any subject.

Visual editing

If you are painting a portrait or still life, you begin the composition process in advance by adding and removing things, bringing in different backgrounds and so on. You can't do this with landscapes, where any alterations must be made as part of the painting process. In this case, it is helpful to make a few preparatory drawings or "thumbnail" sketches to explore variations in cropping and format.

Decide whether an open or closed composition would be best for your picture. Open compositions hint at a world outside the confines of the picture, and you can let parts of objects go out of the frame at top, bottom or sides. Closed compositions hold all the elements within the frame. Open compositions are often used for landscape and flower paintings and can also be effective in human figure studies.

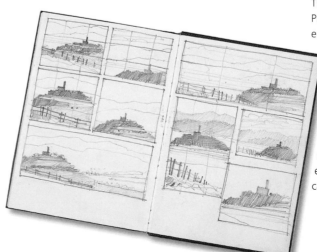

THUMBNAIL SKETCHES
Preparatory drawings enable you to work out several alternate compositions and object-placement variations prior to starting work on a final painting. They also serve as small drawing and painting exercises on which you can practise techniques.

Perspective

Using perspective to create the illusion of three dimensions on a two-dimensional surface is one of the great "tricks" artists use when painting. Italian artists in the fifteenth century formulated the rules of linear perspective. They are based on the optical effect of diminishing size – objects appear to decrease in size as they recede into the distance. In aerial, or atmospheric perspective, colours seem to become paler and cooler in the distance.

SINGLE-POINT PERSPECTIVE
As the name suggests, single-point perspective uses one vanishing point (VP), to which all perspective lines extend.

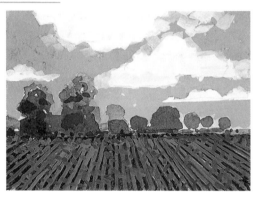

In this sketch of a ploughed field, a simple one-point perspective has been used to show the furrows running into the distance.

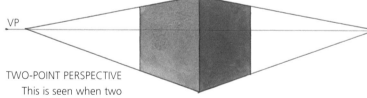

TWO-POINT PERSPECTIVE
This is seen when two planes of an object can be seen receding away from you toward two vanishing points.

This sketch of an old cottage demonstrates the use of two-point perspective to orientate the cottage and position its doors and windows. Remember: perspective should be used only as a guide; in reality, straight lines are not always straight.

Linear perspective

Although mastering the technique of linear perspective can be difficult, the basic rules are remarkably simple. Once you are comfortable using them, you'll be able to achieve images that are well constructed and spatially convincing. It is commonly thought that linear perspective applies only to geometric structures such as buildings. In fact, it affects every subject to some degree.

The main rule is: all receding parallel lines (real or imaginary) running in from the front of the picture meet at a point known as the vanishing point, located on a theoretical line called the horizon line. This rule arises directly from the concept of diminishing size, because as objects become smaller, so do the spaces between them, making the gap between the parallel lines shrink progressively until it disappears altogether.

In the context of perspective, the term horizon line is used very specifically. It is always at your own eye level and is thus affected by your position in relation to the subject. All perspective lines that begin above eye level will run down to meet the horizon line and vanishing point, while those that begin below eye level will run upward. Deciding on the horizon line by choosing the position of your eye level will have a major effect on your composition. If the horizon line is low in the frame, it will appear that you are looking up, while a high horizon will give the impression that you are looking down.

The vanishing point

The simplest form of linear perspective is single-point or one-point perspective, in which all the perspective

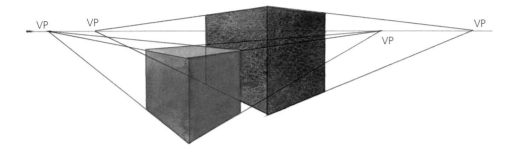

DIFFERING PERSPECTIVES
If two or more objects are positioned in such a way that, although on the same ground plane, they are oriented or turned in a slightly different way, each will have its own set of vanishing points and perspective lines.

lines meet at a single vanishing point directly in front of you. But if there are two receding planes running away from you at different angles, there will be two separate vanishing points, positioned to the left and the right of the subject. If there are several objects all orientated slightly differently, each will have its own vanishing point, but the vanishing points will always be on the same horizon line.

Aerial perspective

Aerial perspective is based on the optical effect that not only do objects become smaller as they recede, they also become hazier and less distinct, with little contrast of tone. This is caused by gases, moisture and tiny particles of dust in the atmosphere that draw a veil over more distant objects. Colours also become cooler and bluer, so that any warm colours such as reds, oranges and bright greens will only be apparent in the foreground.

This is especially important in landscape painting, as you don't always have convenient sets of receding parallel lines to help you create space. You will be able to suggest space to some extent by careful observation of the relative sizes of objects in the foreground, middle ground and distant background, but using aerial perspective will reinforce the effect. These effects can be seen even in relatively shallow space: A group of trees close behind a similar one in the foreground will be cooler in colour, with the tonal contrasts less obvious.

Sky perspective

Both linear and aerial perspectives can be seen in skies, a fact that is not always appreciated. The sky can be thought of as a bowl, with the rim meeting the far-off horizon. At this point, the clouds, being

very distant, will become much smaller than those directly overhead, merging into one another with little or no tonal contrast. Any visible clear sky will be considerably paler nearer the horizon, sometimes taking on a slight green tinge.

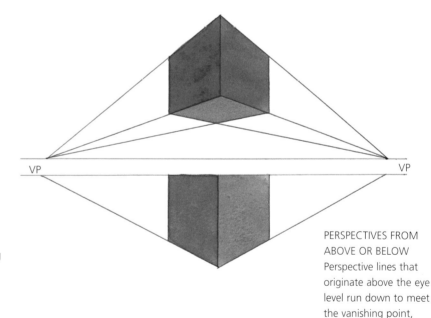

PERSPECTIVES FROM ABOVE OR BELOW
Perspective lines that originate above the eye level run down to meet the vanishing point, while perspective lines that originate below the eye level run up to meet the vanishing point.

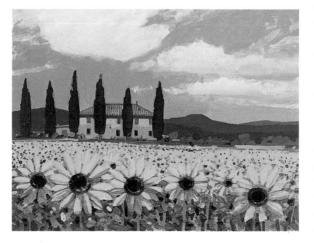

AERIAL PERSPECTIVE
In this illustration of aerial perspective, detail is more pronounced in the foreground, and colours are warmer. In the background, colours tend to become cooler, and detail and contrast are less evident.

Texture and pattern

The surfaces of objects are described and defined by three things – colour, tone and texture. Texture is an important component in composition. Both texture and pattern are powerful tools that you can use to lead the eye and draw focus. Careful use of textured areas is a good way to counterbalance areas of strong, flat colour or of intricate detail. Texture and pattern can also help to suggest form. Vary the texture you paint to suggest the bark on a tree. The texture should be less evident as the trunk curves away from the viewer. Alter the linear textures in a field of grass to depict how the ground rises and falls, or adjust the patterns on a fabric to show the effect that happens when it twists around a form and disappears into the creases and folds.

TEXTURE ILLUSIONS

Paint applied using the end of the brush

Brushstrokes

Sponge marks

Paint shaper marks

Spattering

Scumbling

Roller marks

Texture methods

Texture can be achieved in two distinct ways. The traditional method of representing textures is by using techniques and flat-paint effects to create the illusion of texture. In this respect, acrylic shares techniques with other "flat" painting media such as tempera and watercolour (and some types of oil painting): spattering, sponging, drybrush, scumbling and glazing (see the Techniques section, pages 30–75). The second way is to alter the physical properties of the acrylic medium so that the paint itself becomes the texture. Techniques that build the paint up in relief so that it can actually be felt include impasto with brush and knife, sgraffito, the use of texture and modelling pastes and collage treatments.

You can render smooth, reflective surfaces such as glass, steel, chrome and so on with smooth, fluid paint applied in thin washes or glazes, or by applying thick paint with fluid brushstrokes or floating it on with a painting knife. You could paint surfaces that are slightly pitted, but essentially flat, using spattering, scumbling or sponging techniques, or you could suggest the pitting by imprinting or stippling it in thick paint. Linear textures and patterns, as seen on fabric, a grassy field, a tree trunk, feathers or hair, might be painted using drybrush or sgraffito methods, or with thick impasto applied with stiff bristle brushes.

PHYSICAL TEXTURES

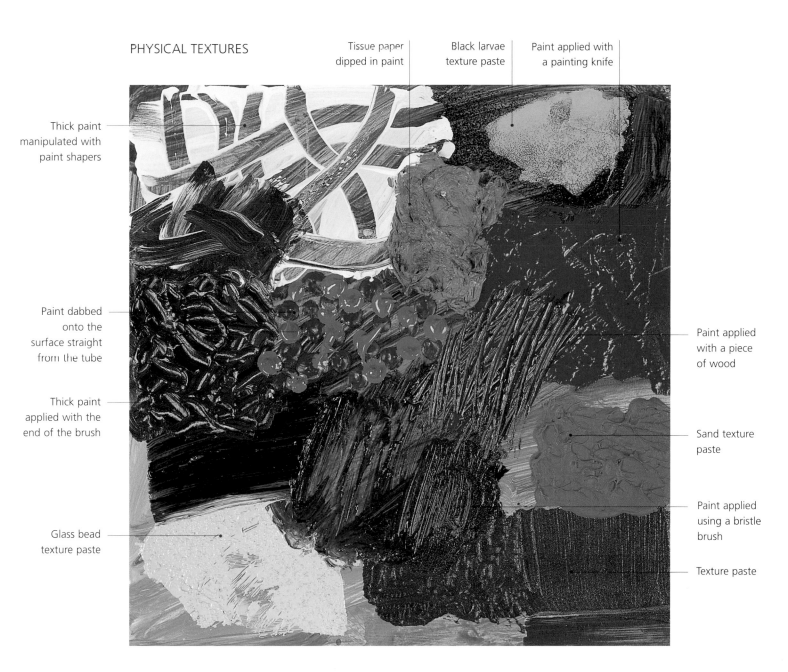

Thick paint manipulated with paint shapers

Tissue paper dipped in paint

Black larvae texture paste

Paint applied with a painting knife

Paint dabbed onto the surface straight from the tube

Thick paint applied with the end of the brush

Glass bead texture paste

Paint applied with a piece of wood

Sand texture paste

Paint applied using a bristle brush

Texture paste

Painting supports

The qualities of your chosen painting support will also influence the way that you work and the techniques used, and may contribute to the success (or failure) of the textures you are trying to depict. If you are planning to paint a landscape using expressive impasto brush- and knife-work, a heavy, coarse-woven canvas might be a good choice. It will hold the marks well, and the weave will show through in the thinner areas of paint, contributing to the effect. You might also use a rough paper to give surface texture to a work done largely in

wash techniques, as many watercolour painters do. It is worth trying out ways of enhancing the characteristics of various different painting supports. But don't forget that you can make your own textures when preparing the support by using knife- or brushmarks that will show through the applications of paint.

Light and tone

The exact tone and colour of an object depend entirely on the degree and quality of the light that falls on it. White light consists of the seven colours of the visible spectrum – red, orange, yellow, green, blue, blue-violet and violet – these colours are visible when light is passed through a prism. We can see any colour because the light waves that fall on a colour are either reflected or absorbed. A red object or surface can be seen because red light waves are reflected but other coloured light waves in the spectrum are absorbed.

INTRINSIC TONE
The intrinsic tone of the colours can be seen clearly in the black-and-white photograph, above, and in the tonal contrast of the lemons in the painting.

Tone

Tone (sometimes called value) in the context of colour simply means the lightness or darkness of a colour, regardless of its hue. Colour tone plays a vital role in describing form. The side of an object that is directed toward the light source will be lighter in tone than the side that turns away from the light, with a series of gradations in between these extremes. If the tonal values are placed in the correct order and position, the form will be clearly discernible, but if not, the form will be difficult, if not impossible, to see. All colours have an intrinsic tone. Yellow, for example, is light in tone, while Prussian blue is dark. Depending on the light source, even light-coloured objects will show considerable variations in tone; in shadowed areas, you may see little or none of the particular colour of the object.

You cannot have light without dark, and the brighter and more intense the light source, the denser and darker will be the shadows.

It is often necessary to simplify tones, and a useful exercise is to describe an object using only three tones. The limitations of our vision simplify tones to some extent. In reality, there are thousands of grey tonal values ranging from light to dark through a grey scale, but we are only able to discern a fraction of this number. However, we can still see a great deal of tonal variation, and trying to reproduce every nuance of tone could make your painting both dull and confused. It is best to start by analyzing the main lights and darks of subjects in a composition and then decide how many middle tones are needed to describe the various elements in individual objects and the picture as a whole.

Natural and artificial light

Because tones and colours are so closely dependent on the light source, you need to give it careful consideration. In studio conditions, the quality and direction of the light can be altered. When working on location, however, you obviously can't do much to change the light source. Most artists, given a choice, would prefer to work with natural light, but this can present problems since it changes constantly, unless you are lucky enough to have a room with windows that face north. North light (for those situated in the northern hemisphere) is the most consistent, regardless of the weather or time of year. Since this is not a choice open to everyone, artificial light is another option, as it is both consistent and infinitely controllable. Daylight-simulation bulbs are now readily available, and avoid using tungsten lights as they emit a warm yellowish colour.

Tonal contrast

The shift in colour tones from light to dark is known as contrast. A subject lit by very bright rays of light will show bright highlights and areas of deep shadows. The brightness will greatly eliminate middle tones and extraneous detail. Images painted in strong light with bright colours look crisp and clean, and often exhibit a distinct graphic quality and a strong sense of depth.

Subjects that are lit by a uniform but indirect source of light, such as that produced by an overcast day, can look flat, as there is insufficient tonal contrast to model forms and provide definition. Changes in both tone and colour also tend to be

USE OF LIGHT
Without directional light to supply a range of tones, objects resemble cutout shapes. Light creates the tones that show up the form.

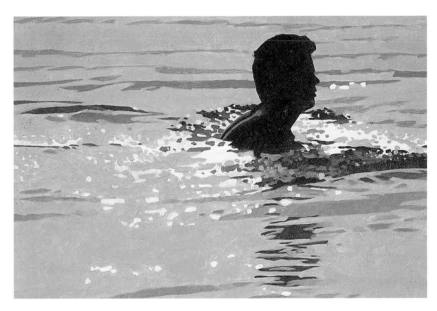

subtle. However, this kind of lighting can be effective in certain types of landscape painting.

The colour tone of a painting has an effect on the mood it creates. Bright paintings appear fresh and uplifting and generally "upbeat". They use a simplified tonal range at the lighter end of the scale, eliminating most if not all of the dark tones, and, typically, colours are bright but not strident. Bright-toned paintings are quite difficult to handle, as they can look slightly weak and insipid unless the colours and tones are chosen with care. Dark paintings create a more sombre mood. In these pictures, the darker end of the tone scale is used, middle tones are made darker than in reality and light tones are used sparingly.

LIGHT QUALITY
Mood as well as colour and tone is affected by the quality of the light. Here, bright light results in a crisp, clear image with a high contrast between the lightest and darkest tones. This helps to suggest a bright summer day.

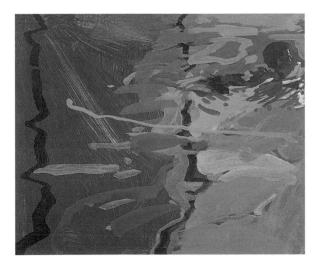

TONAL CONTRAST
Increasing the tonal range, especially through the middle tones, results in a low-contrast, subdued image suggesting dull weather with an overcast sky.

Projects

In this section, the materials and methods described in the first part of the book are put into practice. Ten inspirational paintings are explained in an easy-to-follow, step-by-step sequence that guides you through the techniques used and the picture-making process. All the materials required for each project are listed, and a *See Also* box refers you back to the "Techniques" section for more detailed information.

Fishing boats

Acrylic can be used in a similar way to watercolour, with the colours made lighter by diluting with water. As in traditional watercolour work, the painting is built up in a series of thin, semitransparent washes, with each new layer modifying or altering the one beneath. Most of the traditional watercolour techniques can be used, including sponging and dry brush. The advantage of using transparent colour is that the work is kept bright and fresh as long as you use only a few layers – three or four layers of paint at most.

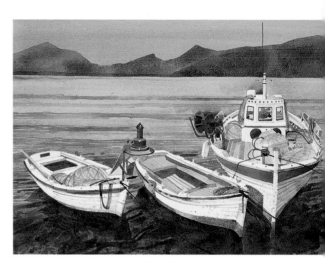

1 Plan the composition based on the "Rule of Thirds" (see p. 80). Arrange three fishing boats along the bottom third of the image, with the larger of the three boats taking up the space on the right-hand side. Run the distant coastline across the top third of the image. The eye should be drawn around the image in a circular motion.

You need to make a reasonably precise drawing as a guide to placing the first washes. It is not possible to make corrections once the paint has dried.

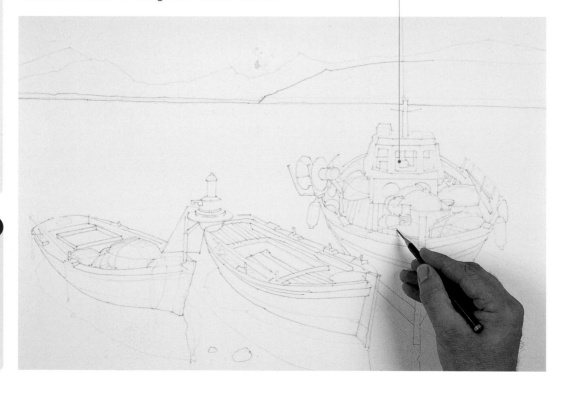

2 Apply a pale blue-grey mixture of ultramarine blue and Payne's grey on each of the boats using the No. 7 brush. Use this wash for the washed-out blue paintwork, the shadows cast by each boat onto its neighbour, and the dark interior of the left-hand boat. Slightly lighten the wash with water to paint in the shaded side of the large boat's wheelhouse.

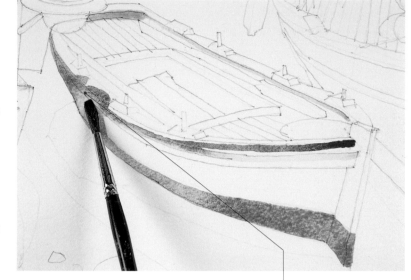

3 Mix raw umber and a little cadmium yellow with plenty of water to create a pale brown wash. Paint this onto the decks of the boats, the oars and the prow of the large boat.

While the washes are still wet, use a brush to drop in clean water to lighten areas.

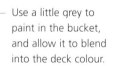

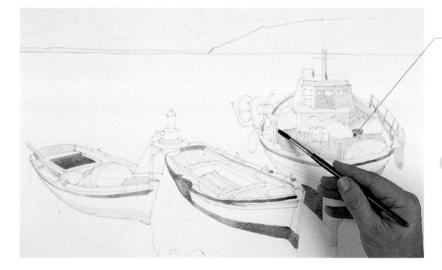

Use a little grey to paint in the bucket, and allow it to blend into the deck colour.

4 Add retarding medium to a mix of cerulean blue and ultramarine blue to slow down the drying time of the paint. Slightly tilt the board to help the colour flow down the paper. Paint the sky, taking the wash over the coastline and down into the sea. When mixing washes for large areas, always make sure to mix enough paint.

Work quickly and deliberately to take the paint around the shape of each boat. You will disguise any brush marks that are left in the sea area when you add the pattern of ripples and reflections.

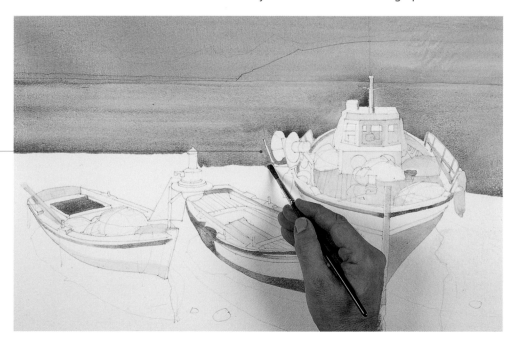

5 When the blue washes have dried, apply a band of cerulean blue to the side of the small boat on the left. Then mix the same blue with a little lemon yellow to provide a light green for the deck of the centre boat. Paint a cadmium yellow band along both sides of the large boat. For the one on the right, which is in shadow, darken the colour with the addition of a little raw umber. Paint the cadmium red band when these washes have dried.

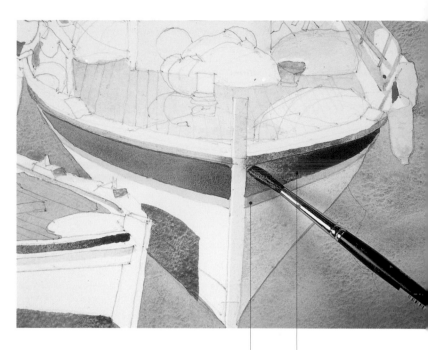

When painting precise areas of colour, make sure the surrounding areas of paint are dry or the colours will bleed into one another.

On the shaded side of the boat, darken the red mix with a touch of Payne's grey.

6 Mix a deep blue-green for the oar and shadows on the deck of the middle boat. Make a "black" by mixing raw umber and Payne's grey, and use this to paint in the dark interior of each of the small boats and the huge lamp on the prow of the left-hand boat.

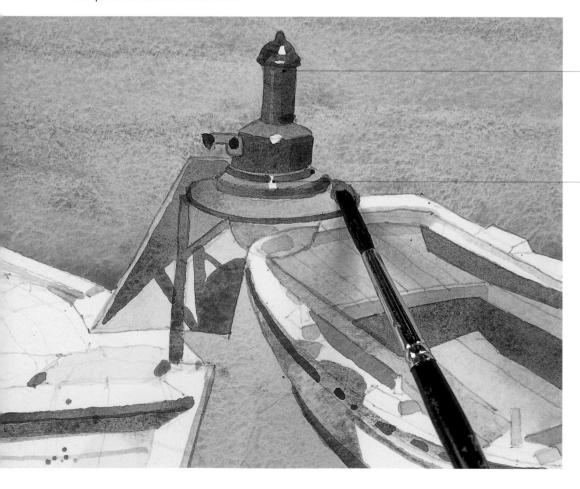

Allow each tone to dry before applying the next one wet-on-dry.

Allow the white of the paper to show through to create the highlights on the side of the lamp.

7 Begin the details on the large boat next. Paint the winding gear with a mix of ultramarine blue and Payne's grey. Mix raw umber and a little of the previous "black" mix for the anchor and the window surrounds. Use a diluted version of the same colour for the boards that run down the deck. Paint the interior of the wheelhouse with a range of blue-greys.

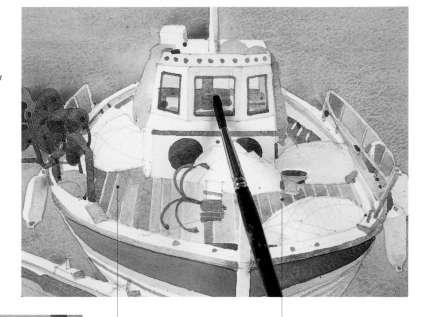

8 Block in the piles of fishing nets with mixes of yellow ochre, cadmium yellow and cadmium red.

In order to suggest the weathering and general wear and tear, vary the tone of the colour for the deck planks.

Use perspective when filling in decking to add to the illusion of depth.

Keep these mixes bright because the colour will darken when detail is added.

9 Paint the main ropes with a dark orange mix, made with raw umber and cadmium red. To suggest the weave of the netting, use the dry-brush method. Dip the bristle fan brush into the paint and brush it over a paper towel to remove most of the paint, leaving just enough to produce broken brush marks that catch only on the top grain of the paper.

The dry-brush strokes should follow the contours of the net pile, suggesting form as well as texture.

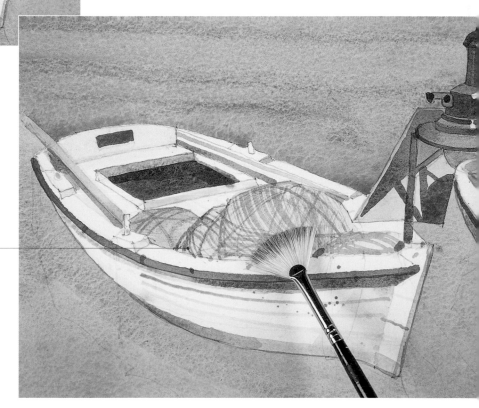

10 For the distant coastline seen through the heat haze, mix cerulean blue, ultramarine blue and Payne's grey with plenty of water to create a dull blue.

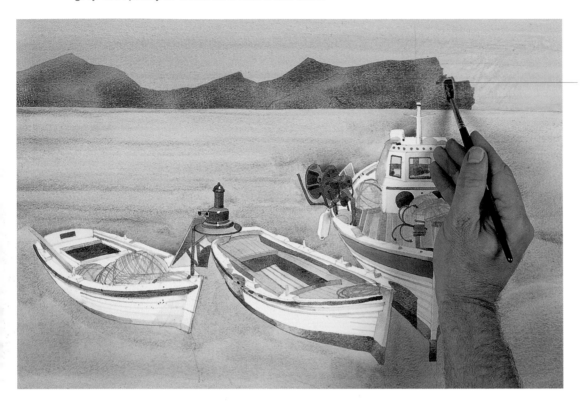

Allow the colour to puddle here and there so that it dries slightly darker in places.

11 Use the same mixture to paint in a band of deeper colour at the very edge of the coast. Approximately halfway across the image allow the wash to open up to represent the nearest part of the landscape – rather than using a solid brushstroke, use dabs of the same wash colour to represent trees and other details at the water's edge.

Adding a little detail to the area where the land meets the sea brings it forward in space.

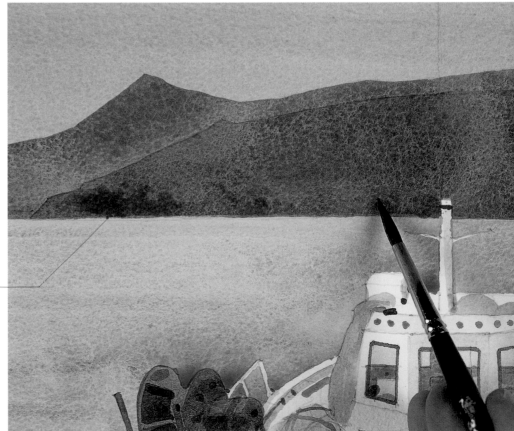

12 Now paint the sea, with a little ultramarine blue and lemon yellow mixed into a pale cerulean blue wash. Build up the waves in a series of horizontal bands, beginning in the middle distance and working toward the front of the picture.

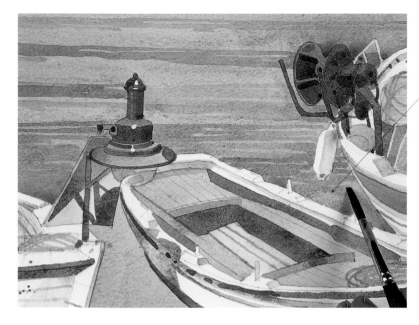

Give the waves perspective by making them slightly larger as they approach the foreground.

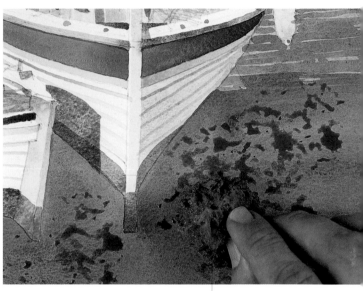

13 Once the washes for the sea are dry, add texture and detail to the area of water in the foreground around and beneath the boats. Use a small natural sponge for this, dipped into a blue-green mix of ultramarine blue, viridian and a little raw umber.

The sponge will make a better mark if it is thoroughly soaked with water and then squeezed dry before you dip it into the paint.

14 Allow the sponge marks to dry so that the definition remains crisp, and apply the same colour with the brush to suggest the darker ripples and the dark shadows beneath the boats. Pull the wet paint out of the shadows into the ripples, and drop in more paint to create a puddling effect.

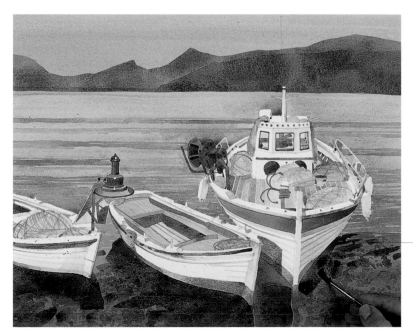

When you apply the blue pigment as a thin wash, it tends to granulate, which creates added interest.

15 When the previous washes are dry, add a touch more ultramarine blue and Payne's grey to the mix to paint in the swirling pattern of ripples and reflections around each boat.

Once the shadows are in place, the boats appear to sit on the surface of the water, adding to the sense of weight.

16 Suggest the texture of the weathered painted hulls of the boats by spattering thin paint from the end of a stiff bristle brush. Mask surrounding areas with newspaper to prevent spattered paint from spreading where it is not wanted.

Hold the brush between your thumb and middle finger and use your forefinger to flick paint from the brush.

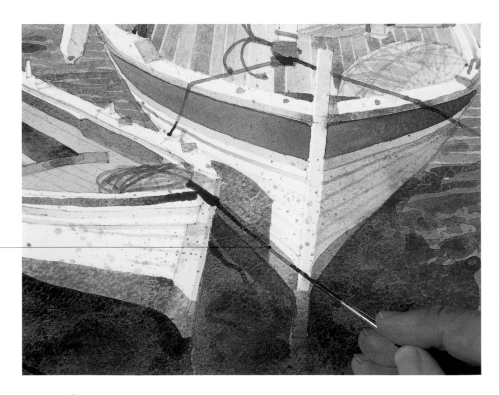

17 To paint the jumble of ropes on each boat and those that secure the boats to the dockside, use the dark mixture of Payne's grey and raw umber, working with the thin, round, long-haired rigger brush.

The rigger brush was invented for painting the rigging of sailing boats, hence its name.

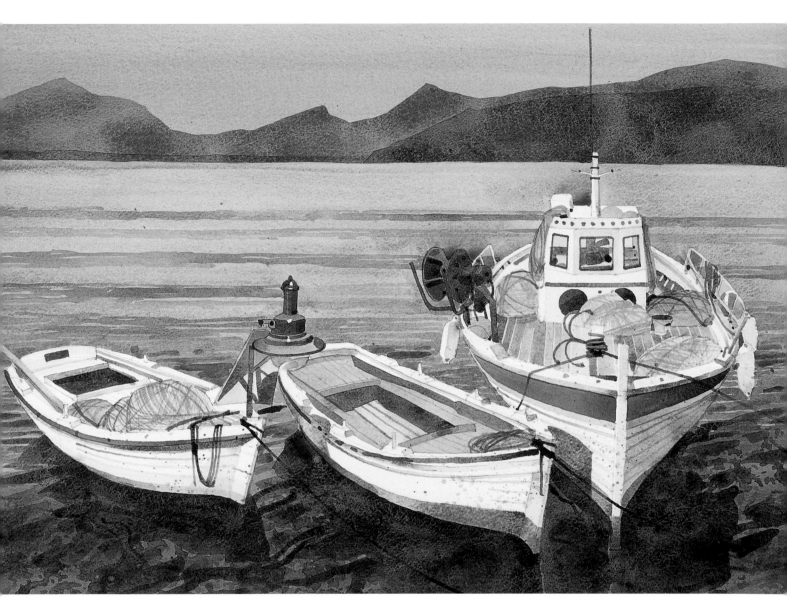

The Finished Painting: Watercolour techniques are excellent for capturing this calm but colourful image of boats in a small Mediterranean harbour. The combination of wet-in-wet and wet-on-dry techniques, coupled with the use of aerial and linear perspective, give the scene a convincing sense of depth and distance, while the tight composition keeps the attention firmly focused on the boats.

Portrait of a young girl

colours and mediums

1 Lemon yellow
2 Cadmium red
3 Raw umber
4 Cadmium yellow
5 Burnt umber
6 Payne's grey
7 Alizarin crimson
8 Yellow ochre
9 Ultramarine blue
10 Dioxazine purple
Acrylic gloss medium

The glazing technique (see p. 38) is an especially useful method for the delicate and elusive tones and skin colours seen in this portrait. Many of the principles are similar to those used in the watercolour-wash technique shown in the previous project, but glazing is best carried out on a harder, less absorbent surface than watercolour paper, and the paint is usually thinned with matt or gloss medium rather than water. You can use glazing techniques by themselves or to modify and develop previously applied colours, which can be of thick or medium consistency.

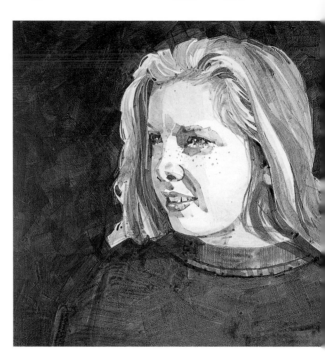

1 Make a careful pencil drawing first. Position the figure slightly to the right but looking across to the left, presenting a three-quarter view of the face, a classic pose in portrait painting.

materials

MDF board prepared with white acrylic gesso, 300 x 300 mm (11 x 11 in.)

H pencil

14.6 mm and 19.5 mm flat sable brushes

Rigger (small, round, long-haired) brush

see also

Preparing supports, page 32
Mixing colour, page 34
Glazing, page 38
Light and tone, page 86

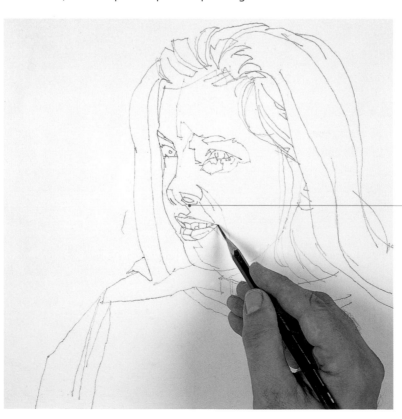

If the lines are too dark, lighten the completed drawing either by using an eraser or by applying another coat of gesso.

2 Apply the glazes dark over light as in watercolour work. Do not use white paint because this will compromise the transparency of the colours. Dilute the paints with clean water and acrylic gloss medium. First establish the basic skin colour with a light pink mixed from lemon yellow, a little cadmium red and a little raw umber. Then add a little more yellow into the mix for the hair.

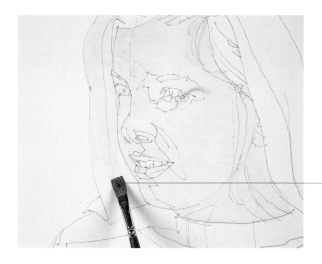

Use a sable brush to apply flat colour without too many brush marks being evident.

3 When the first glazes are dry, apply a second one to the hair, using the same colours as before but with more raw umber and cadmium yellow to make it slightly darker.

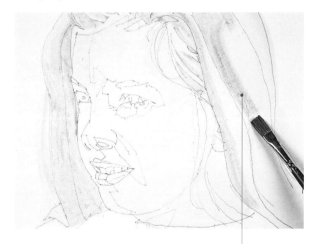

Use the brush to carefully follow the contours of the hair.

4 Mix a slightly darker skin tone using lemon yellow, a little raw umber and cadmium red, and work it around the highlight areas to begin to define the shadows.

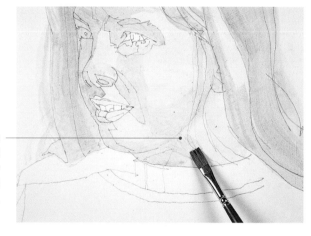

Make the glaze very fluid, and apply it quickly to help avoid brush marks.

5 Darken the hair colour again by adding burnt umber, and apply this to the darker areas of the hair, using the shape of the brush to follow the fall and contours of each section. The glaze may puddle slightly to produce small variations in colour, but such accidental effects can be quite useful.

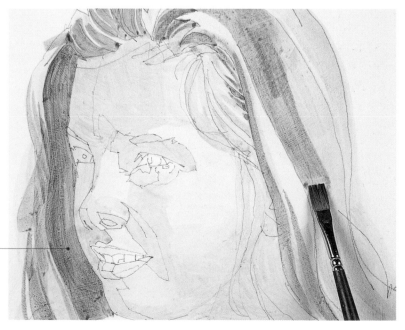

Use the contours of the hair to give shape and depth to the head and face.

6 Define the facial features, starting with the darks of the eyes, the nostrils and the darkest areas within the mouth. Use a rigger brush and a relatively opaque mixture of burnt umber and Payne's grey with a touch of alizarin crimson.

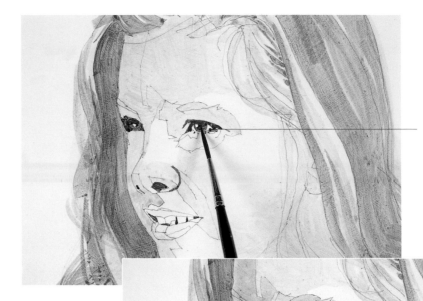

Allow the clean white of the gesso to show through to represent the sparkling highlight seen in each eye.

7 Apply more shadows to the face to build up the forms, using the 14.6 mm flat sable brush and a darker skin colour – burnt umber with a little alizarin crimson and yellow ochre added. Paint in the areas in deep shadow around the eyes and on the left of the face and also the shadow that runs from the side of the nose down to the side of the mouth, the shadows beneath the chin and the cast shadows on the neck.

Avoid brush marks by applying the paint with clean, precise strokes of fluid paint.

8 Add a little more alizarin crimson and a touch of ultramarine blue to the mix to repaint the dark area around both eyes and on the side of the nose and mouth. To create a dusty pink for the lips, make a mix of cadmium red, yellow ochre and a little raw umber, and apply it with the rigger brush. Add a touch of Payne's grey, thinned with plenty of water, and use it to dull the whites of the eyes and paint in the teeth.

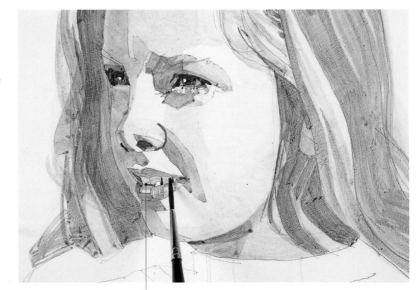

Create highlights on the teeth and lips by allowing patches of lighter paint to show through.

9 Add detail to the eyes using the dark mix used in the previous step – suggest the eyelashes, and lightly dot in freckles over the bridge of the nose.

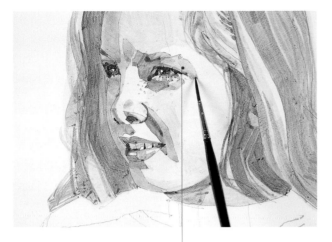

As you add detail, the eyes become increasingly alive.

10 Mix ultramarine blue with Payne's grey for the girl's sweatshirt, and apply it with the 14.6 mm flat brush, making multidirectional strokes.

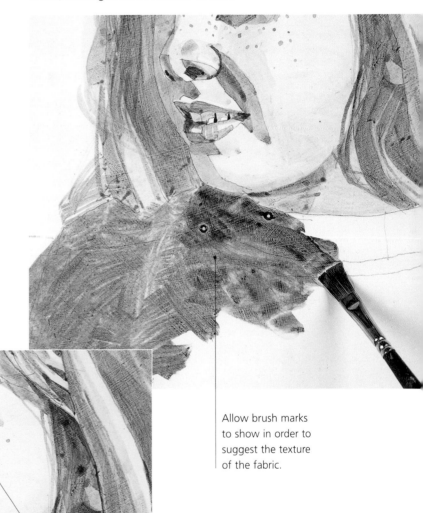

11 To give further definition to the face, make a mix of dioxazine purple and raw umber and darken the shadow area at the inner corner of the eye. Build up detail on the lips with a slightly subdued red made from cadmium red, cadmium yellow and a little raw umber.

Allow brush marks to show in order to suggest the texture of the fabric.

The cooler shadow at the corner of the eye pushes the area back in space, giving a sense of depth and accentuating the contours of the nose.

12 For the background, make a dark brown mix of Payne's grey and burnt umber and apply it with the 19.5 mm flat brush, cutting the colour carefully around the head and hair. Once dry, apply a second coat to consolidate and darken the colour.

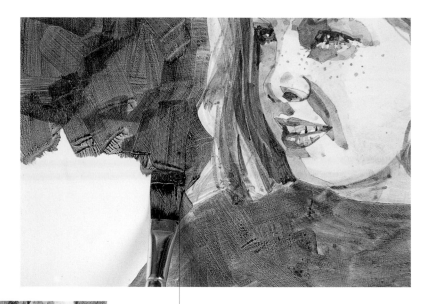

13 Deep blue is needed for the shadows and detail on the sweatshirt. Mix ultramarine blue and Payne's grey and apply it with the 14.6 mm flat brush. Use the rigger brush to paint in the darker seams.

Use the brush to redraw the shape made by the hair.

Even a little detail on the sweatshirt prevents it from reading as just a flat blue shape.

14 Finally, paint in the ribbing around the neck of the sweatshirt using the dark blue of the previous step diluted with more water.

A series of parallel lines and a few small marks are all that is needed to describe the neck of the sweatshirt.

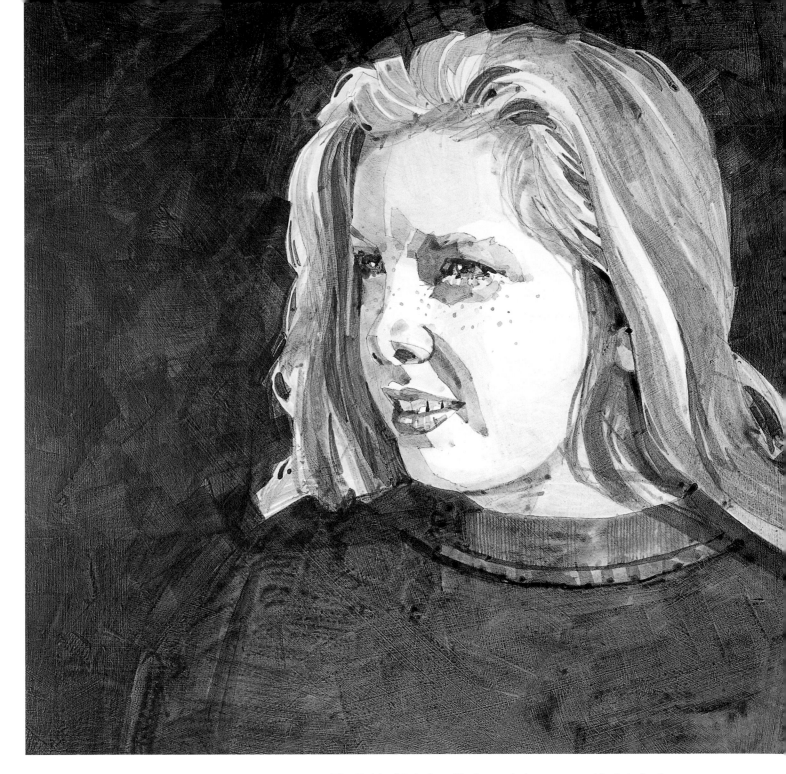

The Finished Painting: Glazing techniques are an ideal choice for portraits, especially of children and young people whose faces are smooth and unlined. There is a danger of making the applications of paint too smooth, which can easily make for a bland, uninteresting result, but here there is sufficient texture in the background, clothing and hair to provide a rich and interesting paint surface.

Sunflowers

colours and mediums

1 Cadmium yellow
2 Raw umber
3 Cadmium red
4 Burnt umber
5 Alizarin crimson
6 Payne's grey
7 Ultramarine blue
8 Yellow ochre
9 Titanium white
10 Pthalocyanine green

Applying thick paint over thin is a classic technique usually used when working with oil paint in order to prevent cracking as the oil dries. It is also a prudent way of working with acrylic paint. The technique is simple and straightforward and allows the basic design and colours to be correctly established before thick paint is applied. This prevents wasting paint through having to scrape it off to allow for corrections, and increases the visual depth and intensity of the colours used.

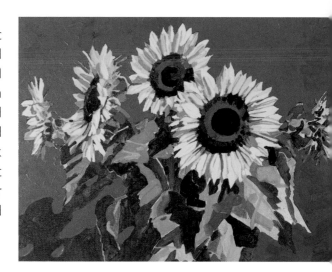

materials

Canvas board
407 x 508 mm (16 x 20 in.)

Black conté pencil

6 mm and 14.6 mm flat bristle brushes

Small, flat, chisel-like brush

Matt medium, gel medium

see also

Mixing colour, page 34
Opaque techniques, page 40
Impasto, page 42

1 Position the subject centrally on the support with the flowers arranged to achieve a loosely triangular composition. Use a black conté pencil to sketch the flowers; it leaves a clear line and is slightly cleaner to use than charcoal. If you make a mistake, the pencil can be erased using a conventional eraser and redrawn.

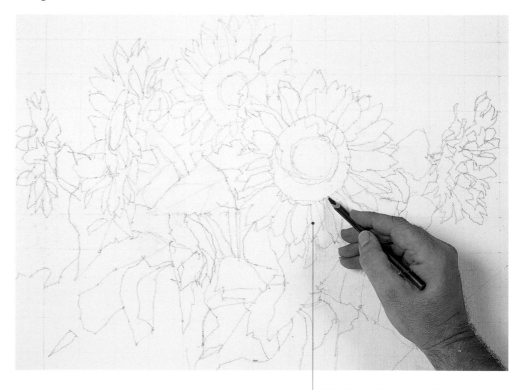

Working with a reasonably precise drawing keeps the work on track and lets you concentrate on colour and brushwork.

2 Make a deep orange mix of cadmium yellow, raw umber and a little cadmium red thinned with a little water and matt medium. Use a 6 mm flat bristle brush to block in the mid-tone dominant colour on the petals and seed heads of each sunflower.

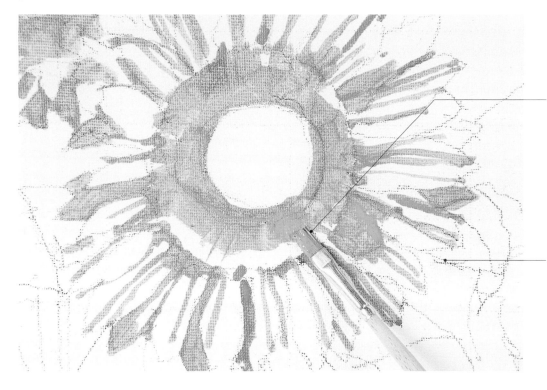

Turn the brush onto its side and apply the paint with the thin edge to create fine fluid lines.

The drawing acts only as a guide and is gradually concealed as paint is applied.

When working in a small or confined area, angle the brush so that the thin edge or a corner applies the paint.

3 Apply cadmium yellow straight from the tube and thinned as before. Using the 6 mm flat bristle brush, begin to paint the sunflower petals, working around and between the deep orange previously applied.

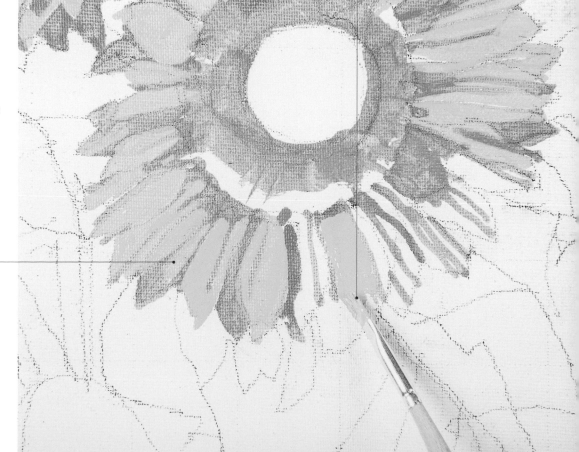

Use fluid, angled brushstrokes to work the bright yellow paint into the shape of the petals surrounding each seed head.

4 Put in the rich orange-brown colours of the central seed heads using thin mixes of burnt umber, cadmium yellow and a little alizarin crimson. To create darker mixes, add Payne's grey and more alizarin crimson.

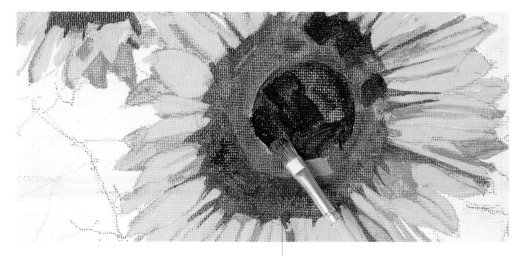

Use sweeping brushstrokes to block in each seed head, but take care when painting the colour changes created by the fall of the light.

5 Once you have established the flower heads, turn your attention to the stems and foliage. Block in the medium green areas using a mix of ultramarine blue and yellow ochre. Take care to leave the areas of light and the areas around each leaf clear.

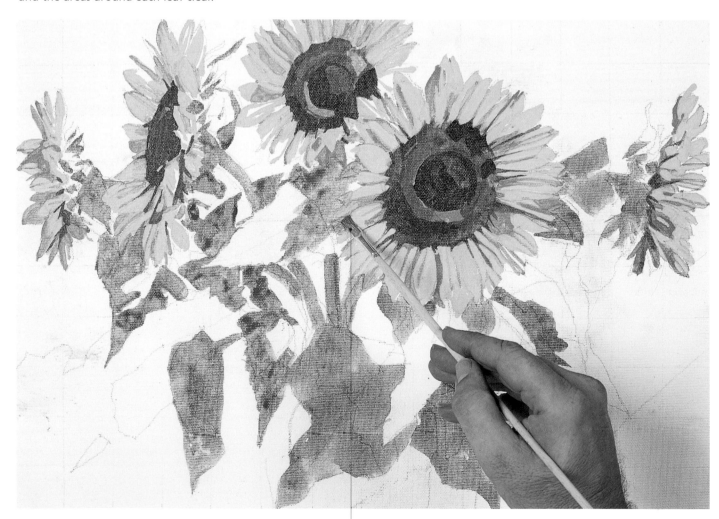

Use a small, flat, chisel-like brush to create the sharp, pointed, angular shape of the leaves.

6 Next, using the same mix of ultramarine blue and yellow ochre lightened with titanium white, paint in those areas of foliage that catch the light. Then, block in the dark grey-green background with a mix of pthalocyanine green, alizarin crimson, Payne's grey and a little yellow ochre. You will notice immediately how the background colour lifts the flowers forward in space.

A larger (14.6 mm) flat bristle brush will quickly cover the rest of the background with paint.

Use the 6 mm flat bristle brush to cut carefully in and around the yellow petals, redrawing and redefining their shape if required.

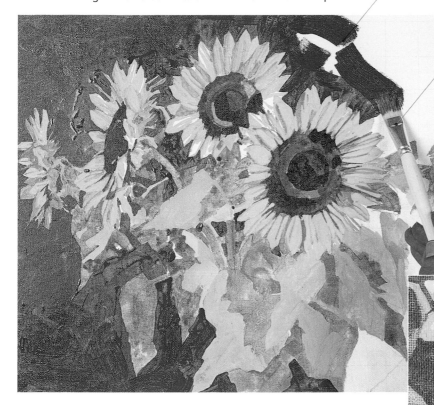

7 Once you have established the image, you can introduce detail and texture by adding gel medium to your mixes. The more gel you add, the thicker the paint will be.

8 Strengthen and define the pattern on each of the seed heads with various brown and orange mixes of cadmium red, cadmium yellow, burnt umber, alizarin crimson and Payne's grey.

Work wet-in-wet with direct, confident brushstrokes to create thick dabs and swirls of colour.

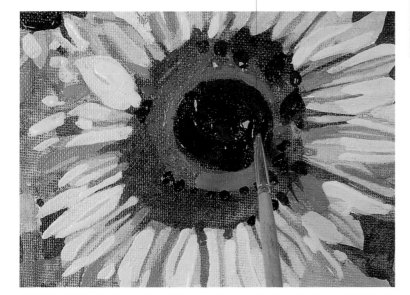

Use cadmium yellow mixed with a little cadmium red and the dab-and-flick technique to redefine the darker yellow petals. Indicate the deep orange gaps at the base of the petals with a vivid mix of cadmium yellow, cadmium red and burnt umber.

For the light yellow, sunlit petals, add titanium white to cadmium yellow and go in with the angled tip of the 6 mm flat bristle brush.

9 To indicate those areas of leaf in shadow, use dark green mixes of pthalocyanine green, Payne's grey and a little alizarin crimson. If the colour is too dense in areas of leaf hit by the light, or in the short, pointed layers of foliage at the base of the flower heads, you can create highlights by adding yellow ochre and titanium white to your mixes.

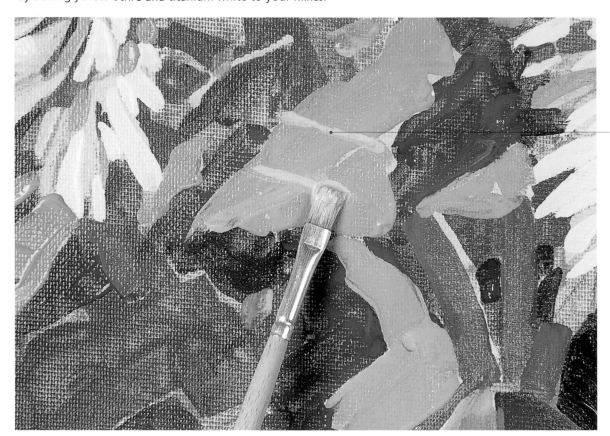

Use confident, fast strokes of light green worked across the wet paint to suggest the veins in the sunflower leaves.

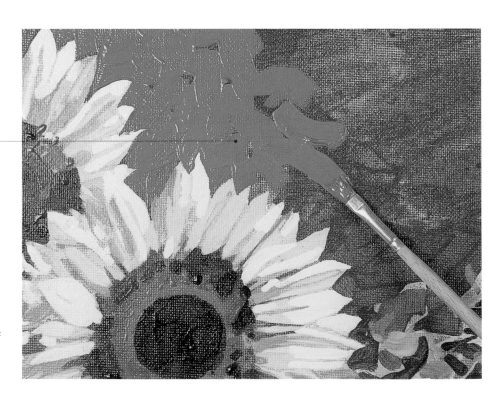

Build up a random pattern of brush marks by varying the direction of each stroke.

10 Finally, deepen and consolidate the background colour using grey-green mixes of pthalocyanine green, Payne's grey, alizarin crimson, yellow ochre and titanium white. Use plenty of gel medium to ensure that each brushstroke keeps its shape.

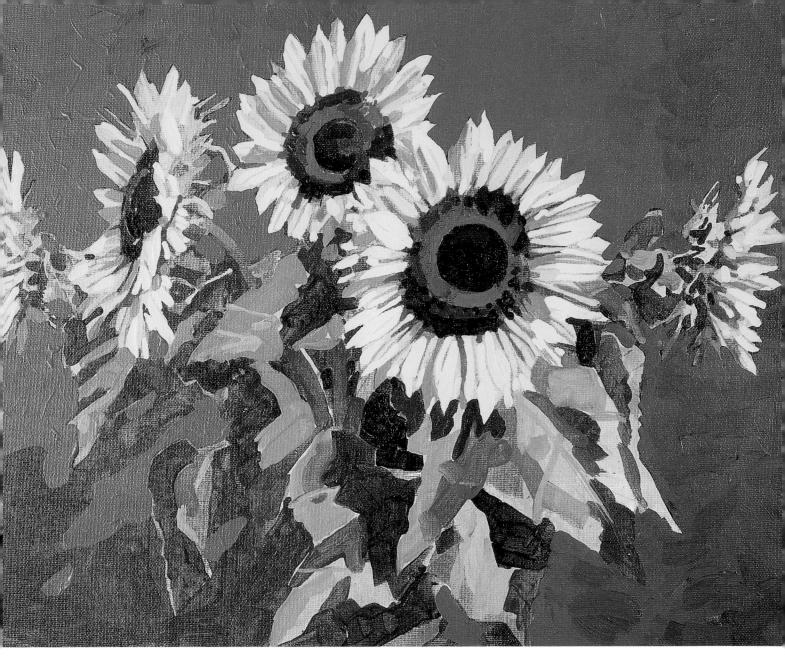

The Finished Painting: The sunny, impressionistic mood of the subject is accentuated by direct, confident brushwork and bright, simple colour mixes. The straightforward use of dark, medium and light tones throughout gives the picture a convincing sense of depth. Although the painting is finished, it could easily be reworked by adding thicker layers of paint, making the brushwork still more evident.

Winter trees

colours and mediums

1 Payne's grey
2 Titanium white
3 Viridian
4 Burnt umber
5 Cadmium yellow
6 Raw umber
7 Cadmium red
8 Cerulean blue
9 Ultramarine blue
Acrylic matt medium
Retarding medium

materials

Linen canvas primed with acrylic gesso, 407 x 508 mm (16 x 20 in.)

14.6 mm flat bristle brush

14.6 mm flat synthetic brush

see also

Mixing colour, page 34
Opaque techniques, page 40
Composition, page 80
Light and tone, page 86

The tangled branches and weathered bark of trees seen in winter sunlight offer the ideal opportunity to work quickly by applying opaque paint over a loosely applied monochromatic brush drawing. This acts as an underpainting and allows you to establish the tonal balance rapidly before applying colour. It effectively speeds up the painting process and is an especially useful technique for transient effects, such as weather conditions or shadows.

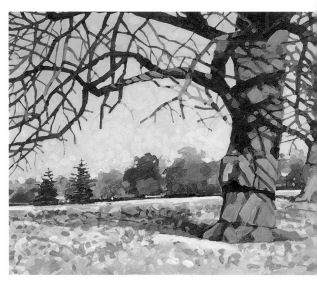

1 Throughout this project, mix a small amount of matt medium with all your colours. Make a rapid brush drawing using the 14.6 mm flat bristle brush and Payne's grey, diluted with water, to establish the composition. Place the dominant tree over to the right-hand side approximately one-third of the way in from the edge of the image, and allow the branches to tumble across the top third of the picture space, with the foreground and the row of trees in the middle distance occupying the lower third.

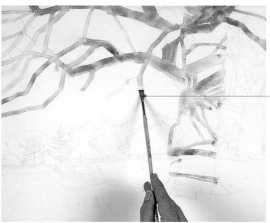

To prevent a premature buildup of paint and to speed up drying, use relatively thin applications of paint in the underpainting.

2 Establish the elements across the middle distance and the foreground in the same way, applying the paint quickly and loosely.

If the thin paint forms puddles or runs down the surface, thicken the mixture slightly.

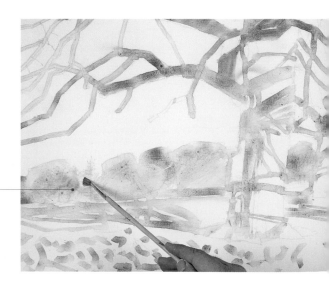

3 Gradually darken the tones to provide a tonal framework for the applications of colour. When using this method, don't be concerned if the overall range of tones appear lighter than in reality. You can continue to deepen and extend the range of the underpainting until you are happy with it.

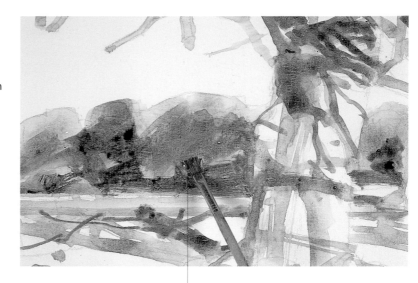

4 Use undiluted titanium white to make alterations and adjustments to the image, but take care not to build up the thickness of paint too quickly.

Increase the depth of tone by adding darker washes.

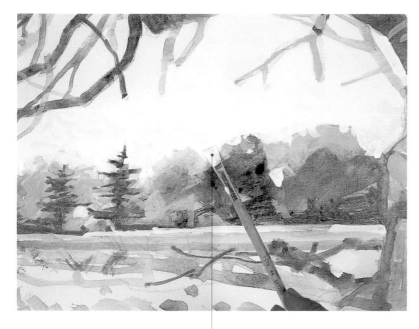

5 Now apply the colour. Use some retarding medium with all colours from now on to keep the paint moist, and work in lighter paint to blend with the first colour wet-into-wet. Paint the bank of trees first with the 14.6 mm flat synthetic brush and mixes of viridian, burnt umber and Payne's grey. Modify and lighten these dark greens with the addition of cadmium yellow and titanium white.

White has greater opacity than most colours, enabling you to make corrections easily.

Mix the paint to a creamy consistency and use precise, short brushstrokes that follow the contours of the trees.

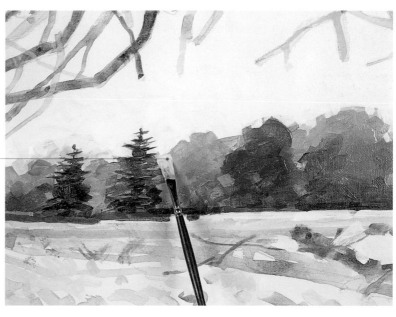

6 Paint the foreground next. Add a little of the previous green mixture to a mix of cadmium yellow, raw umber and white, and apply it across the image just below the tree line and intermittently across the foreground and between the trees. To establish the colour of the dried leaves on the ground, mix a dull orange from cadmium yellow and cadmium red, lightening it with white and subduing it with raw umber as necessary.

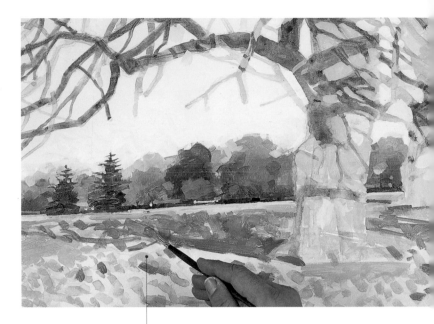

7 Build up the foreground with more of the mixes made from raw umber, cadmium yellow and white, rapidly applied using short, multidirectional brushstrokes with the synthetic brush.

When building up the leaf-strewn ground, vary the direction and length of the brushstrokes.

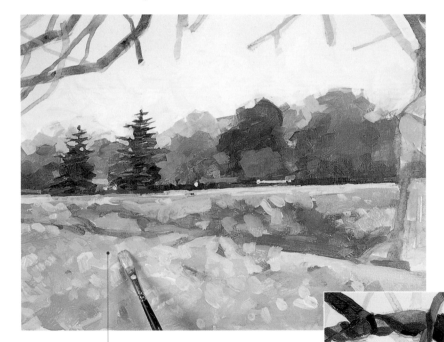

For thick lines, apply the paint with the flat end of the brush; for thinner lines, use the side or end of the brush.

Allow each brushstroke to retain its identity by avoiding overbrushing the paint.

8 Begin work on the foreground trees. First rework the dark shadows, using a dark brown mix of Payne's grey and burnt umber, making angled brushstrokes that follow the contours of the shapes.

9 Now that the position of the cast shadows have been established, block in the rest of the trees using a range of browns mixed from raw and burnt umber, cadmium yellow and titanium white.

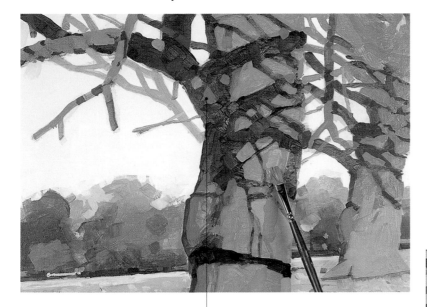

Use a combination of slightly different brown mixes to indicate the form and texture of the surface.

The tangled network of crossing branches begin to stand out as the spaces in and around them are painted.

10 For the sky, mix a pale blue from cerulean blue, a small amount of ultramarine blue and plenty of white. Take the colour carefully around the tree branches. These "negative shapes" play an important part in defining the positive ones and allow you to redefine the position of the branches, if necessary. This negative-painting method takes longer than painting the branches over the sky but achieves quite a different effect.

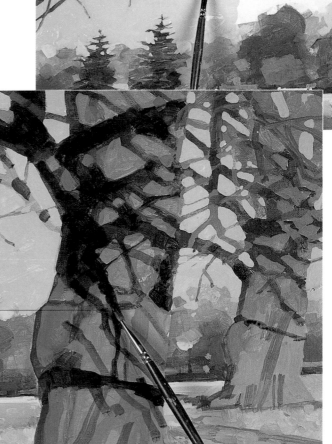

11 Now return to the dark shadows cast across the main trunk and branches of the trees, using a mix of ultramarine blue and Payne's grey to deepen and cool the colours.

Use a fairly stiff mix and scumble the paint over the existing shadows (see *Scumbling*, p. 60).

12 Lighten the brown mixtures used in step 9 to repaint the light-struck areas on the trunk and branches of the tree. Keep the brushstrokes loose and allow the darker paint to show through in places.

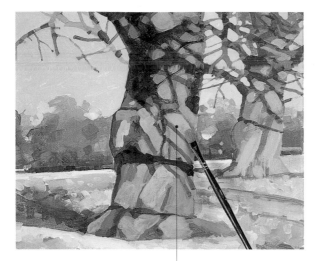

13 The area beneath the tree is scattered with dry leaves, broken twigs and fallen branches. Add these details by using a range of dull green and light brown mixes similar to those initially used for this area.

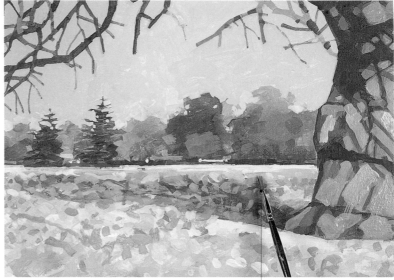

The pattern of lines left by the fibres of the brush echo the pattern of the bark.

14 Repaint the sky with a slightly lighter mix of the original cerulean blue, ultramarine blue and white.

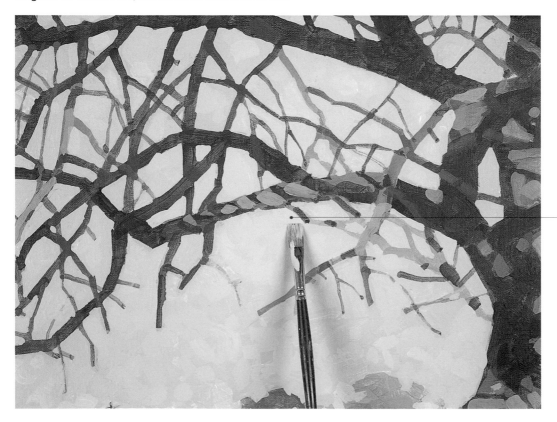

Use the end, the edge, and the tip of the brush in order to vary the shape and size of the marks that you make.

Repaint the sky using multidirectional open brushstrokes to allow the previous slightly darker colour to show through.

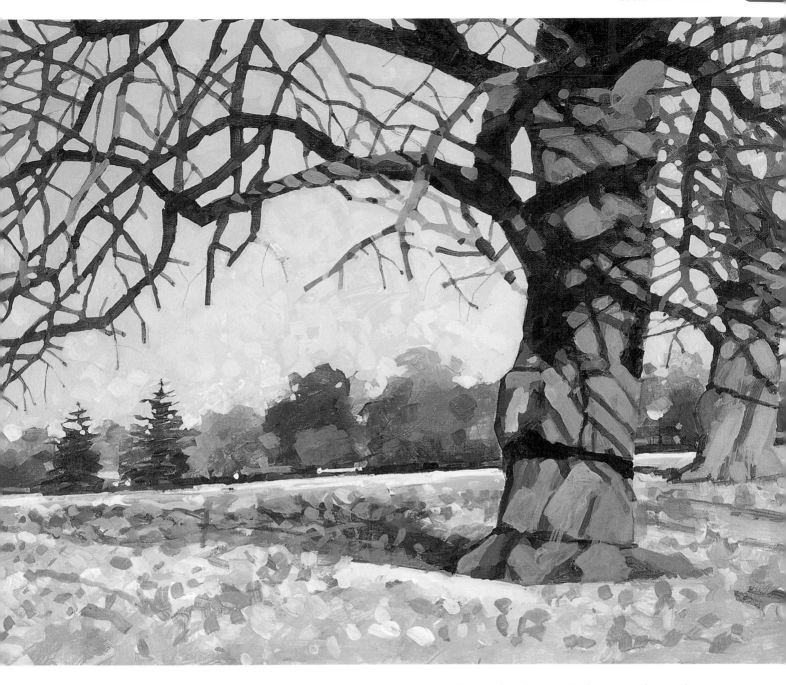

The Finished Painting: The tonal underpainting has created a good foundation on which to build the image, and the short, direct brushstrokes create an impressionistic effect that suits the scene very well. If you are painting on location in changing weather conditions, this technique allows you to achieve a finished image relatively quickly.

Fruit and vegetables

colours and mediums

1 Raw umber
2 Yellow ochre
3 Titanium white
4 Payne's grey
5 Burnt umber
6 Viridian
7 Cadmium yellow
8 Cadmium red
9 Alizarin crimson
10 Cerulean blue
Retarding medium

1	2	3	
4	5	6	
7	8	9	10

materials

Canvas board
407 x 508 mm (16 x 20 in.)

6B graphite stick

Masking tape

24 mm foam brush

Stiff cardboard

Craft knife

Natural sponge

Large and small trowel-shaped painting knives

Fixative

One of the many joys of acrylic paint is that it can be applied with many tools other than traditional brushes. This can bring new and exciting qualities to an image as well as exercise your creativity and allow you to have fun with your paint. It is also a useful way to freshen up a painting that has lost its way or become overworked using traditional methods.

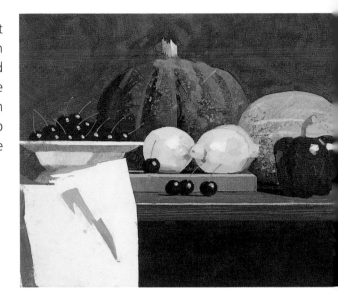

1 Plan the composition based on a squashed triangle, with the stalk of the melon at the apex and the tabletop at the base. Sketch in the main elements using a 6B graphite stick and concentrating on the outlines of the shapes.

Once the drawing is complete, give it a spray of fixative to prevent it from being smudged and erased as you work.

2 Before you begin to apply paint, use the tape to mask out the areas that are to remain white. This includes the white napkin and the lip of the bowl holding the cherries.

The hard surface of the canvas board makes it possible to trim the masking tape once it is in place.

3 Mix raw umber, yellow ochre and white to create a dull yellow-brown for the background and table, and block in these areas with the 24 mm foam brush. Use the same brush and a mixture of Payne's grey and white to paint the dish holding the cherries. Then add the dark area beneath the table with a mix of Payne's grey and burnt umber.

Use the straight edge of a piece of scrap paper as a mask to keep the dark paint off the edge of the table.

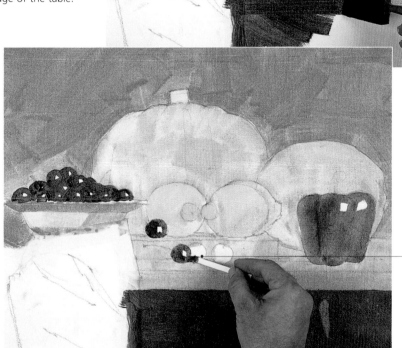

4 Mix a pale green from viridian, cadmium yellow and raw umber and block in the two melons. Use cadmium yellow for the lemons and cadmium red mixed with burnt umber for the red bell pepper. For the cherries, make a deep red using cadmium red and alizarin crimson darkened with a little burnt umber and Payne's grey, and apply it with a small 24 mm strip of thick cardboard.

If the end of the cardboard becomes too wet and soft as you work, simply cut it off and continue with the dry piece.

5 Make a deep green by mixing viridian, cadmium yellow and raw umber, and add a little retarding medium to slow down the drying time. Use a wedge of cardboard to apply this colour to the dark areas of the melon. Then add more cadmium yellow, a little raw umber and titanium white to lighten the green and apply it in the same way, working it over the light-struck area of the melon's surface.

Use the end and edge of the cardboard wedge to scrape back into the paint, suggesting a pitted and marked surface.

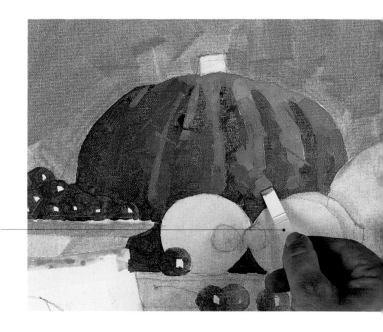

6 Allow the paint for the melon to dry before lightening the green again with more cadmium yellow, raw umber and white. Apply this with a small piece of natural sponge, wetting it first and squeezing out the excess water – a damp sponge holds more paint than a dry one.

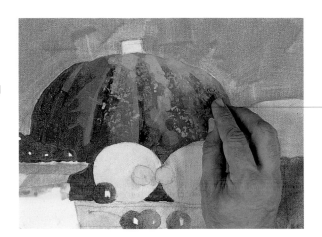

A small piece of sponge is easier to manipulate than a large one.

7 To consolidate the colour of the smaller melon, mix a light green starting with white and adding a little viridian, raw umber and cadmium yellow, and Payne's grey with just a touch of cerulean blue. Paint the pattern on the melon by using a 25 mm-wide wedge of cardboard to pull the pale colour across the form in three or four shallow arcs.

8 Still working on the smaller melon, use the sponge to add a little dark green texture between the lemons and the red pepper. Mix cadmium yellow with titanium white and raw umber to create a range of yellows to paint the lemons, add retarding medium and apply the colours with a small trowel-shaped painting knife and a wedge of cardboard.

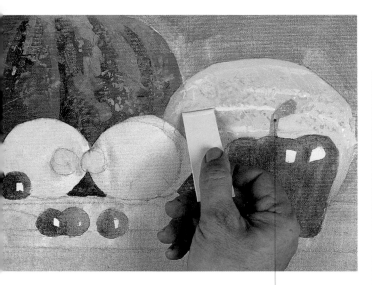

The stem of the pepper is formed by taking the pale green paint around the darker green underpainting.

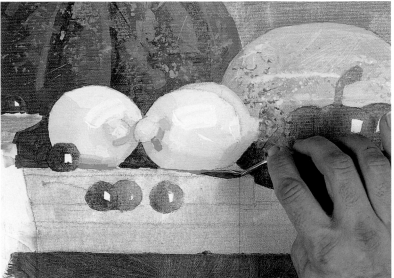

The edge of the painting knife creates a crisp linear mark. Use it here to paint in the dark colour at the base of each lemon.

9 Use the same implements to paint the pepper with mixes of cadmium red and alizarin crimson lightened with a little orange (made from cadmium red and cadmium yellow) and white.

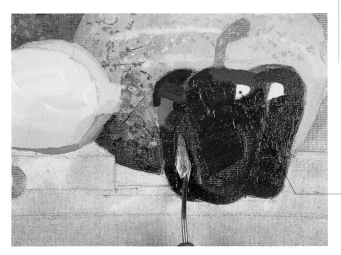

Create the highlight on the pepper by allowing the white ground of the support to show.

10 Once the previous layers of paint are dry, paint the table and the chopping block. Use masking tape to achieve straight edges. Apply the tape to isolate each separate area in turn, and remove it after the paint has been applied. The browns for the table are made using combinations of raw and burnt umber, with added cadmium yellow and white.

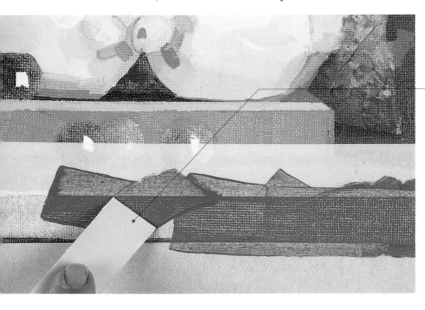

Apply the paint with stiff cardboard. Notice how this pulls the colour over the surface, leaving dark edges around each stroke.

When using a sharp knife for sgraffito effects, use the side to scratch, rather than cut, through the paint.

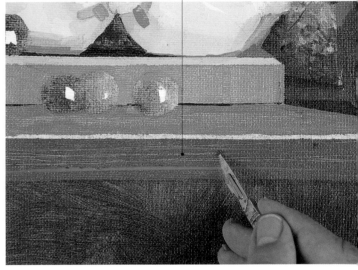

11 Use masks for the thin, light ochre line where the light catches the edge of the table. Add a few light brown lines (made from burnt umber and cadmium yellow) to the table's edge. Finish creating the wood-grain effect by using a sharp craft knife to scratch into the paint.

12 Mix cadmium red and alizarin crimson darkened with Payne's grey to create a deep red for the cherries, apply it with a wedge of cardboard and then work over it with a lighter red without the added grey. For the highlights, dab on white paint with the point of the painting knife. Use the same method for the lemons and pepper.

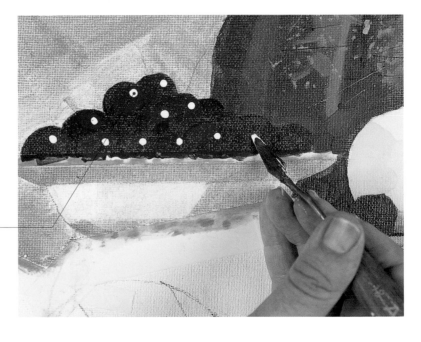

Use a relatively fluid mix for the highlights, and take care with the placing of each dab of white.

13 Darken the background with a mix of raw umber and Payne's grey. Use the foam brush, working carefully around the fruit. If the brush is too large for the smaller areas, manipulate the paint with a piece of cardboard.

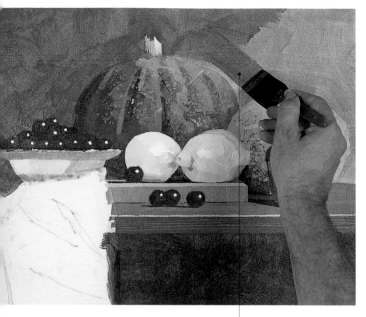

Apply thin lines of paint with the edge of the painting knife, together with a little sgraffito, to create the texture on the stem of the melon.

14 Remove the masking tape that has been protecting the white napkin and the edge of the dish. Add a little raw umber to Payne's grey and white, and use the larger painting knife to touch in the shadows and creases on the napkin.

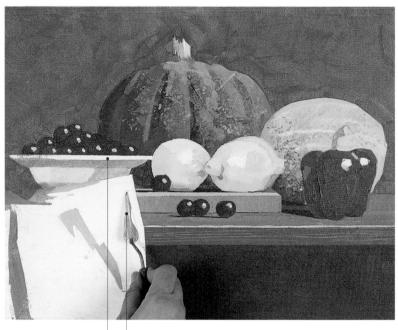

Isolate the rim of the dish with masking tape and paint with pure titanium white.

Trowel white paint onto the napkin, working around the shadows.

15 Make a fairly fluid green from a little viridian, raw umber, cadmium yellow, Payne's grey and white. Dip the edge of the larger knife into it and make thin curved lines to represent the stalks of the cherries.

Make a slightly curved line by applying the edge of the knife to the support and applying a little lateral pressure while pulling the knife upward.

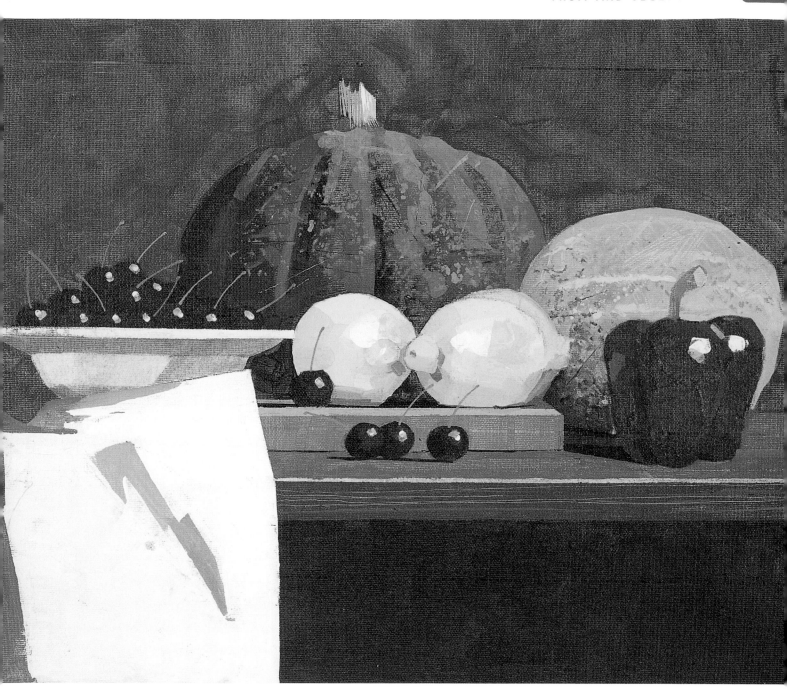

The Finished Painting: The triangular composition keeps the attention firmly in the centre of the image, while the light fruit in the foreground stands out strongly against the darker melon and the background. The shapes are kept simple so that they are relatively easy to paint using the chosen tools.

Mediterranean church

colours and mediums

1 Cerulean blue
2 Raw umber
3 Payne's grey
4 Viridian
5 Titanium white
6 Cadmium red
7 Burnt umber
8 Dioxazine purple
9 Ultramarine blue
10 Cadmium yellow
11 Yellow ochre
Retarding medium

Texture plays a very important role in painting. It not only adds considerable interest to an image but also gives clues to the qualities of a surface. In addition, it can be used in a more abstract way as a compositional device to direct the eye to a particular area. Texture can be made by thickly applying the paint to achieve a physical, tactile quality, or by using thin-paint techniques that create the illusion of texture, as in this project.

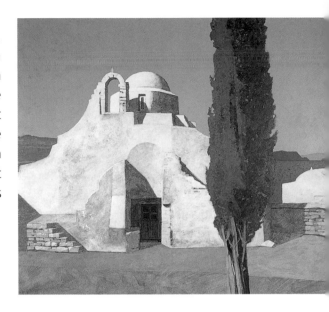

1 As in many of the projects in this chapter, this composition can be broken into thirds, with the sky occupying the top third and the foreground the lower third. The cypress tree splits the image in two. Position the tree approximately a third of the way in from the right-hand side. Using a soft graphite stick, draw the main elements in outline.

materials

MDF board primed with acrylic gesso, 610 x 711 mm (24 x 28 in.)

Soft graphite stick

50 mm flat bristle brush

14.6 mm flat bristle brush

6 mm flat soft synthetic brush

Small bristle fan blender brush

Natural sponge

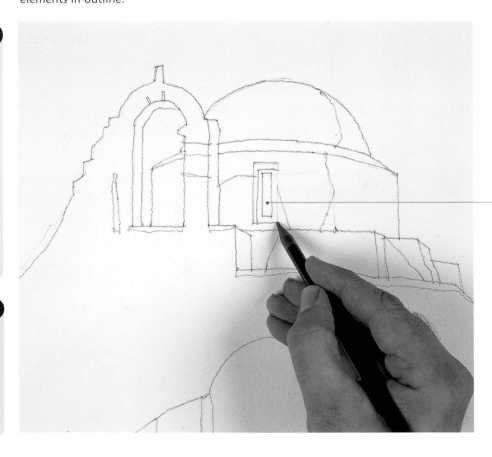

Make the drawing sufficiently dark to show through the coloured ground you will apply in the next step.

2 Using the flat 50 mm bristle brush, scrub a thin mixture of cerulean blue over the top half of the support, keeping the brushstrokes loose and visible. Pull the colour down over the lower half, gradually mixing in raw umber.

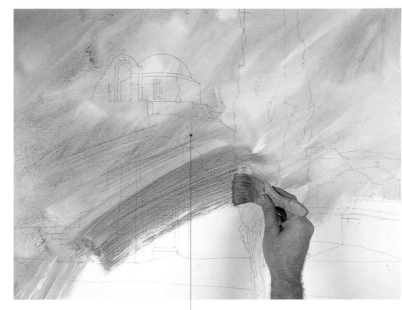

3 Mix a fairly stiff mixture of Payne's grey and raw umber, adding retarding medium but no water. Work the dull grey colour into the shadow areas of the church using the 14.6 mm bristle brush. Add progressively more raw umber as you work toward the bottom of the image and across the foreground.

The ground colour must not be too opaque because you must not obscure the drawing that will serve as a guide for your subsequent work.

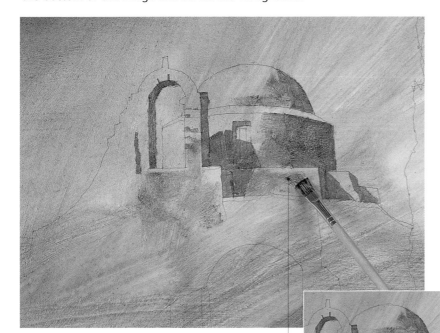

4 Mix viridian and raw umber to create a dull green. Paint the hills on the left (not seen in this image; see the image for step 10) and the cypress tree that cuts through the image. Again, keep the paint stiff and the brushstrokes relatively loose.

Scrub the paint hard so that it catches on the slightly raised brush marks left in the gesso priming.

Constantly vary the direction of the brushstrokes to give a lively surface texture.

5 Add a little Payne's grey to raw umber to create a dark brown-grey, making the mixture slightly more fluid by adding a little water. Use the flat synthetic brush to paint in the dark sections in the bark of the tree, together with the dark recess in the doorway of the church.

6 The next step is to work white paint at tube consistency into the sunlit areas of the building. Use the 14.6 mm flat bristle brush, scrubbing the paint as before so that some of the brush marks in the gesso ground as well as the colours of the subsequent underpainting show through.

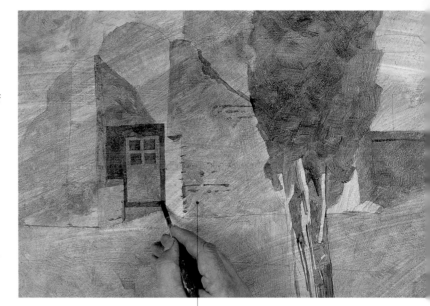

Use this mixture to add a few dark details where the brickwork on the church wall casts a shadow.

7 Brush the white paint out over the rest of the building using firm brushstrokes to spread the paint well. Cut in around the shape of the cypress tree, but avoid creating a hard edge.

Where the light catches any sharp corners, the paint is applied slightly more thickly.

Allow the underlying layers of paint to show through to create the illusion of a textured and pitted surface.

8 Mix a deep red using cadmium red, a little burnt umber and Payne's grey. Use the flat synthetic brush to paint in the shadowed red door in the recess at the front of the church.

As before, apply the paint so that previous layers show through.

Sgraffito is a quick way to describe the cracked panelling and peeling paint of the ancient door.

9 While the paint is still wet, use the end of the paintbrush handle to draw a series of vertical lines.

10 Prepare a dull violet mix using dioxazine purple, a little Payne's grey and titanium white. Paint in the darker section of the coastline seen in the distance. Add a little white to lighten the mix and paint in the rest of the coastline. Then paint the sea using a dull blue made from Payne's grey and ultramarine blue with a touch of raw umber.

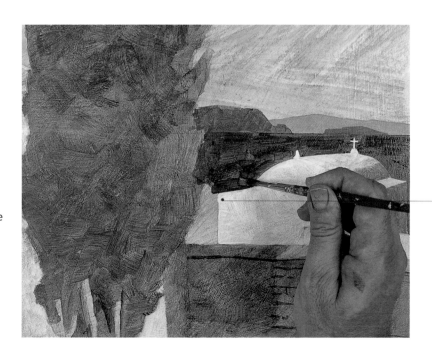

As you paint around the small building, it immediately begins to stand out as a light shape.

11 Mix cerulean blue and titanium white. Block in the sky, using open brushstrokes and constantly varying the direction of the strokes.

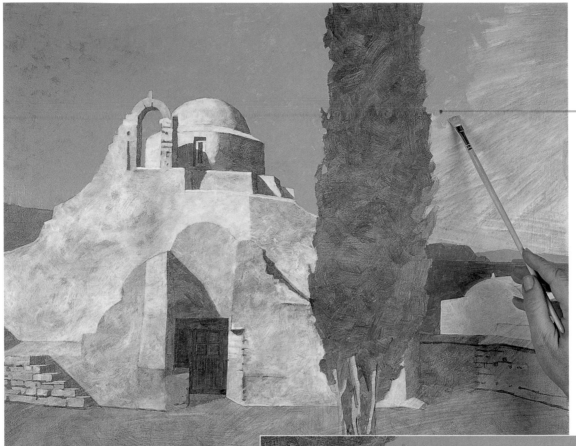

Break the edge of the cypress tree by painting small dabs of the sky colour over the green in places.

12 Add a little white to lighten the deep blue used to paint the sea in step 10. Rework the area with the lighter mix and the flat synthetic brush.

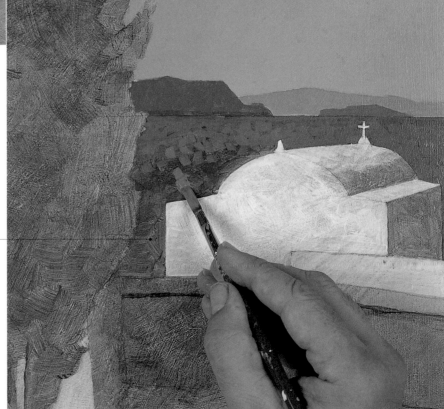

To give a sense of perspective, make the brushstrokes larger as you near the bottom of the area.

13 Apply more texture to the church with a sponge. Mix titanium white with plenty of water, wet the sponge and squeeze it dry, then dip it into the paint and dab it onto the wall.

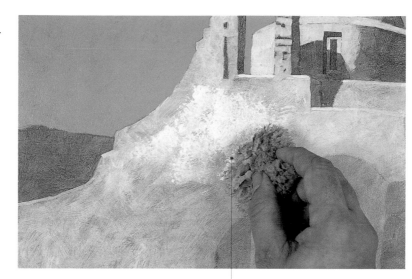

14 Use the 6 mm flat soft synthetic brush to apply thicker titanium white on the dome of the church and the brickwork around what used to be the bell tower.

Turn the sponge as you work to vary the pattern.

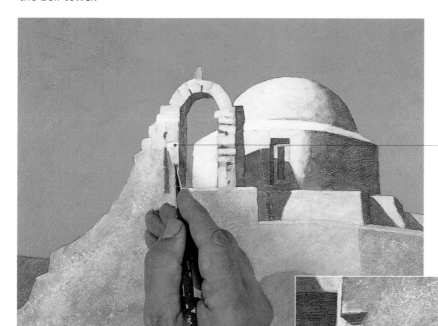

The pattern of the brickwork is achieved by making a series of single strokes with the small, flat brush.

15 Mix Payne's grey, raw umber and white. Paint the light side of the tree trunk, then leave to dry. Add more white to the mixture for the pattern of the bark. Dip the bristle fan blender into the paint, wipe it on a rag so that only a little paint remains and make a single downward stroke.

Take care to work with only the minimum of paint on the brush or the effect will be compromised.

16 Paint the shadowed side of the cypress tree using a dark green made from viridian, raw umber and Payne's grey.

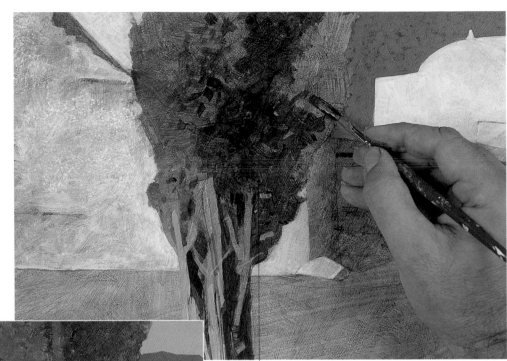

17 Add a little white, cadmium yellow and raw umber to lighten the green mix. Work over the light side of the tree.

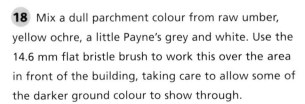

To give the effect of the foliage, vary both the direction and size of the brushstrokes.

Build up the texture of the foliage by working the paint in layers. Lighten the mix a little more for each layer.

18 Mix a dull parchment colour from raw umber, yellow ochre, a little Payne's grey and white. Use the 14.6 mm flat bristle brush to work this over the area in front of the building, taking care to allow some of the darker ground colour to show through.

The area at the very front of the picture appears closer because its texture is more easily read.

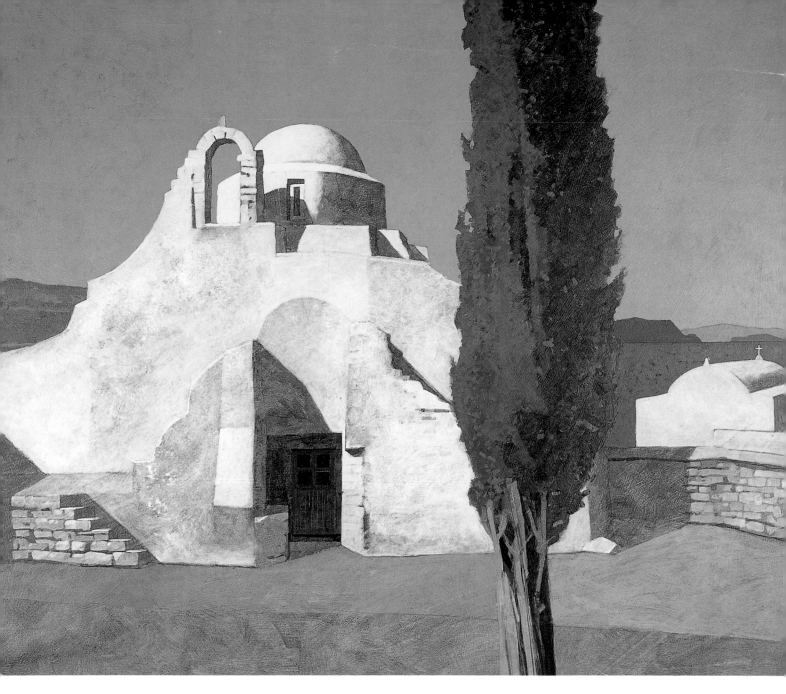

The Finished Painting: The textures of the stonework and tree have been realized by using simple flat-paint effects and by exploiting the slight physical texture left from the brush used for the priming. From the very first applications of paint used for the coloured ground, these textural qualities were evident, and all subsequent applications of paint were made in such a way as to enhance them.

Rocks and pines

In the Mediterranean church project on pages 122–129 we saw how to create the illusion of texture by using thin-paint techniques involving clever brushwork and scumbling methods. Here the texture is achieved in a different way – by using one of the many texture pastes provided by paint manufacturers for this very purpose. Texture pastes, which are usually applied with a knife, thicken and change the nature of the paint and give a strong physical presence to the finished work.

1 Sketch out the main elements of the design using a soft charcoal pencil.

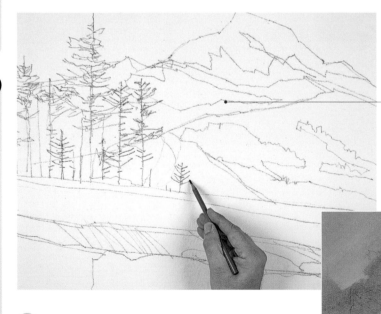

Corrections to the drawing are easily made by rubbing over the charcoal marks with a soft rag.

2 Using the paint quite thinly at this stage, block in an underpainting with the 24 mm flat bristle brush, using mixes of cerulean blue, dioxazine purple, phthalocyanine green and raw umber.

Use paint well diluted with water for the underpainting.

3 To represent the dark mass of the mountain, paint a cool mix of dioxazine purple and Payne's grey with the smaller bristle brush.

4 Once the paint is dry, repaint the mountains using slightly darker colours, plus a dark green made by mixing phthalocyanine green, Payne's grey and raw umber.

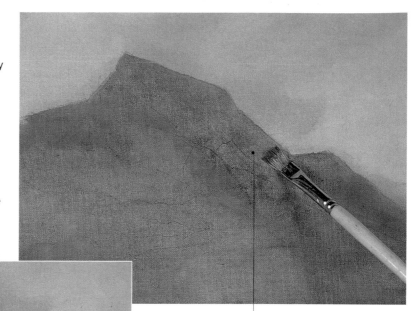

Apply the well-diluted paint as a thin wash.

Keep the paint thin and semitransparent at this stage.

5 Allow the washes to dry before the next stage. You can use a hair dryer to speed the process. Paint the snowcapped peaks with pure titanium white mixed with a little matt medium, applied first with the 14.6 mm flat bristle brush and then with a wedge of cardboard.

The wedge of cardboard makes the perfect angular-shaped marks to imitate the areas of snow caught on the jagged mountain ridges.

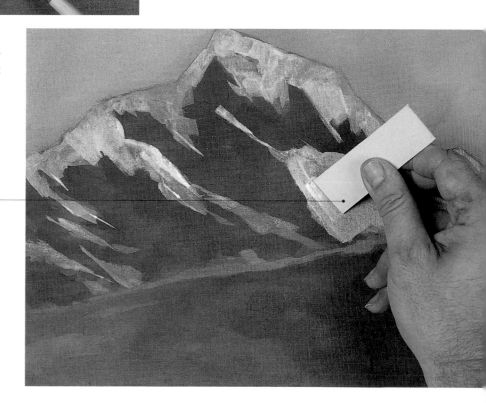

6 The snow on the lower slopes is not as deep and has begun to melt in places, showing the colour of the rocks and vegetation beneath. Scrub on thin washes of white using the 24 mm flat bristle brush.

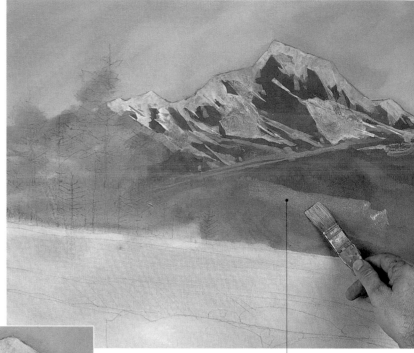

7 Paint the forest of pine trees that cloaks the lower slopes next, using the 14.6 mm flat soft-hair brush and dark green paint mixed from pthalocyanine green, Payne's grey and raw umber.

The thinned white paint does not fully cover the dark colour beneath, suggesting a light snow cover.

Use the end of the brush to create each tree in a single short stroke.

8 Once the areas of trees are established, redefine the slopes between them. Use the piece of cardboard again to pull out the paint in long, thin lines.

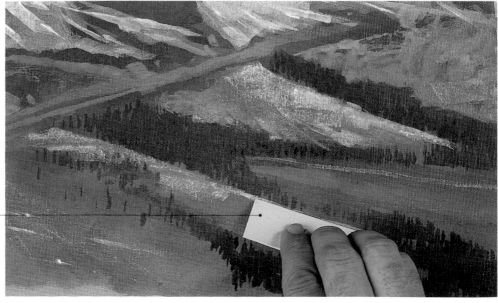

The cardboard is used on its edge to create linear marks.

9 For the tall pine trees on the left-hand side, mix a dark green from phthalocyanine green, Payne's grey and raw umber. Apply it with the bristle fan blender, dabbing just the end of the brush onto the surface to produce irregularly shaped branches.

10 Once the main structure of the trees has been painted with the dark green, allow the paint to dry. Then mix a lighter green by adding lemon yellow and white. Still using the fan blender, paint the lighter areas of pine needles over the dark underpainting.

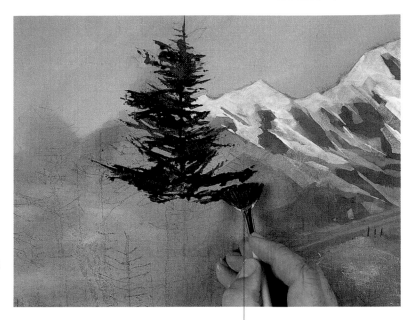

Use the very end of the fan blender to create the jagged, uneven edges of the branches.

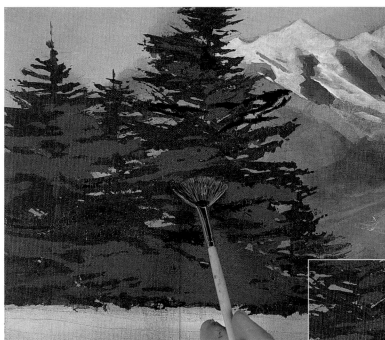

11 To paint in the trees that can be seen in the middle distance at the right-hand edge of the dark stand of conifers, use the rigger brush and the same dark green mixes as before, but thinned with a little water.

Work carefully over the dark areas, taking care not to obliterate them completely.

A rigger brush is ideal for making fine, precise strokes for the branches of the tree.

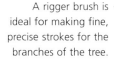

12 Mix a light blue from cerulean blue and titanium white, adding matt medium to achieve a creamy consistency, and apply it to the sky area using the 14.6 mm flat bristle brush.

Keep the brushwork open, and vary the direction of the strokes.

13 Once the first rough application is dry, lighten the mix very slightly with more white, and rework the sky area with the 14.6 mm flat soft-hair brush.

Vary the direction of the brushstrokes, and keep the work fairly open so that the previous layers of paint show through in places.

14 Now you can move on to the foreground. Mix raw umber with a little cadmium yellow to create a warm hue that will act as the base colour for the boulders and rock strata running across the lower third of the image.

Pull the colour across the image with the 14.6 mm flat bristle brush, varying the density and thickness of the paint.

15 Apply thicker applications of paint using the trowel-shaped painting knife.

Pulling the paint upward and away from the boulder creates a sharp, crisp edge that makes the shape stand out.

16 With the paint still wet, draw the lines of rock strata by scraping into the paint with the pointed end of the painting knife.

17 To achieve the subtle, slightly coarse textural effect required for the areas of rock, mix resin sand texture paste into a paint mixture of raw umber, plus a little cadmium yellow, Payne's grey and white.

Carry out any sgraffito work while the paint is still wet.

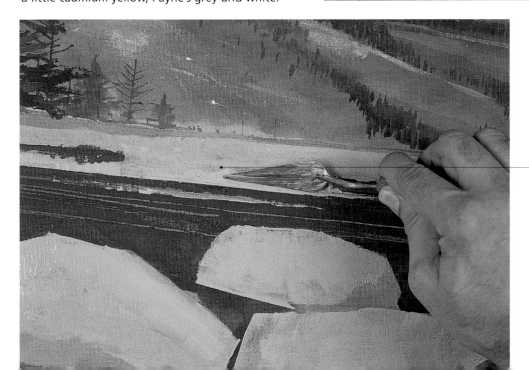

Apply paint thickened with texture pastes with a painting knife, because they tend to clog up the bristles of brushes.

18 For the area of rocks seen on the left of the image, mix some titanium white, raw umber and cadmium yellow. Use the 14.6 mm flat bristle brush and thick paint without texture paste.

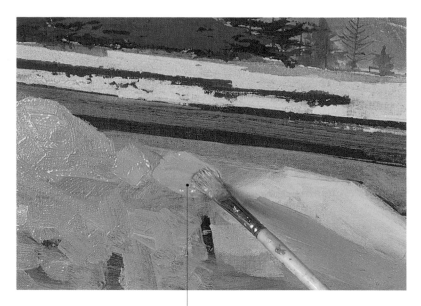

19 Allow all the paint to dry. Where texture paste has been added, this may take some time, but the process can be accelerated by using a hair dryer. Mix a dark brown from raw umber and burnt umber and use the 14.6 mm flat bristle brush to apply it over the textured areas. Spatter a little paint onto the rocks and boulders in the foreground.

Use directional brushstrokes that follow the contours of each rock.

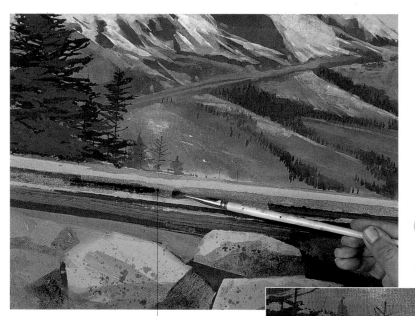

Apply paint in thin glazes over the textures to help redefine the shape of the strata and boulders.

20 Add final emphasis and definition with the painting knife, using a creamy mixture of burnt umber and Payne's grey.

Dip the painting knife in creamy paint and pull it sideways on edge to create a crisper, sharper, more incised mark than would be possible with a brush.

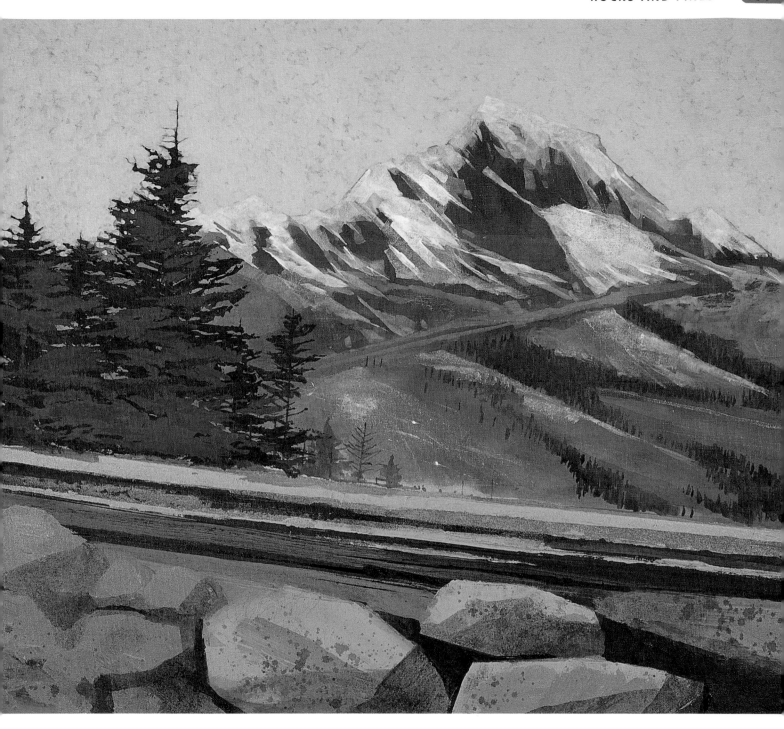

The Finished Painting: The chilly grandeur of this mountain scene is perfectly captured by the use of the cool limited palette of colours that create an acute sense of space and recession. The dark sentinel-like trees dominate the middle distance, while the combination of textures and warmer colours used in the foreground pull the area to the front of the picture plane.

Woman in a bright skirt

colours and mediums

1 Burnt umber
2 Ultramarine blue
3 Cadmium red
4 Cadmium yellow
5 Titanium white
6 Payne's grey
7 Cerulean blue
8 Alizarin crimson
9 Raw umber
Acrylic matt medium

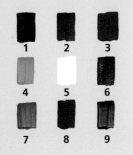

In this project, masking methods are used to produce crisp, clean edges. Acrylic is the ideal medium for these techniques, because the paint dries quickly enough to enable paper masks to be put in place more or less immediately with minimal interruption to the work flow. With a little practice, it is also possible to hold masks over wet paint and work over them quickly without disturbing the paint beneath.

1 Sketch in the main elements with the charcoal pencil. The figure should occupy the full height of the support and be positioned to one side in order to look in and across the picture area.

materials

Canvas board
457 x 610 mm (18 x 24 in.)

Hard charcoal pencil

14.6 mm flat bristle brush

14.6 mm flat synthetic brush

Craft knife

Masking tape

Scrap paper for mask

The hard charcoal pencil allows for a fairly precise drawing even on a textured surface.

see also

Opaque techniques, page 40
Masking, page 50
Composition, page 80

2 Using the 14.6 mm flat bristle brush, establish the main skin colours using mixes of burnt umber, ultramarine blue, cadmium red, cadmium yellow and titanium white. Mix all the colours with a little water and matt medium throughout the whole course of the painting.

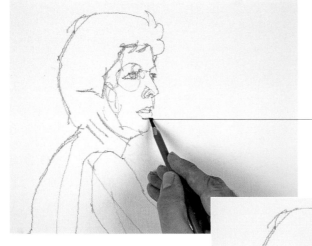

Notice how the direction of the brushstrokes follows the contours of the figure.

3 Continue to work across the body, lightening and darkening the colours as necessary.

4 Once the main flesh colours are established, turn your attention to the hair. Use the same brush to apply a dark blue-brown made by using Payne's grey and burnt umber.

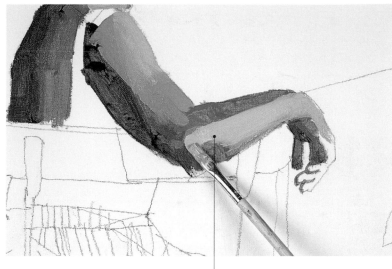

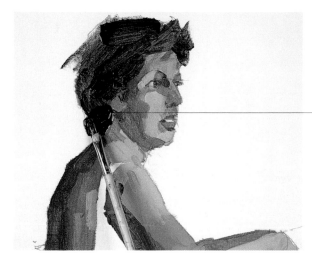

Keep "in touch" with the forms by placing each brushstroke so that it follows the contours and direction of the surface.

Make broad but fairly precise directional strokes.

5 Add more Payne's grey into the mix, and paint in the dark top. Then use the same mix to block in the dark shadows at the rear of the figure and across the skirt.

6 For the dull green of the waistband, mix cadmium yellow with a little cerulean blue and then dull the colour by mixing in a little orange made from cadmium red and cadmium yellow – this is used for the larger area below. Use Payne's grey and white to make the grays for the middle portion of the skirt. Add white and a little more cadmium red to the orange mix in order to create the light pink at the bottom of the skirt.

To paint the pattern of colours around the hem of the skirt, turn the brush on its side to create narrow marks.

The dark brushstrokes reinforce the charcoal drawing.

7 Mix a vivid red by combining cadmium red with a little alizarin crimson, and paint in the chair supports.

Use the edge of the brush and a precise sure stroke from top to bottom.

8 Prepare a medium grey for the wall behind the figure, mixing Payne's grey with a little cadmium yellow and plenty of white.

9 Work this medium grey paint around the sunlit areas of background; then add white into the mix and block in the lit area.

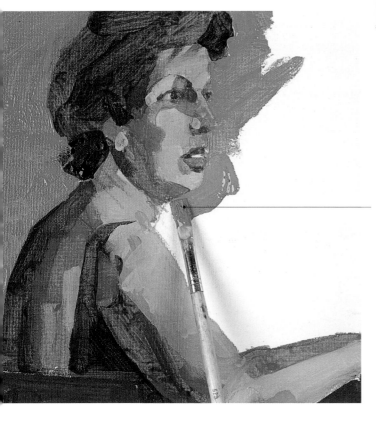

Apply the grey loosely to the background, carefully working around the figure.

Scrub a little darker grey into the light area in order to suggest some indistinct shadows cast by the sun shining through the foliage outside the window.

10 Once dry, the image can be reworked and the colours modified and consolidated. To do this, follow more or less the same order as for the initial blocking in, using the 14.6 mm flat synthetic brush for the skin tones.

The synthetic brush gives a smoother, more precise application of paint.

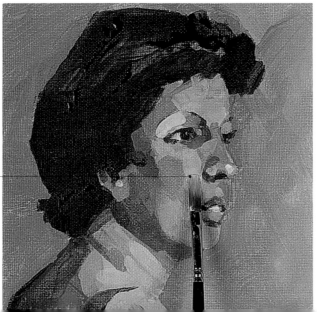

11 Use the same colours as before for the skirt, but make them slightly lighter and more opaque by adding more white.

Form the shadows in the creases on the skirt by allowing the darker underpainting to show through.

12 Paint the pattern around the hem of the skirt with a range of bright orange, red and blue mixes, still using the synthetic brush.

Used on its edge and with a gentle pressure, the soft brush will make fine, precise lines.

13 The background colour now needs to be darkened to illuminate the figure, and a paper mask must be used to redefine some of its parts. Mix Payne's grey with raw umber and white, and apply it with the mask held in position.

Work away from the mask to avoid pushing the paint beneath it.

Take care not to apply too much pressure with the knife or you may cut into the support.

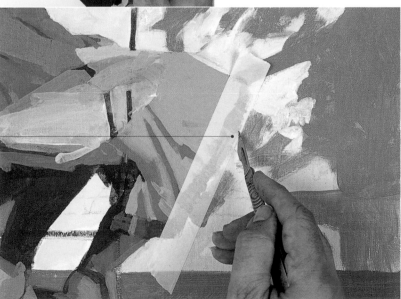

14 When the paint for the edge of the skirt is fully dry, apply a strip of masking tape and cut it into shape with a sharp craft knife.

15 Peel away the tape that is not needed, and make sure the rest is securely attached before applying the paint as before, working away from the masked area. Peel the tape off carefully while the paint is still wet.

16 Apply more tape to create a straight edge for the carpet. Mix raw umber, burnt umber, cadmium yellow and white, and paint it on, varying the direction of the brushstrokes.

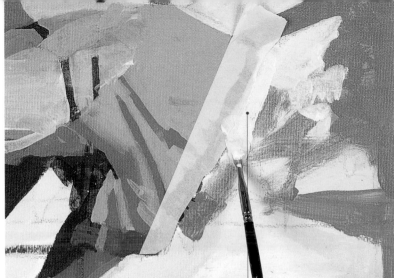

Mixing the paint to a creamy consistency will help to create a clean, precise line.

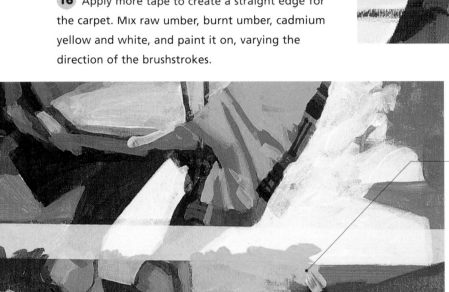

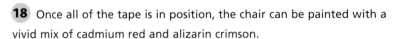

Establish the dark shaded area first, then lighten the mix using more yellow and white for the area in the light.

17 Once the paint is dry, more elaborate masking can be done to define the chair. Apply the tape and cut out any areas as needed to allow paint through.

18 Once all of the tape is in position, the chair can be painted with a vivid mix of cadmium red and alizarin crimson.

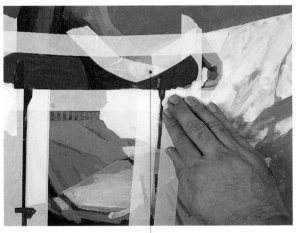

Tape can be carefully applied to create curves. A sharper curve can be made by using a narrower piece of tape.

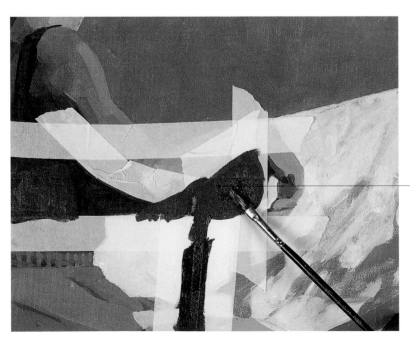

For the shadows, leave the darker underpainting uncovered.

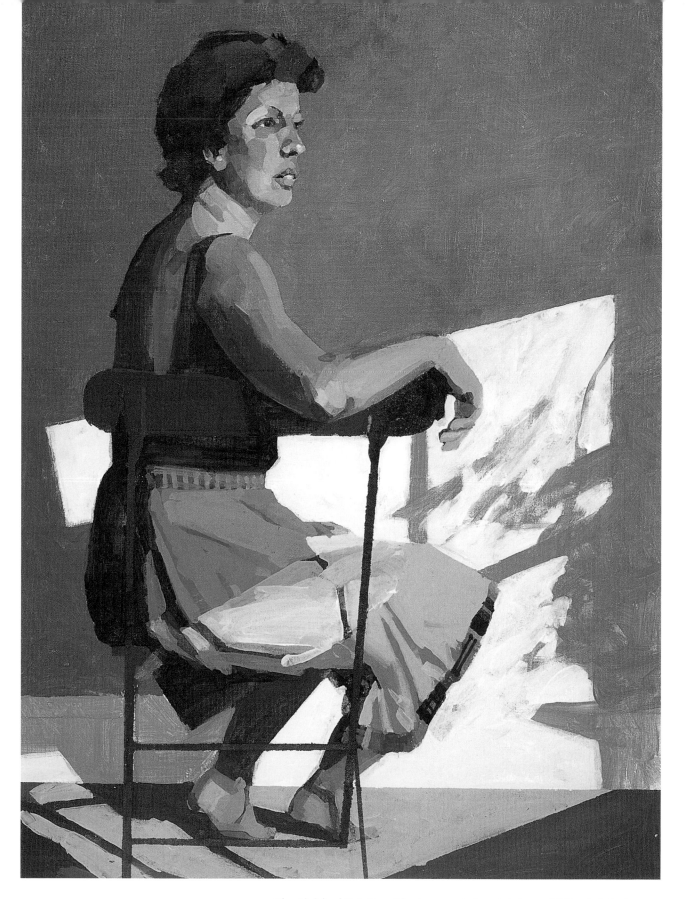

The Finished Painting: The loose paintwork is brought firmly into focus by using masking techniques to sharpen and define edges and certain areas of paint. The technique is quick and effective, but take care not to overdo it. Here the masking techniques are relatively precise, but a looser result more suitable for landscape painting could be achieved by using torn paper.

Market scene

colours and mediums

1 Payne's grey
2 Raw umber
3 Cadmium red
4 Cadmium yellow
5 Ultramarine blue
6 Burnt umber
7 Titanium white
8 Alizarin crimson
9 Cerulean blue
10 Phthalocyanine green
 Acrylic matt medium

materials

**Gesso-primed MDF
355 x 455 mm (14 x 18 in.)**

**Prepared painted
lightweight paper**

3B graphite stick

6 mm flat synthetic brush

14.6 mm bristle brush

Craft knife

Cutting board

White pastel pencil

Tracing paper

Hard pencil

see also

Collage, page 72
Mixed media, page 74

Acrylic paints and mediums all have pronounced adhesive qualities that make them ideal for use with collage techniques. The paint is also nonacidic and thus will not harm or cause deterioration in any of the papers or other materials that you use in the collage. Collages can be made from found materials, such as newspaper and magazines, from scraps such as bus or train tickets, or you can prepare your own by loosely painting watercolour or drawing papers, as in this image.

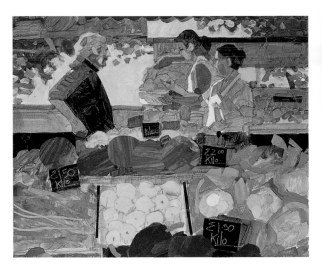

1 Make a light sketch with the graphite stick to establish the composition. The figures are ranged across the top third of the image with the produce tumbling toward the front, and the relative sizes of the figures and the fruit and vegetables lend an exaggerated sense of perspective to the work.

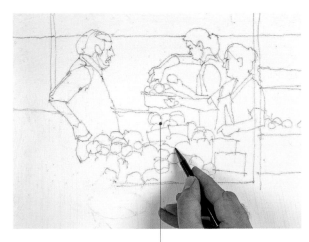

Make the drawing relatively precise, because it will be followed closely in the initial stages.

2 Using the 6 mm synthetic brush, begin to paint the figures in the background with simple semitransparent mixes of Payne's grey and raw umber mixed with a little water and matt medium.

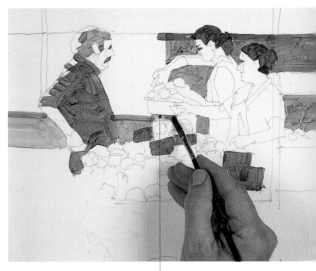

The paint should be thin and the brushwork should be precise and controlled.

3 To create the colours for the figures, mix cadmium red, cadmium yellow, ultramarine blue and burnt umber with white, and apply thinly as before.

4 To paint in the canopy at the top left, mix a dull purple from burnt umber, a little alizarin crimson and cerulean blue. Burnt umber, cadmium yellow and white with a little added cadmium red creates a dull orange for the fruit being handled by the girl, and cadmium yellow is used to block in the lemons. Paint the foliage and leaf vegetables with a range of medium greens mixed from cadmium yellow, pthalocyanine green and burnt umber.

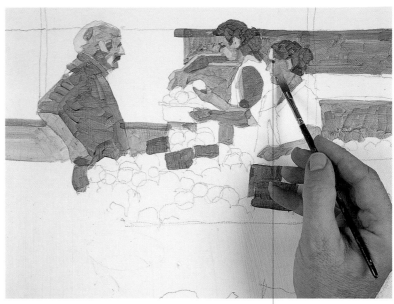

Because the paint is semitransparent, the darker colours show through the second layer.

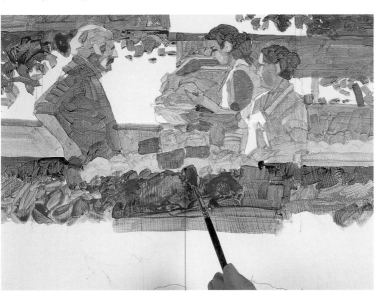

Let the brush marks show to add interest.

5 Paint the wooden boxes with a mix of raw umber and cadmium yellow; the fruit and vegetables with mixes of cadmium red, alizarin crimson and cadmium yellow; and the slate boards with Payne's grey and burnt umber.

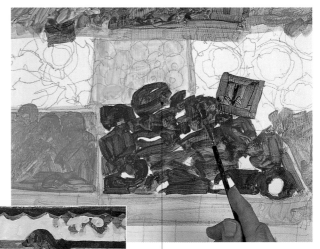

Detail is not needed, as the idea is simply to provide a base colour onto which the collage materials can be applied.

6 Once the image has been blocked in and is dry, the collage work can begin. In order to prepare the collaged papers so that they fit a specific area, place a sheet of tracing paper onto the image and make a simple outline.

Make sure the image is completely dry or the tracing paper will stick to the support or smudge the paintwork.

7 Turn the sheet of tracing paper over and place it on the back of the painted paper intended for the collage. Use a hard pencil to trace around the image in order to transfer it to the paper.

8 Working on a cutting board or piece of cardboard, use a sharp craft knife or scalpel to cut carefully around the pencil trace.

The tracing must be done on the back of the collage paper or it will be reversed once cut out.

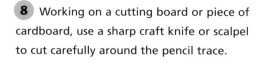

Make sure the blade of the knife or scalpel is sharp – replace if necessary.

9 Before attaching, place the shape over the relevant area to check the fit.

10 Once you are sure the shape is right, secure it to the support using matt medium. Paint the medium directly onto the support and replace the paper shape while the medium is still wet. Once in position, paint more medium on top, using the 14.6 mm bristle brush to press the paper firmly into place.

If the shape needs to be altered, it can be cut or trimmed with the knife.

Any medium showing on collage paper or elsewhere will become transparent as it dries.

11 Continue the collage process, working from the back to the front of the picture. The tracing-paper method need only be used for complicated shapes; most simple shapes can be easily cut freehand.

12 Vary the shape of the collaged papers so that they approximate the object or area they represent, but try not to be too literal. The image will benefit if the shapes are simple.

Thin paper can be applied in layers, but if you intend to use very thick paper, you may need to cut around shapes so that they fit side-by-side.

Thin, dark strips at the edges of the boxes indicate their position and perspective.

The loose brushwork used when colouring the collage papers now comes into its own, giving the shapes a distinct texture.

The adhesive qualities of the paint can be utilized by pressing more paper shapes into the wet paint.

13 To define the red peppers and make them stand out better against their background, paint around them with a mix of alizarin crimson, burnt umber and Payne's grey.

The darker base red helps the peppers to stand out and gives a sense of depth.

Attach the shapes at the back of the box first, gradually working forward so that each vegetable appears to occupy its correct spatial position.

14 Cut out several pepper shapes, noting how these vary according to the angle of viewing. Attach the dark rectangle for the signboard first, followed by the pepper shapes.

15 Cut several curved green stalks and a few circular green shapes to represent the stalks that are seen from directly in front.

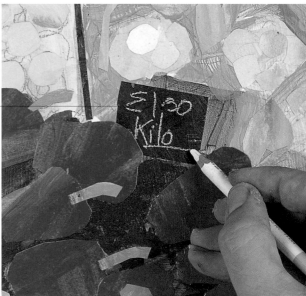

The addition of green, along with red, makes the colours appear brighter by contrast.

16 Cut and glue dark grey paper beneath the boxes to indicate the shadow cast onto the front of the stall where they overhang the table.

The dark shadows add depth and help to push the front edges of the box forward.

17 Allow the image to dry thoroughly, and then write in the prices on the slates with white pastel pencil.

The pastel pencil has a similar texture to chalk, making the sign more realistic.

18 Suggest the grain on the end of the wooden boxes using the graphite stick.

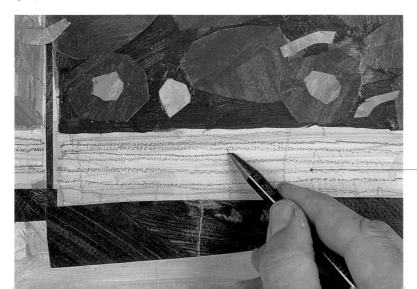

Make sure the surface is fully dry and don't make the lines too straight or you will lose the wood-grain effect.

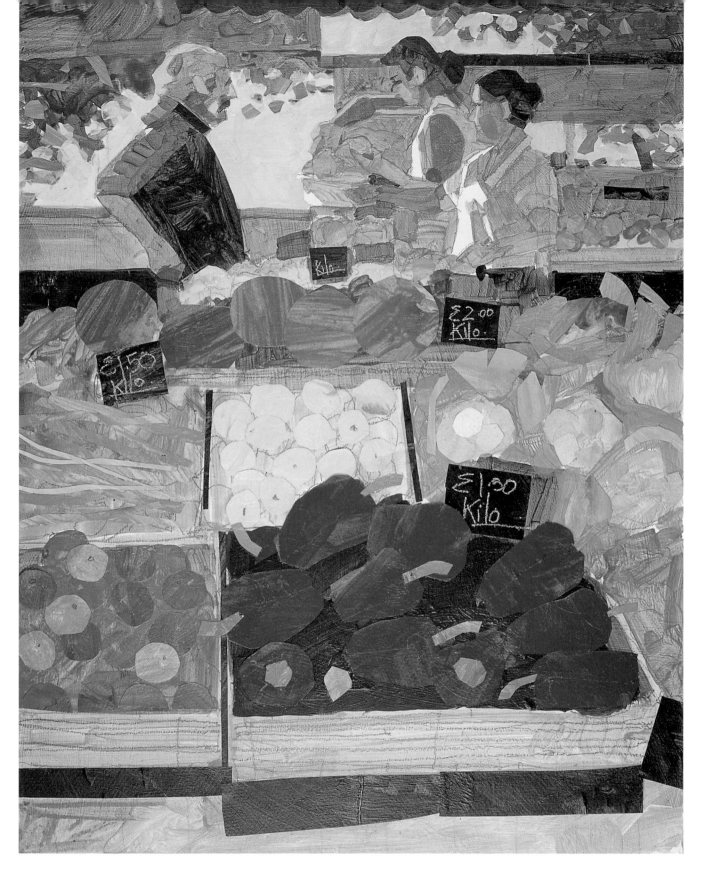

The Finished Painting: A danger with collage is that there may be too much contrast between the paper shapes and the paintwork, but here the image is fully integrated because the same kind of brushwork has been used for both. Painting the papers loosely helps create textures that add extra interest, while the hard-cut edges add focus to the collaged shapes.

Natural objects

colours and mediums

Acrylic paints
1 Raw umber
2 Cerulean blue
3 Cadmium yellow
4 Titanium white
5 Burnt umber
6 Cadmium red
7 Alizarin crimson
8 Ultramarine blue
9 Payne's grey
Acrylic matt medium

Pastel pencils
Grey
Ochre
Terracotta
Umber

Hard or soft pastels
Dark and light blue
Burnt umber
Warm grey
Yellow ochre
Raw umber

materials

Gesso-primed MDF
457 x 660 mm (18 x 26 in.)

Soft graphite stick
(or pencil)

14.6 mm bristle brush

No. 7 round synthetic brush

Medium-sized paint shaper

14.6 mm flat
synthetic brush

Small natural sponge

33 mm housepainting
bristle brush

Large feather

Mixed media work opens up a wealth of picture-making possibilities, and the choice of media that can be used with acrylics is a wide one, with only one restriction: Acrylics, being water-based, cannot be used over an oil-based medium. Charcoal, pastel and graphite, along with all other dry drawing materials, can be used with acrylic and, if mixed with acrylic mediums, will turn into a form of paint while still retaining their own identity. This enables a range of techniques that extend the "look" of the material, providing a unique quality to the work.

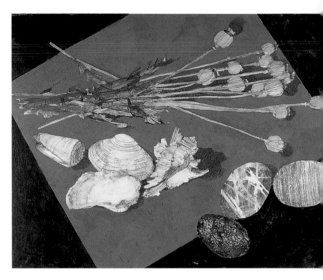

1 Position and sketch in the objects using a soft, sharp graphite stick or pencil. Much of this initial work is intended to show in the final image, so pay attention to the quality of the line work, keeping it fluid and attractive.

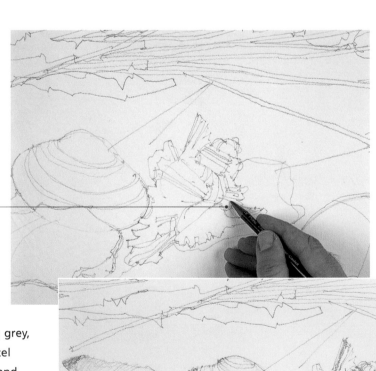

The prepared gesso surface is very receptive to drawing materials.

2 Continue the drawing, using grey, ochre, umber and terracotta pastel pencils. Keep the drawing open and linear rather than making solid blocks of colour.

Keep your hand away from the support, since the dusty pastel is easily smudged.

3 Add more colour with dark and light blue hard pastels, using the flat side to apply the colour in simple blocks. Soft pastels can also be used.

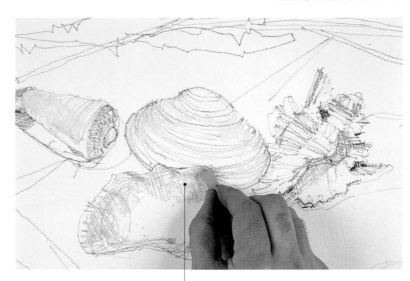

4 Now work into the drawing with matt medium and the 14.6 mm bristle brush to spread the graphite and pastel marks across the surface. Don't overdo the blending, however, or the drawn marks will be completely obliterated.

The brush marks left in the gesso priming break up the strokes, adding to the textured effect.

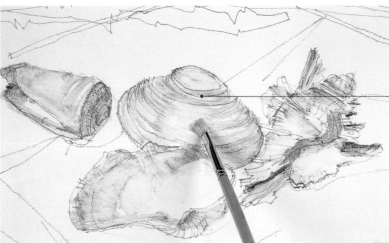

Once the medium has dried, the graphite and pastel marks will be permanently fixed.

5 Work on the stones in the same way with burnt umber and warm grey pastel. This mixes well with the medium to create a good depth of colour.

6 Turn your attention to the dried poppy seed-heads, and repeat the process used for the stones, using a yellow-ochre pastel to supply the colour. Don't be concerned about keeping the paintwork within the original drawn lines.

The thick acrylic medium and the stiff brush create a pleasingly textured surface.

The graphite lines drawn in the first stage are still visible.

7 Leave the work to dry out completely and then rework it with further applications of graphite and pastel, still keeping it essentially linear in feel.

Use the line work to explore and describe the form of each object.

8 Make a dull green-grey mix of acrylic from raw umber, cerulean blue, a little cadmium yellow and white, plus water and matt medium, and loosely paint in the leaves of the poppies. While still wet, use the paint shaper to manipulate the paint and pull it into shape.

Work quickly while the paint is still wet. Retarding medium can be used instead of matt medium.

9 Work into the pencil and pastel marks with the round synthetic brush and fairly thick white paint to modify the internal structure of the shells.

White acrylic is not completely opaque. If you intend to use it to paint over any mistakes, you may need several coats.

10 To paint the pattern on the dark brown stone, make an ochre mix from burnt umber, cadmium yellow and a little cadmium red, and apply it with a natural sponge.

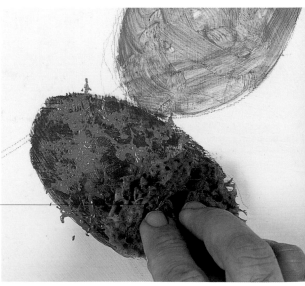

Wet the sponge before dipping it into the paint, and take care not to apply too much pressure or the effect will be lost.

11 Apply several layers to the stone, making each one slightly lighter than the last, and letting each layer dry before applying the next. Mix white paint to a creamy consistency and flick it onto the grey stone using the end of a large feather, the corner of a rag or a fan-shaped blending brush.

12 The texture on the third stone is achieved by spattering the white paint using a stiff bristle housepainting brush.

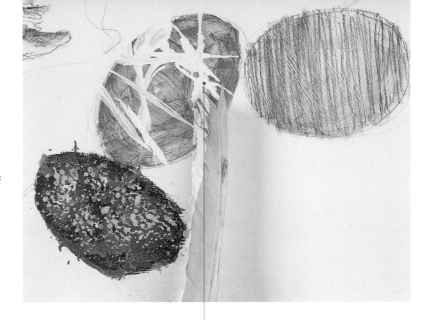

This technique is one that is often shown in books on paint finishes; it is used to imitate marble.

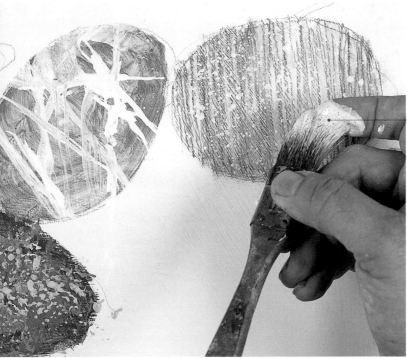

Test the method on a piece of scrap paper to make sure the paint is the right consistency so that it leaves the brush easily.

13 Once the image is dry, the background of pink tissue paper can be painted. Mix alizarin crimson and a little cadmium red with ultramarine blue and white, and apply it with the 14.6 mm flat synthetic brush.

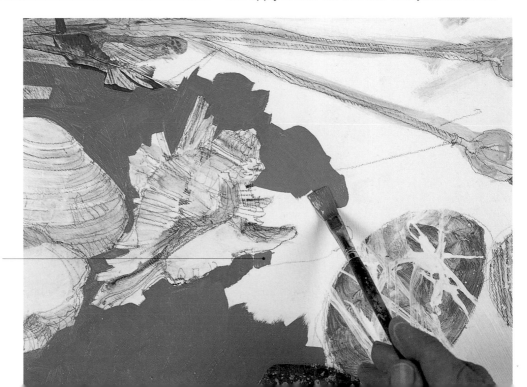

Work the paint carefully around the objects, redefining their shapes as you work.

14 Once dry, repaint the area using the same colour, with the addition of more white.

15 Now return to the graphite stick or pencil and strengthen the shadow area with marks following different directions.

Allow the slightly darker layer to show through in places to represent the areas of cast shadow.

Keep the pencil work loose and open, in keeping with the earlier drawing.

16 Complete the image by painting the dark brown surface on which the pink paper rests. Use the 14.6 mm flat synthetic brush to apply a mix of burnt umber and Payne's grey.

In order to achieve a relatively opaque covering, you may need to apply two or more coats.

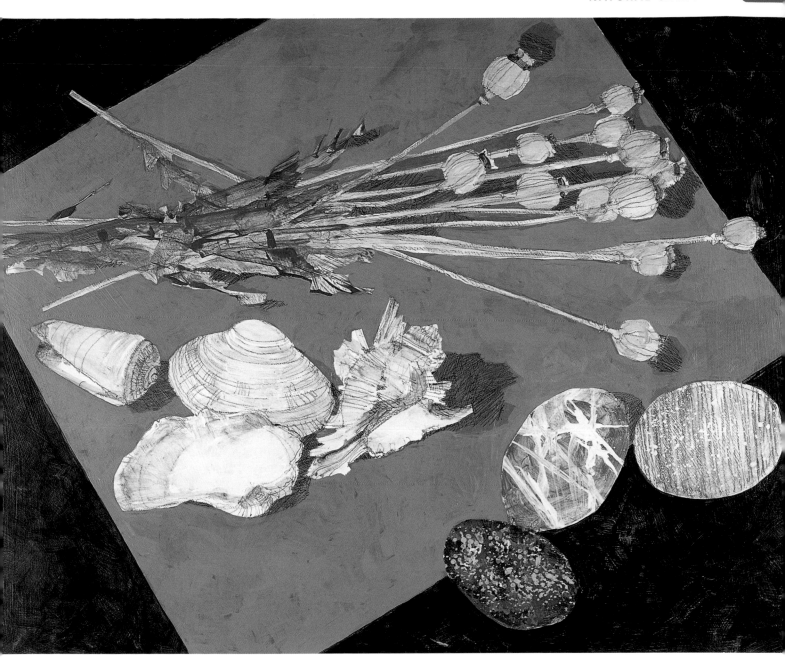

The Finished Painting: The use of different media gives an exciting new look to a well-used motif, demonstrating how strongly the working method affects the finished result. This is only one approach to mixed media work, but it may serve to provide ideas for further experimentation.

Glossary

Acrylic paint A water-based paint in which the pigment is bound in a synthetic acrylic resin.

Barium sulphate (BaSO$_4$) This compound combines with zinc oxide (ZnO) to make a white pigment known as lithophone, or with sodium sulphate (Na$_2$SO$_4$) to make another white pigment, known as blanc fixe.

Blend The act of smoothing together two different colours so that one changes imperceptibly into the other.

Blender A type of fan-shaped brush used for blending colours together.

Broken colour Colour that is applied in a way that allows another colour or surface to show through in places.

Bulking medium A medium used to increase the volume of paint. (*See also Extender and Gel medium.*)

Charcoal Used as a drawing implement. It is available either in pencil form or as compressed charcoal sticks in different grades.

Collage A work put together from assembled fragments.

Colour index A universally accepted colour-coding system published by the Society of Dyers and Colourists and the American Association of Textile Chemists and Colorists.

Colour wheel A diagrammatic arrangement of colours showing the basic aspects of colour theory.

Complementary colours The pairs of colours that are opposite each other on the colour wheel: red and green, blue and orange, and yellow and violet.

Composition The way an entire picture is designed and constructed.

Conté pencil Hard sticks of pigment, bound with gum arabic.

Easel A vertical prop for the painting support.

Extender A medium that increases the volume of paint without altering its colour.

Fixative A thin varnish sprayed onto pastel or charcoal drawings to prevent smudging.

Flow improver A medium used to reduce surface tension of the water in the acrylic emulsion, making the paint flow more smoothly.

Gel medium A thicker version of the basic matt and gloss mediums. Gel mediums add body to the paint and are often used for impasto work. They will also make the paint more transparent.

Gesso medium A mixture of glue-size whiting and white pigment, traditionally used to prime a rigid support. Today acrylic gesso is made for use on any support.

Glaze A thin, transparent wash of colour.

Gouache A water-based opaque paint.

Graphite A carbon-based mineral used in the manufacture of paints.

Hue The term for a pure colour found on a scale ranging the spectrum – red, orange, yellow, green, blue, indigo and violet.

Imprinting The technique of pressing a patterned or textured object into wet paint on the painting surface and then removing it.

Impasto The technique of applying paint thickly so that it stands out from the surface of the painting.

Lifting out A watercolour technique where paint is removed with a wet brush or sponge.

Marouflaging A technique used to prepare a rigid painting support by attaching canvas to a board using acrylic medium as an adhesive.

Masking Placing a material onto a support to prevent paint from making contact.

Medium The substance added to paint to change its consistency or appearance. Acrylic mediums include matt, gloss, retarders, flow improvers, texture pastes and gesso primers.

Monoprinting The printing of a single image, rather than a series of images.

Opaque technique The use of paint to obtain a non-transparent finish.

Optical mixing (*See Pointillism.*)

Overpaint (v.) The process of painting over a previous coat of paint.

Painting knife Used for laying paint onto a surface or for scraping paint off to create texture or to correct mistakes.

Paint shaper These resemble traditional paintbrushes but have a flexible rubber tip instead of hair or fibre bristles. The marks they leave are similar to those made using a painting knife.

Palette 1. The flat surface on which paints are laid out and mixed. 2. The range of colours used in a work, or the characteristic range used by an individual artist.

Palette knife Used for mixing large quantities of paint on a palette. Can also be used to carry out the same functions as a painting knife.

Pastel A paste made from powdered pigment; often used in crayon form.

Perspective The way in which the effect of distance is represented graphically.

Pigment The substance that provides colour in paints.

Pointillism The technique of applying blobs of colours to a surface so that, although the pigments do not actually mix, from a certain distance the colours appear to blend together.

Porous Permeable to fluids.

Primary colours The only colours that cannot be made by mixing other colours: red, yellow and blue.

Primer Material used in preparing a surface for painting.

Printing The technique of covering a patterned or textured object with paint and pressing it onto a surface.

Retarder A medium that increases paint-drying time.

Resist A technique that involves using two materials (such as wax and acrylic paint) that, under normal circumstances, repel each other.

Rigger brush A type of small, round, long-haired brush originally used for painting the rigging of sailing ships.

Rule of Thirds The most famous formula for the ideal placement of elements within a composition.

Scratching technique (*See Sgraffito.*)

Scumbling Applying colour loosely over another colour to give an irregular, broken surface.

Secondary colours The colours that are obtained by mixing two primary colours.

Shade A darkened version of a colour, made by adding black.

Sgraffito A way of drawing by scratching or scraping through the top layer of a painting to reveal a different colour or tone beneath.

Skin The thickening layer formed at the surface of the paint as it begins to dry.

Spattering A method of sending droplets of paint over a surface.

Stay-wet palette Especially designed for acrylic work, stay-wet palettes keep paint moist for long periods. They work by osmosis: moisture evaporating from the surface is replaced by water from the dampened reservoir paper beneath the semi-permeable membrane, which forms the working surface of the palette.

Support (n.) The surface – canvas, wood, board or paper – on which a painting is made.

Tertiary colours Colours that are made by mixing a primary colour with the secondary colour next to it on the colour wheel.

Texture paste Mediums into which various aggregates have been added. The medium is mixed with paint to add texture.

Tint A lightened version of a colour, made by adding white.

Tone (also value) The lightness or darkness of a colour. Every colour has an intrinsic tone.

Transparent Thin or sheer enough to see through.

Translucent The ability of light to permeate.

Underpainting The technique in which paint is applied as a base for additional layers of paint.

Vanishing point The point on a theoretical horizon line where lines of perspective meet.

Varnish A protective coating applied to the surface of a dry painting.

Wash A very diluted, transparent paint mixture that is applied broadly over large areas in watercolour and acrylic work.

Watercolour paper Paper designed specifically for wet media such as watercolour or acrylic work.

Wet-into-wet The addition of wet paint into or over an area of paint that has not dried, in order to blend or modify colours and tones already on the canvas.

Wet-on-dry The application of wet paint over an area of dry paint.

Index

Acknowledgments

My thanks to Jo Fisher and Anna Knight at Quarto for all their help in producing this book.

Quarto would like to thank the following: London Art Co UK Ltd (www.londonart.co.uk) and Artshole (www.artshole.co.uk).

All other photographs and illustrations are the copyright of Quarto Publishing plc.